THE WORLD OF
Pasta

(c) 2003 Feierabend Verlag, OHG,
Mommsenstr. 43, D-10629 Berlin.

Idea: Peter Feierabend
Recipes, Styling, Production: Patrik Jaros
Recipe Assistant: Martina Dürkop
Editor of the original text: Martina Dürkop
Assistant: Bamboo
Photography: Günter Beer - food.beerfoto.com
Assistant: Kathi Günter, Sarah David-Spickermann
Photos taken at BuenavistaStudio, Barcelona
Layout: Kathi Günter, Günter Beer

Multilingual Management: LocTeam, S. L., Barcelona
www.locteam.com
Translated from German by Alex Guardiet

(c) 2003 Text, Design, Photography, Recipes:
Günter Beer, Patrik Jaros & Feierabend Verlag,

Printing and Binding: Eurolitho s.p.a., Mailand
Printed in Italy
ISBN: 3-89985-054-8
 61 08033 1

Important: All ingredients – especially fish and seafood – should be
fresh and in perfect conditions. Lettuces must be washed very carefully.
Those vulnerable to Salmonella enteritidis infections – in particular the
elderly, pregnant women, young children and those with weakened
 immune systems – should consult their doctor before consuming raw
eggs, raw fish or seafood.

Günter Beer · Patrik Jaros

THE WORLD OF
Pasta

Feierabend

Contents

Level of difficulty Preparation time

40

Pasta – the king of the kitchen

It is not clear whether pasta's cradle was China and introduced to the rest of the world by Marco Polo, or whether it really was invented by the Italians. However, the fact is that no other food is as versatile as pasta. Wan tan, soba noodles, Chinese transparent noodles, hundreds of Italian varieties, created with inventiveness and a passion for the art, American cheddar cheese noodles and Swiss pizzoccheri: the whole world loves pasta, and it has become a synonym for a modern way of life. It stands for quick nutrition, but at the same time it belongs to the finest haute cuisine of the masters, who always manage to find new aspects of it.

The trendiest restaurants in cities ranging from New York to Sydney await their guests with new pasta combinations, who in turn never tire of trying it in new guises. Pasta will always be a favourite: whether in the classic Italian style, Asian style, a mixture of styles, savoury or sweet.

You will find everything from Linguine vongole (page 50) to Spaghetti Nerone (page 12), as well as interesting variations such as German potato noodles with coffee sauce and cardamom (page 177). This book will give you an insight into the Italian way of life – as well as the flair of Chinese wok dishes.

The endless possibilities offered by pasta appear here in traditional pasta dishes, but there are also many surprises.

Let yourself be tempted!

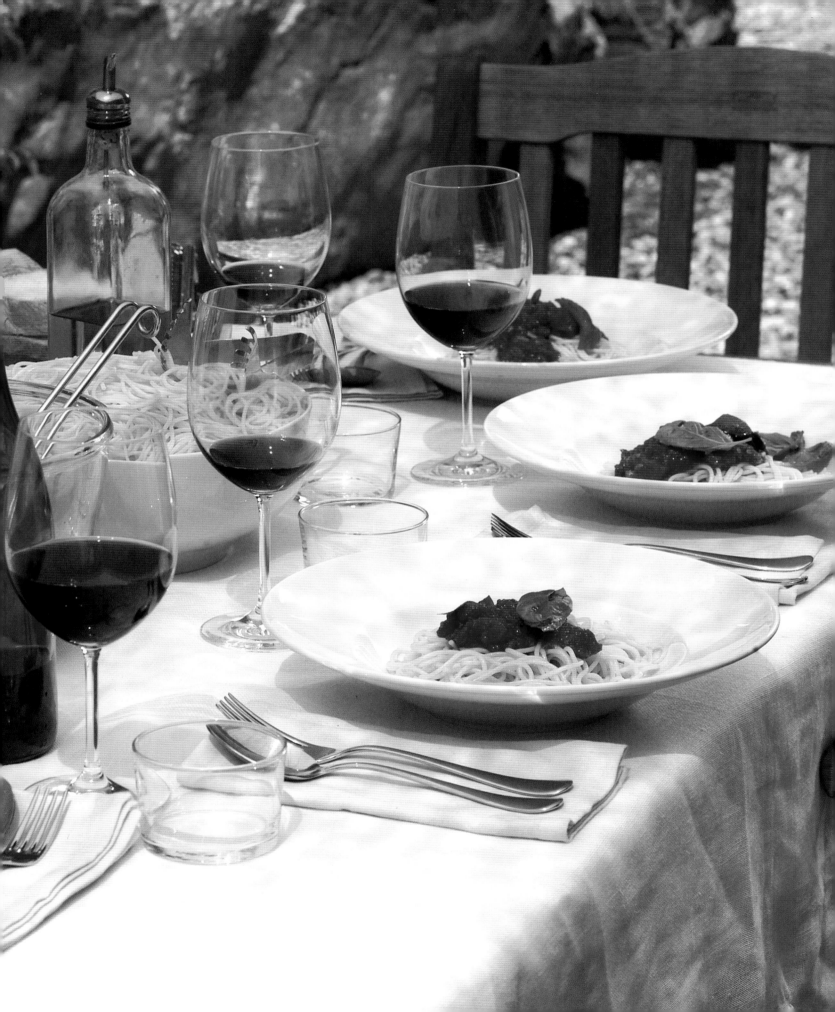

Simple tomato sauce
Italy

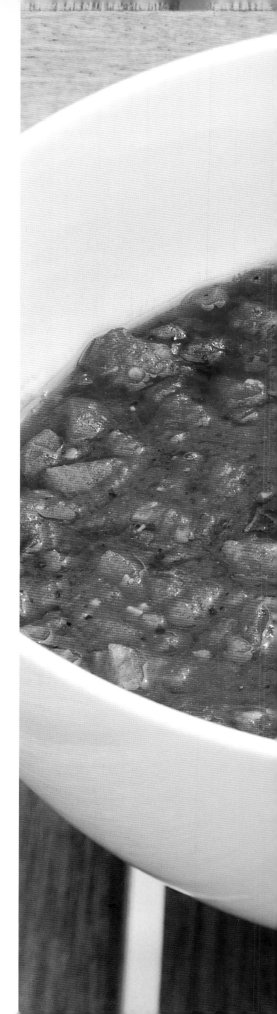

Makes about 1 litre of sauce

2 tins of peeled tomatoes (about 800 g / 28 oz)

6 tbsp olive oil

2 red onions, finely chopped

2 garlic cloves, finely chopped

1 tbsp tomato paste

A few basil stems tied together to give aroma

to the boiling water

Salt
Freshly ground black pepper
1 pinch of sugar

A few basil leaves, not too finely cut

Put the tomatoes in a sieve with a pointed end and drain, saving the juice. Cut the tomatoes into quarters, discard the hearts and chop the flesh.
Heat the olive oil, add the onions and garlic and fry until transparent, then add the tomato paste.
Add the basil and season with salt, black pepper and the pinch of sugar. Pour over the tomato juice and simmer for about 20 minutes. Reduce the tomato juice to about half the original quantity.
Add the chopped tomatoes, remove the basil and simmer for a further 5 minutes.
Finally, adjust the quantities of salt, black pepper and sugar and add the basil leaves. Place the tomato sauce in preserving jars while still warm, and seal them.
The sauce will keep for up to two weeks in the fridge.

Tip
Tie the basil stems with kitchen string so that they are easy to remove from the sauce.
An easy to prepare tomato sauce with an intense fruity flavour.
Since you can only find ripe tomatoes during a short period of the year, this simple but intense tomato sauce is a good alternative for the rest of the year.

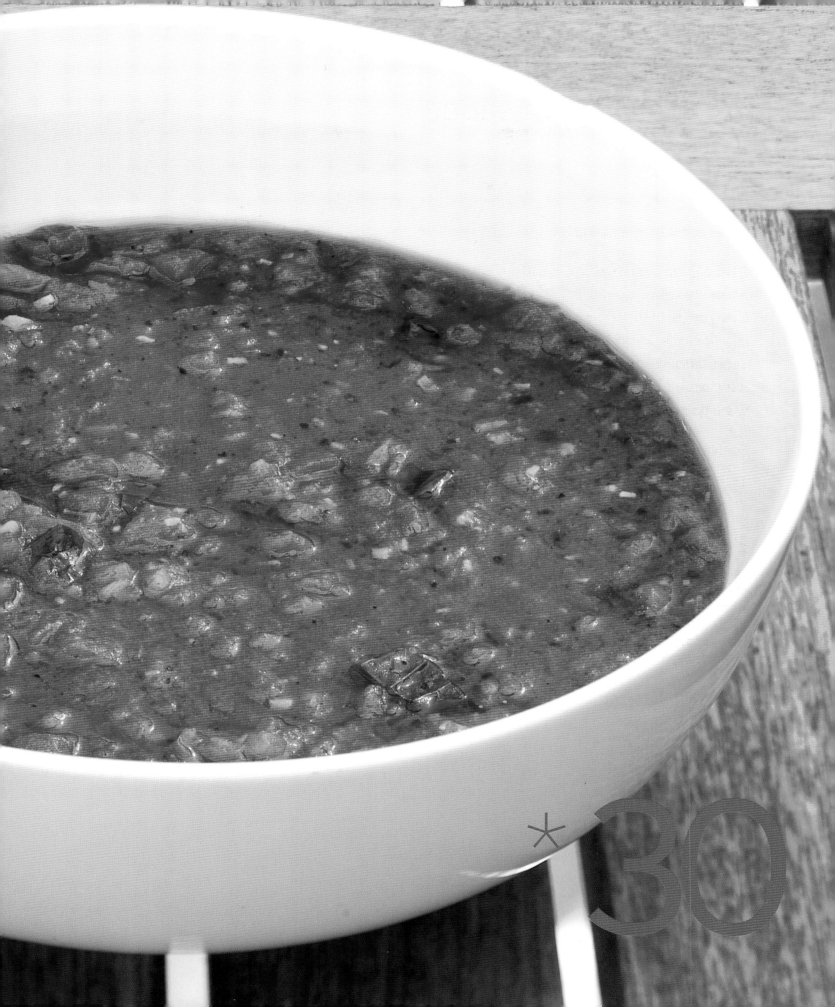

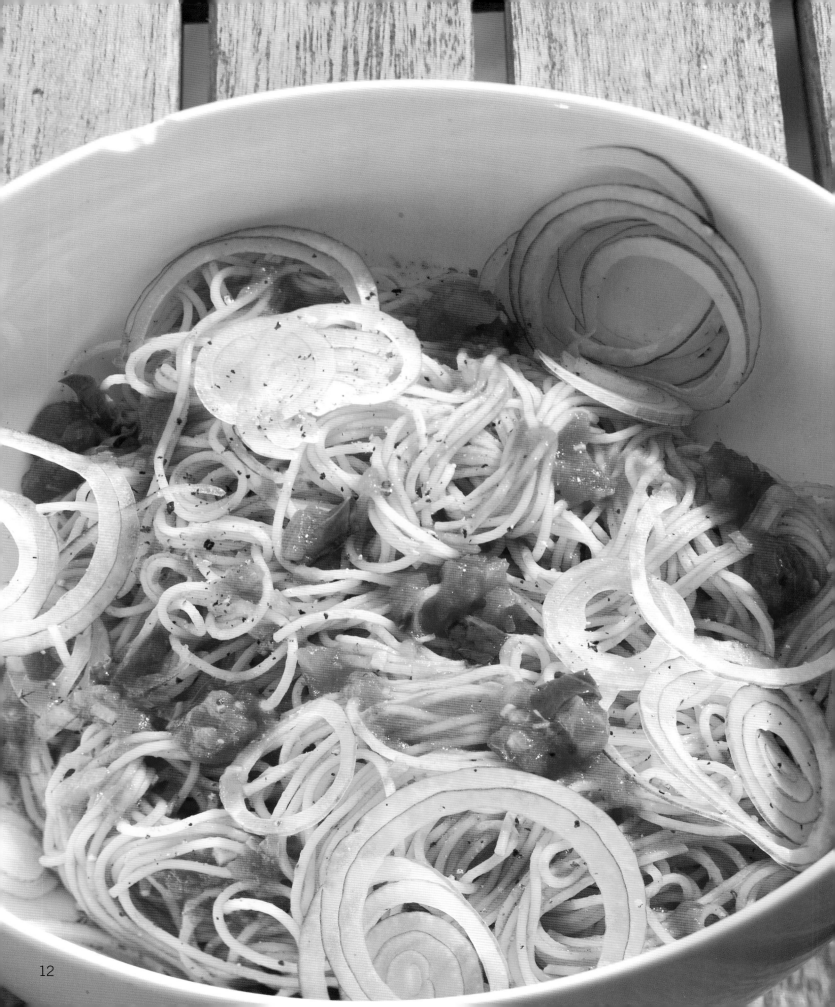

Spaghettini Nerone

Italy

1 onion, finely chopped

1 garlic clove, finely chopped

½ Peperoncino, dried and pounded

3 tbsp of extra virgin olive oil

500 ml / 16 fl oz / 2 cups of tomato sauce
(see recipe on page 10)

500 g / 18 oz spaghettini

1 slice of cold butter (about 30 g / 1 oz)

Salt
Freshly ground black pepper

2 red onions, sliced in wafer-thin rings

Red onions are milder and sweeter than ordinary onions,
but they add a lovely colour to the dish.

Fry the chopped onion, garlic and
peperoncino in olive oil until transparent.
Pour over the tomato sauce and season with
salt and black pepper.
Meanwhile, boil the spaghettini for 8 minutes
or until al dente in plenty of salted water
Put in a sieve and drain thoroughly, then
place in the pot with the warm tomato
sauce.
Cook together until the sauce filters into the
pasta. Just before serving stir the cold butter
into the pasta to bind.
Place on warm plates and serve with the
onion rings scattered over the top.

*25

Herbs

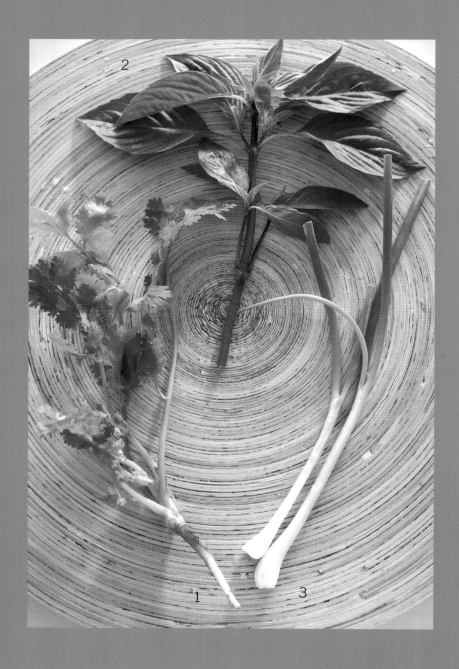

1 Coriander
2 Thai basil
3 Spring onions
4 Marjoram
5 Bayleaves (dried)
6 Dill
7 Mint
8 Sage
9 Basil
10 Parsley

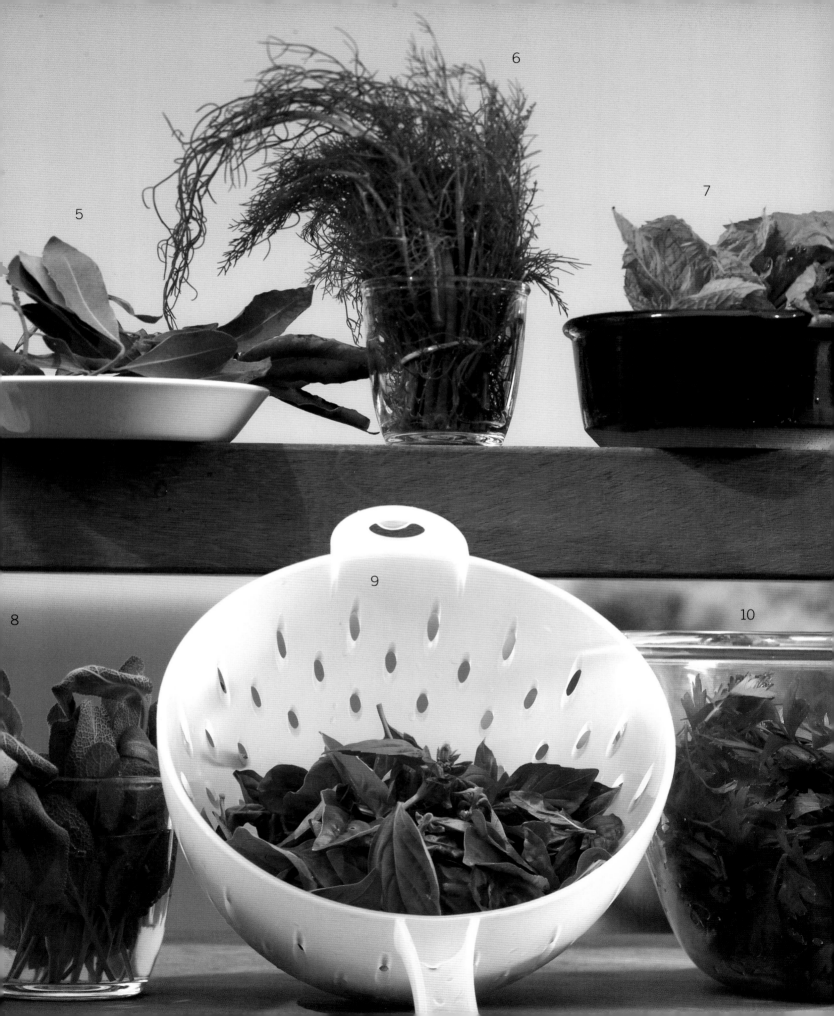

Chicken stock

1 boiling fowl (1.3 kg)

3 l / 96 fl oz / 12 cups water

200 g / 7 oz onions, peeled
150 g / 5 oz carrots, peeled
3 celery stalks
1 leek
1 bunch of fennel
1 garlic clove, halved

4 bayleaves
2 cloves
8 juniper berries
4 pimento corns
10 black peppercorns
1 tbsp sea salt

1 bunch of parsley stalks
1 bunch of fennel leaves
Celery leaves

You will recognise a fresh, healthy chicken by its white skin, firm flesh and the fresh smell.

White or red onions are both suitable for this stock.

Wash the soup chicken thoroughly, both outside and inside, and remove all traces of blood. Place in a pot in cold water, add salt and slowly bring to the boil. Remove any foam and white matter with a ladle, then simmer for an hour; do not remove the fat.
Add the vegetables, spices and herbs and simmer for another hour, adding more water if necessary.
Carefully remove the chicken and vegetables and cover until needed.
Strain the stock through a fine sieve and set aside.
Will keep for at least a week in the fridge.

*90

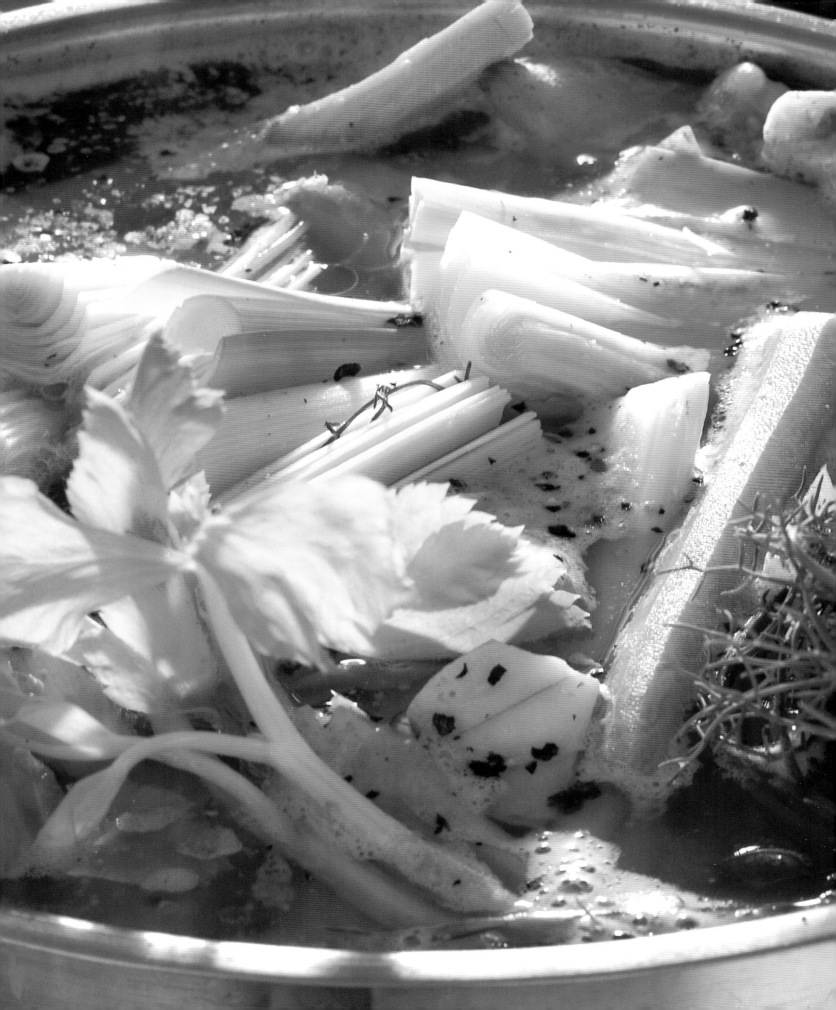

Udon noodles in chicken soup with vegetables and coriander
Japan

250 g / 9 oz udon noodles

1 leek sliced diagonally into thin rings

2 carrots, sliced diagonally into thin strips

1 bunch of young spring onions, cut into 3-cm long pieces

1 l / 32 fl oz / 4 cups of chicken stock (see recipe on page 16)

1 bunch of coriander

Chilli oil

The vegetables should be cut in bite-sized pieces; this way they will fit into small bowls.

Boil the udon noodles in unsalted water, then drain and place in warm soup bowls.
Put the vegetables in the soup bowls and pour hot chicken stock on top.
Finally sprinkle with coriander leaves and a few drops of chilli oil.

Tip
Chinese egg noodles are also suitable for this dish, in which case add a little cooked chicken or pork to the stock.

If you like it spicy, you can add chili sauce or oyster sauce.

*30

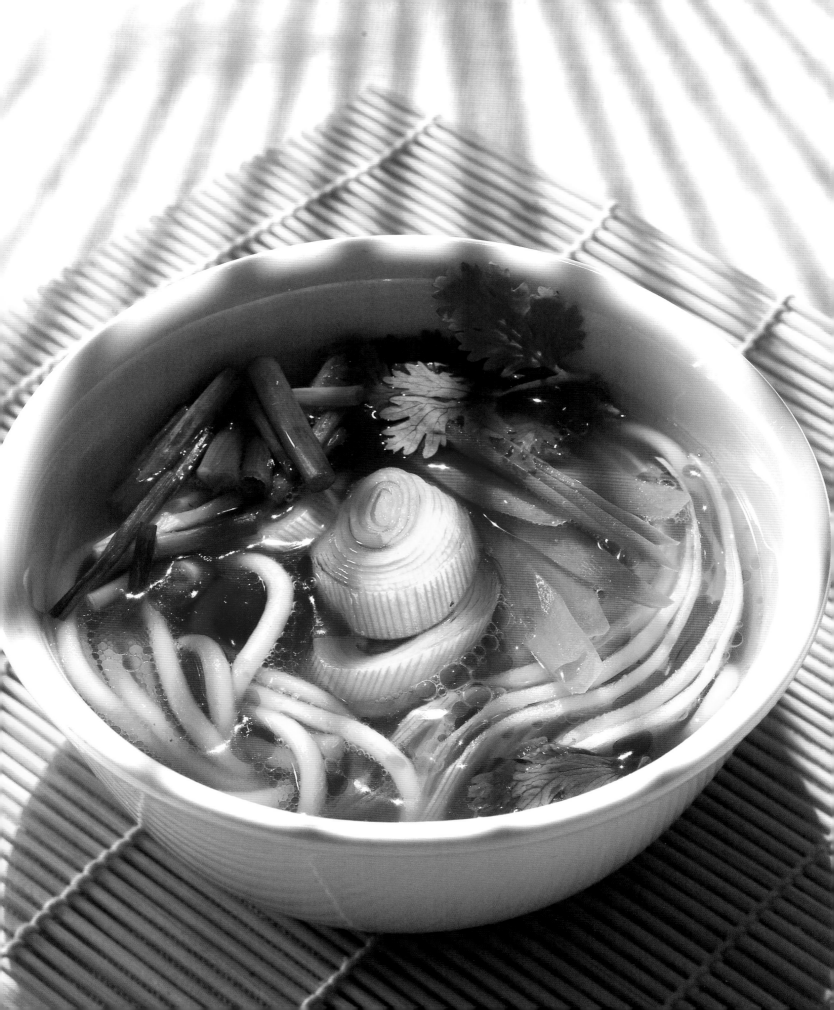

Cold soba noodles with raw egg and spring onions
Japan

250 g / 9 oz soba noodles (buckwheat noodles)

4 very fresh farm eggs, cold

1 bunch of spring onions

4 tbsp soy sauce

Boil the soba noodles in unsalted water, drain and then rinse under running cold water. Arrange on four plates. Break open one egg for each plate in a small bowl, taking care not to break the yolk. Sprinkle the finely cut spring onions over the egg, then top with 1 tbsp soy sauce.

How to eat this dish: mix the egg, spring onions and soy sauce in the shell using chopsticks without changing the consistency of the egg.
Then combine this mixture with the cold noodles, making sure the noodles are well coated with it.

Soba noodles are no longer "foreign exotics" – you will find them in any Asian food shop.

*30

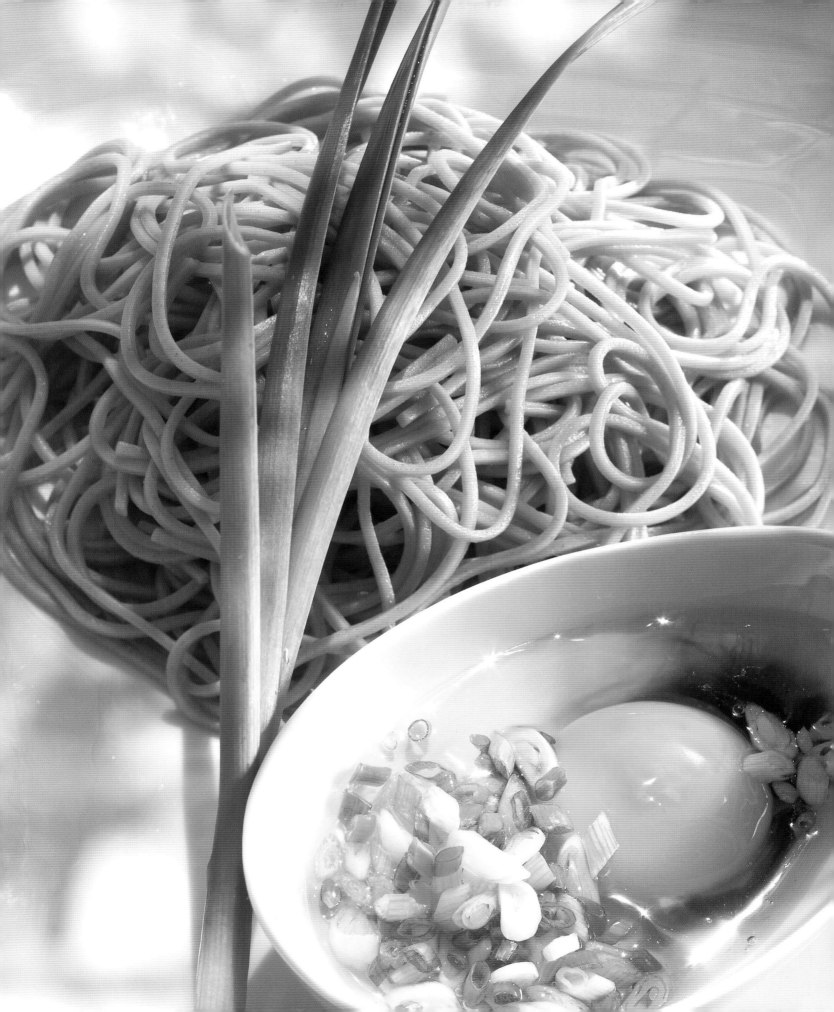

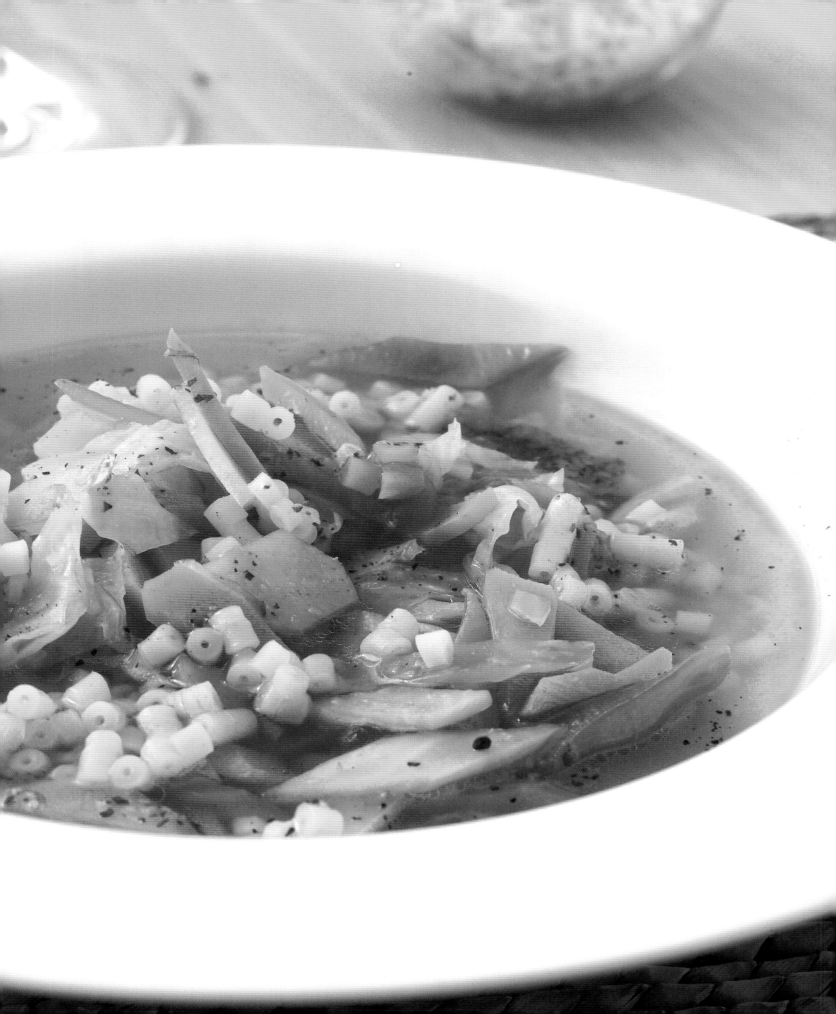

Minestrone with ditalini

Italy

1 onion, peeled

1 garlic clove, peeled

2 carrots, peeled

¼ celeriac

½ head of fennel, trimmed

1 celery stalk

1 small leek

80 g / 3 oz savoy cabbage leaves

60 g / 2 oz broad beans

2 tbsp olive oil

750 ml / 24 fl oz / 3 cups of chicken stock
(see recipe on page 16)

60 g / 2 oz ditalini

Salt
Freshly ground black pepper

2 tbsp pesto (see recipe on page 92)

Freshly ground Parmesan cheese

White bread

It is best to chop up the vegetables separately and then add them at different stages, depending on how long they take to cook.

Cut the onions, garlic, carrots, celery, fennel, celeriac, leek, savoy and beans into small pieces.
Heat the olive oil, and fry the onions and garlic until transparent. Add the carrots and fennel and season with salt and pepper, then pour in the stock and let it simmer for 10 minutes.
Add the rest of the vegetables and cook for a further 10 minutes.
Cook the ditalini in boiling salted water for 6 minutes, then drain and put into the soup.
Sprinkle fresh Parmesan over the minestrone and add a little pesto. Toast the white bread, sprinkle some olive oil on top, add a little salt and serve with the minestrone.

*45

Stuffed Montserrat tomatoes with pasta salad
Spain

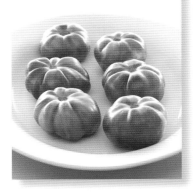

Montserrat tomatoes can be identified by the shape, which resembles a pumpkin, and by their greenish markings.

8 ripe Montserrat tomatoes

250 g / 9 oz shell-shaped pasta

150 g / 5 oz cherry tomatoes

2 carrots, finely chopped

2 celery stalks, finely chopped

1 shallot, finely chopped

1 tbsp of capers
40 g / 1 ½ oz black olives without stones
40 g / 1 ½ oz green olives without stones

½ bunch of parsley leaves, finely chopped
Mint leaves, finely chopped
Light green celery leaves

6 tbsp of extra virgin olive oil

4 tbsp sherry vinegar

Salt
Freshly ground black pepper

1 tbsp pesto

Remove the tomato tops and set aside. Scoop out the insides of the tomatoes with a teaspoon. Cook the pasta in accordance with the packet instructions, then drain and rinse under running cold water.

Quarter the cherry tomatoes and combine in a bowl with the carrots, celery and shallot. Coarsely chop the capers and black and green olives place in the bowl. Season with salt, pepper, olive oil and sherry vinegar and combine with the chopped vegetables. Add the pasta, then spoon the salad into the tomatoes and replace the "lids".

Spoon a little pesto into the hole where the tomato stalk was, then sprinkle over the mint and celeriac leaves and drizzle a little olive oil over top.

Tip
This is a wonderful summer dish; cucumbers can easily be substited for the tomatoes if you wish, in which case use dill instead of mint.

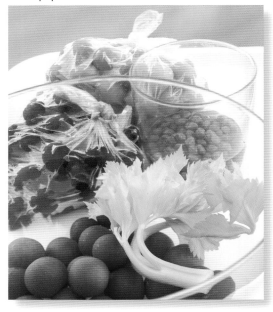

Also pickled olives go well with this dish.

* 30

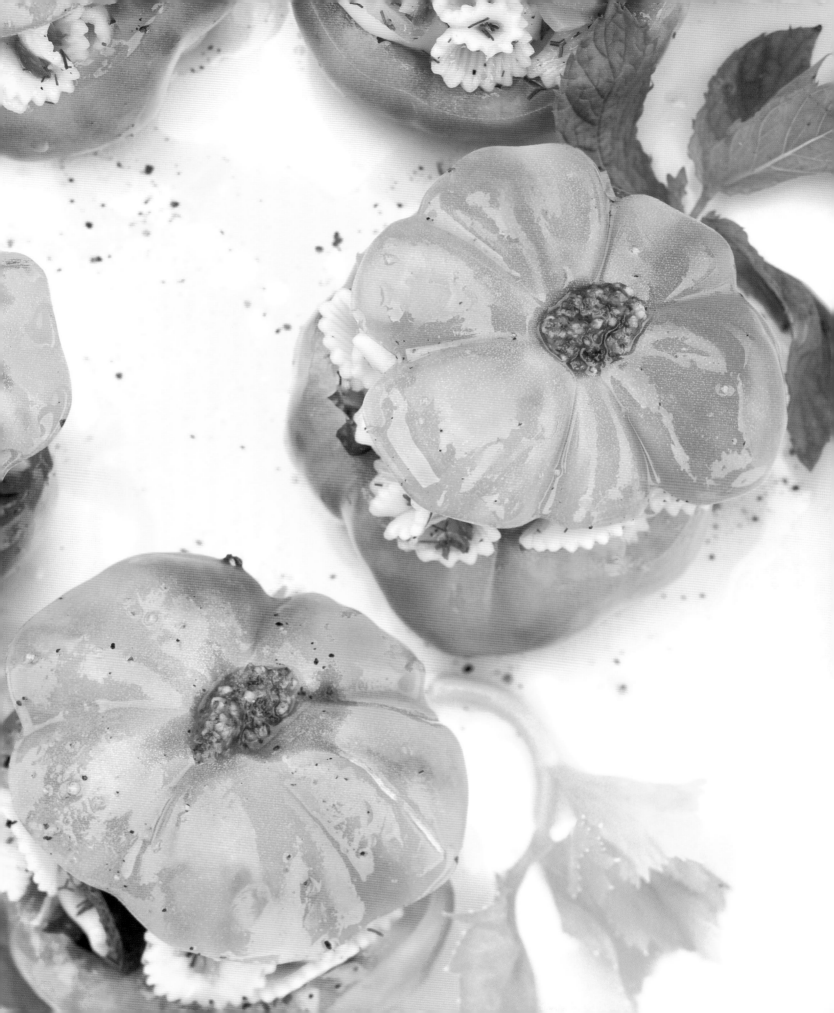

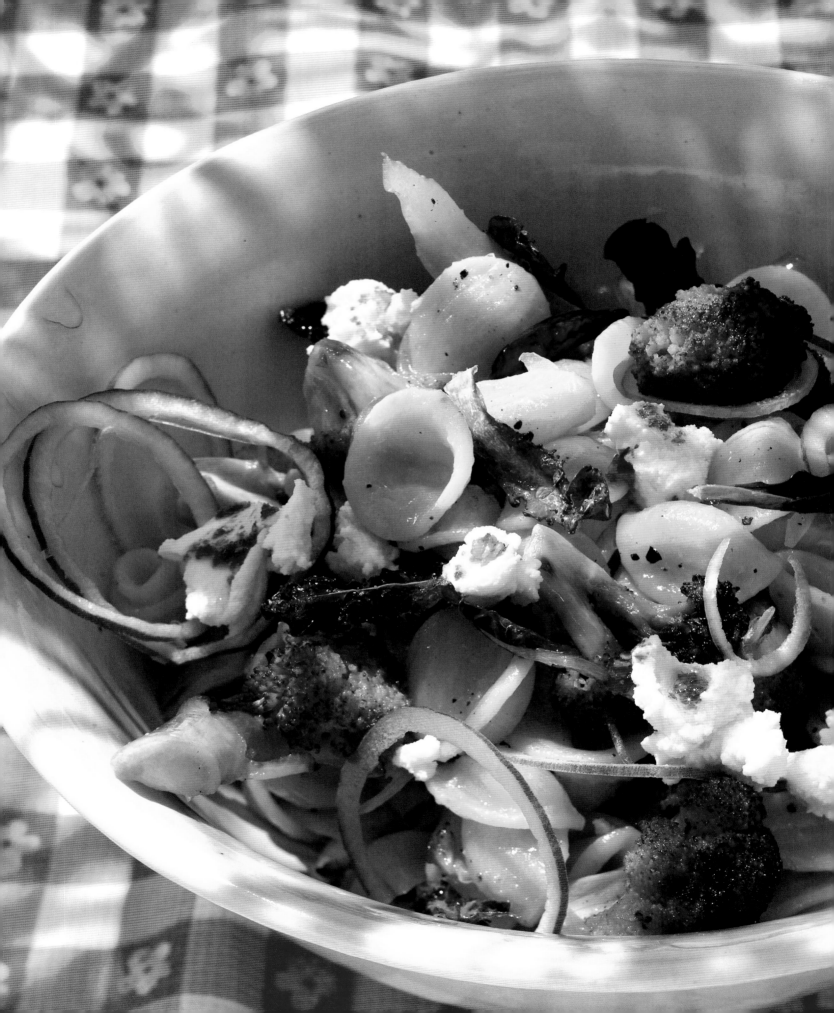

Orecchiette with broccoli and red onions

Italy

600 g / 21 oz broccoli

500 g / 18 oz orecchiette

Salt

2 garlic cloves, peeled

4 tbsp olive oil

2 tbsp butter

100 g / 3 ½ oz fresh ricotta

1 red onion, thinly sliced

Peperoncino oil

Freshly ground black pepper

Remove the leaves and thick stalk from the broccoli. Peel the stalk and cut in small pieces. Halve or quarter the broccoli rets, depending on size.
Cook in plenty of boiling salted water until al dente and then drain in a sieve. Plunge in ice cold water.
Boil the orecchiette in plenty of salted water for 12 minutes and drain, retaining the water.
Meanwhile, gently fry the broccoli in a little olive oil. Slice the garlic, add to the pan and fry for another 5 minutes. Add the orecchiette and pour over a couple of tablespoons of the pasta water.

Add the rest of the olive oil and the butter, toss around the pan and season well with salt and black pepper.
Put everything in a large bowl. Garnish with small pieces of ricotta and onion rings, and drizzle over some peperoncino oil.

Tip
If you like it really spicy, add a small chopped anchovy and some freshly ground Parmesan at the end.

Gemelli aglio e olio with roast garlic

Italy

500 g / 18 oz gemelli

4 garlic cloves, peeled

2 peperoncini, fresh and according to taste

6 tbsp of extra virgin olive oil

1 slice of cold butter

Salt
Freshly ground black pepper

Fresh herbs to taste

Thinly slice the garlic. Crush the peperoncini in a mortar or cut in very small pieces using a knife. Careful: the seeds of these small peppers are very hot.
If you do not like very hot flavours, cut the pepper in half and remove the seeds before crushing.
Boil the gemelli in plenty of salted water for 3 minutes.
Meanwhile, heat the oil, gently fry the garlic and then add the peperoncini.
Drain the pasta in a sieve, retaining some of the water. Put the pasta in the olive oil and add some of the pasta water using a small ladle. Season with salt and pepper, and add a little butter to finish.
Add fresh herbs, such as chopped up parsley or basil, to taste and serve immediately.

Tip
A basic rule of thumb for Italian pasta dishes: Always set aside some of the water you used for cooking the pasta, as the starch in it helps to bind the sauce and enhances the flavour.

*35

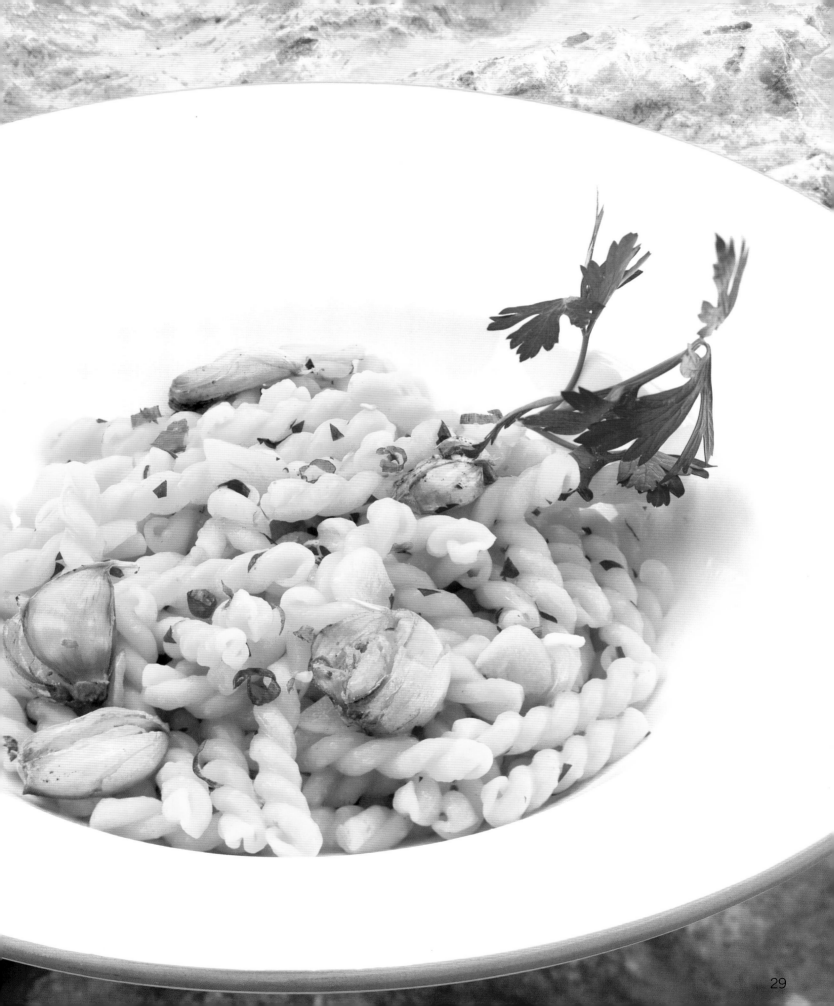

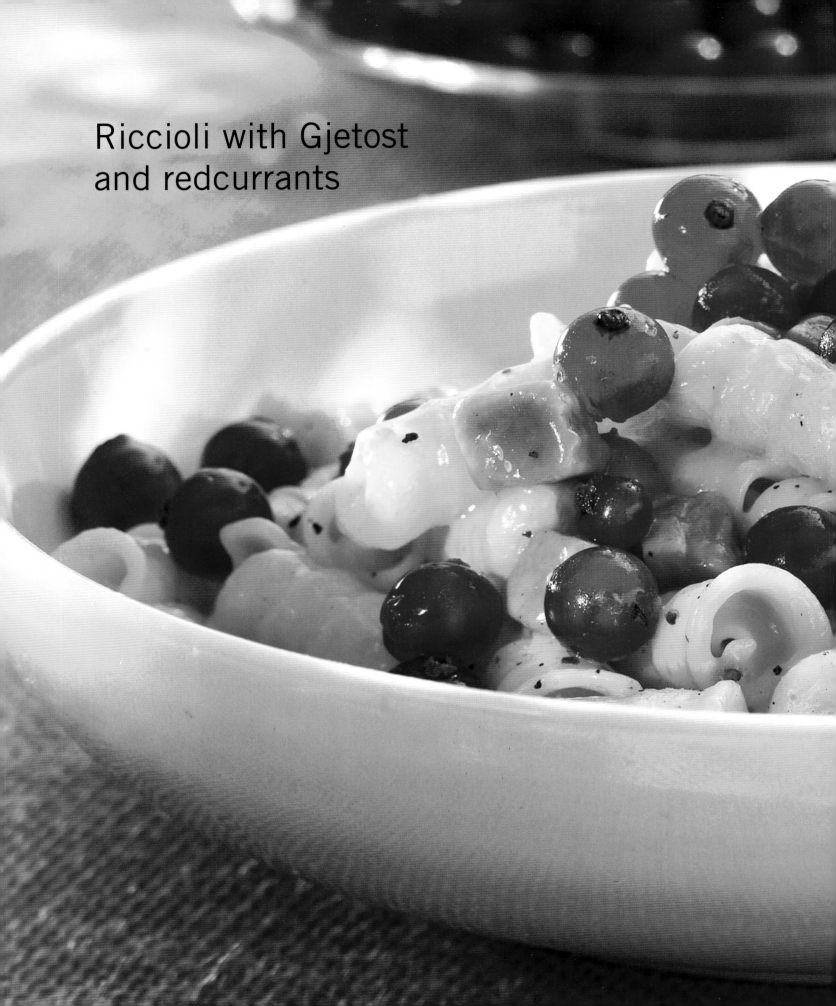

Riccioli with Gjetost
and redcurrants

*30

Riccioli with Gjetost and redcurrants
Sweden

500 g / 18 oz riccioli

60 g / 2 oz unsalted butter

300 g / 10 ½ oz Gjetost, cut into ½ cm cubes

Freshly grated nutmeg

150 g / 5 oz redcurrants, removed from stalks

Salt
Freshly ground black pepper

Cook the riccioli in plenty of boiling salted water according to the packet instructions. Drain and return to the pot, leaving 1 cm water at the bottom. Add the butter and Gjetost and stir until the liquid disappears and the cheese begins to melt.
Season to taste with salt, black pepper and nutmeg. Arrange on plates immediately, topping with the fresh redcurrants.
An interesting combination of a slightly sweet cheese and tart redcurrants.

Tip
Gjetost is a Norwegian cheese made from cow's or goat's whey and cream.
Heating during the cheese-making process caramelizes the milk sugars in the whey, which is what gives it its typical caramel flavour.

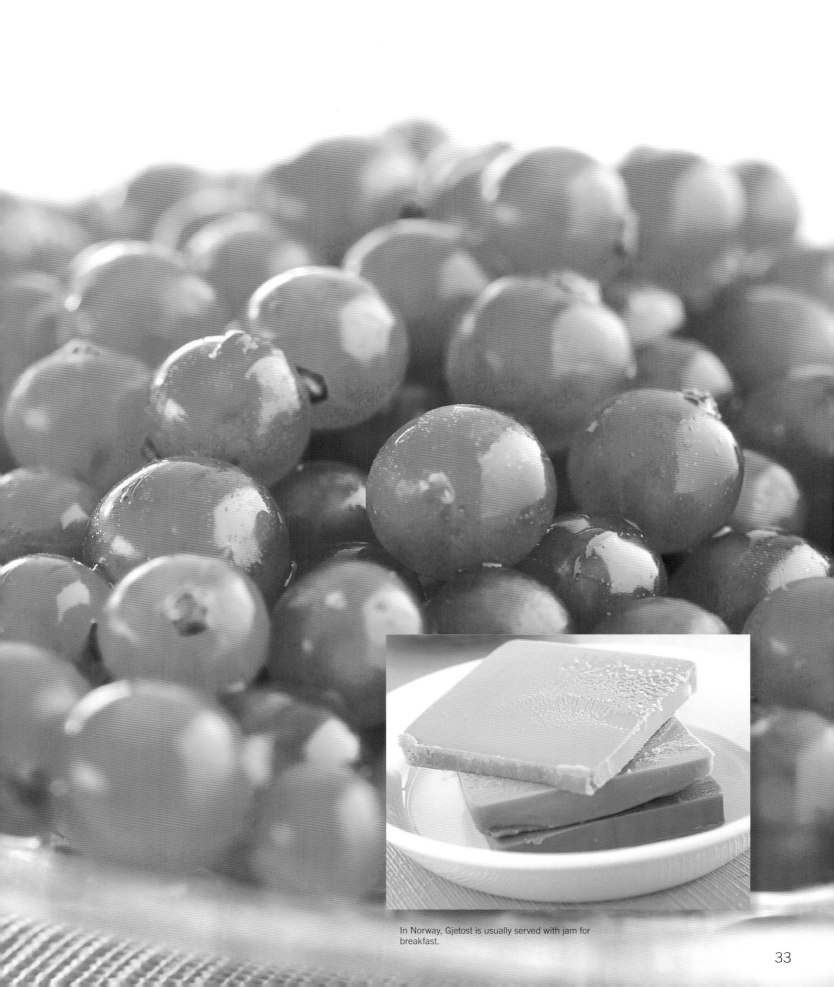

In Norway, Gjetost is usually served with jam for breakfast.

33

Gnocchette with radicchio, capers and scarmozza

Italy

2 small heads of radicchio, cut into strips

½ garlic clove, finely chopped

½ bunch of sage, roughly chopped

6 tbsp olive oil

1 tbsp of capers
50 g / 1 ¾ oz olives, without stones and cut into pieces

500 g / 18 oz gnocchette

100 g / 3 ½ oz scarmozza, cut into small pieces

Salt
Freshly ground black pepper

Scarmozza affumicata, a so-called filata cheese, is a smoked cheese that is made from cow's milk.

Put the olive oil in a pan. Stir fry the garlic and sage leaves, then add half the radicchio and fry for a further 5 minutes. Add the capers and olives and season with salt and pepper.
Meanwhile, cook the gnocchette until al dente and stir into the sauce.
Using a small ladle, add some of the pasta water and arrange on the plates.
Finally, sprinkle the scarmozza and the remaining radicchio on top and serve immediately.

* 35

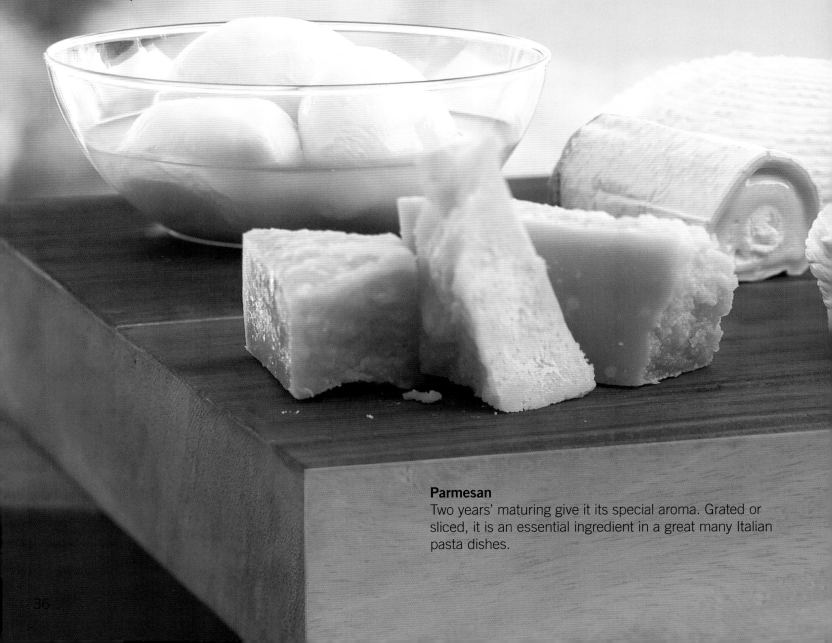

Ricotta romana
This mild sweet-tasting cheese is produced from cow's or sheep's whey. The name "ricotta" means cooked again, and is a reference to the way it is made.

Mozzarella
This soft cheese is made from cow's milk and is originally from Italy. It matures in a slightly salted whey bed. The name comes from the verb "mozzare", which means to cut off – because the cheese is drawn and cut into shape.

Goat's cheese roll
This is available at different stages of maturity, ranging from fresh to very mature. For fillings you would use the fresh variant, and for frying or grating the more mature variants. The flavour is reminiscent of hazelnuts and mushrooms.

Parmesan
Two years' maturing give it its special aroma. Grated or sliced, it is an essential ingredient in a great many Italian pasta dishes.

Cheese varieties

Manchego
The name of this famous Spanish cheese comes from the Manchego sheep, which come from the region of La Mancha. Its black skin with a pattern that resembles a wicker basket is its most striking feature.

Gorgonzola
The Italian blue cheese has a spicy taste, and a sweet note when young.

Marcellin
This small, creamy soft cheese of French origin is made from raw cow's milk. It adds the necessary flavour to cheese sauces or ravioli fillings.

Provolone
This cheese, which is made from cow's milk, is also available in a smoked version. Cut into small pieces, it is an ideal flavour enhancer in Italian pasta dishes and salads.

Rigatoni with Gorgonzola sauce

Italy

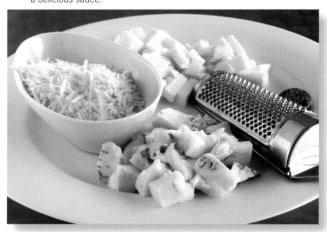

Three cheeses: add a pinch of nutmeg and some pepper for a delicious sauce.

250 g / 9 oz cream

100 ml / 3 ¼ fl oz / ½ cup milk

200 g / 7 oz Gorgonzola, rindless

100 g / 3 ½ oz Mozzarella

50 g / 1 ¾ oz Parmesan

500 g / 18 oz rigatoni

Freshly ground black pepper
Freshly grated nutmeg

Bring the cream and milk to the boil in a small, flat saucepan. Cut the Gorgonzola and Mozzarella into small pieces and grate the Parmesan.
Add the cheese to the boiling mixture of cream and milk and season with black pepper and nutmeg.
Meanwhile, cook the rigatoni until al dente according to the packet instructions, then drain and add to the cheese sauce. Combine thoroughly and serve.
Season well with coarsely ground black pepper before serving.

*25

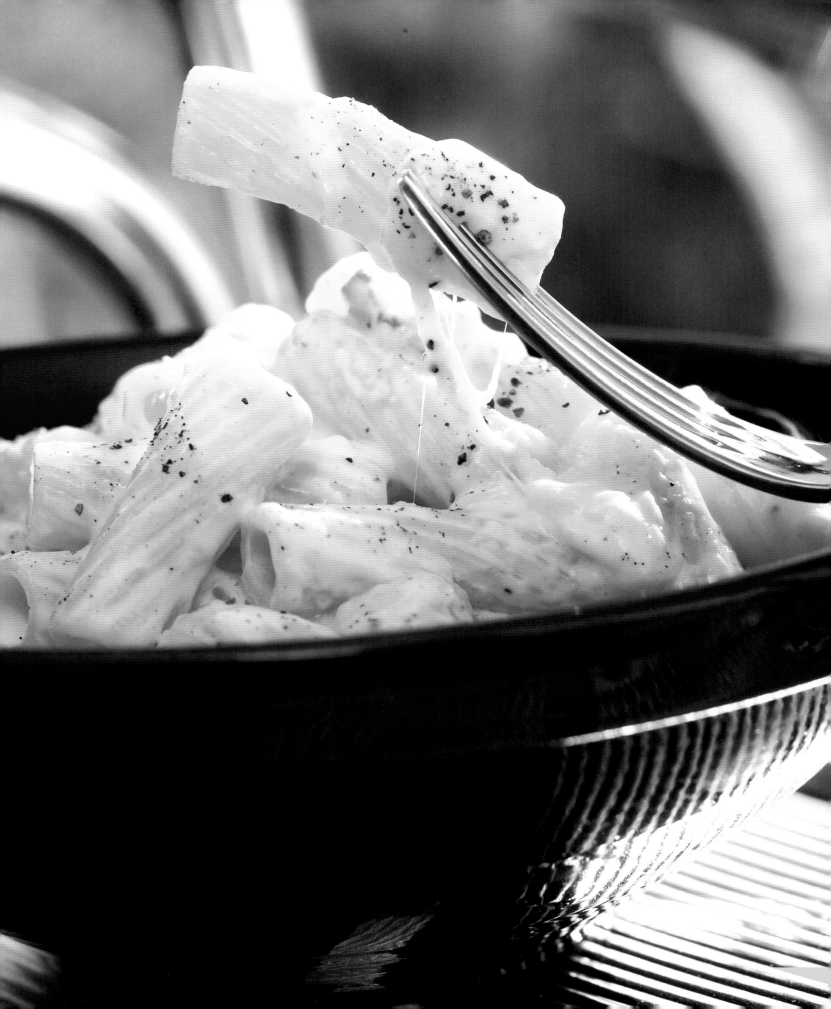

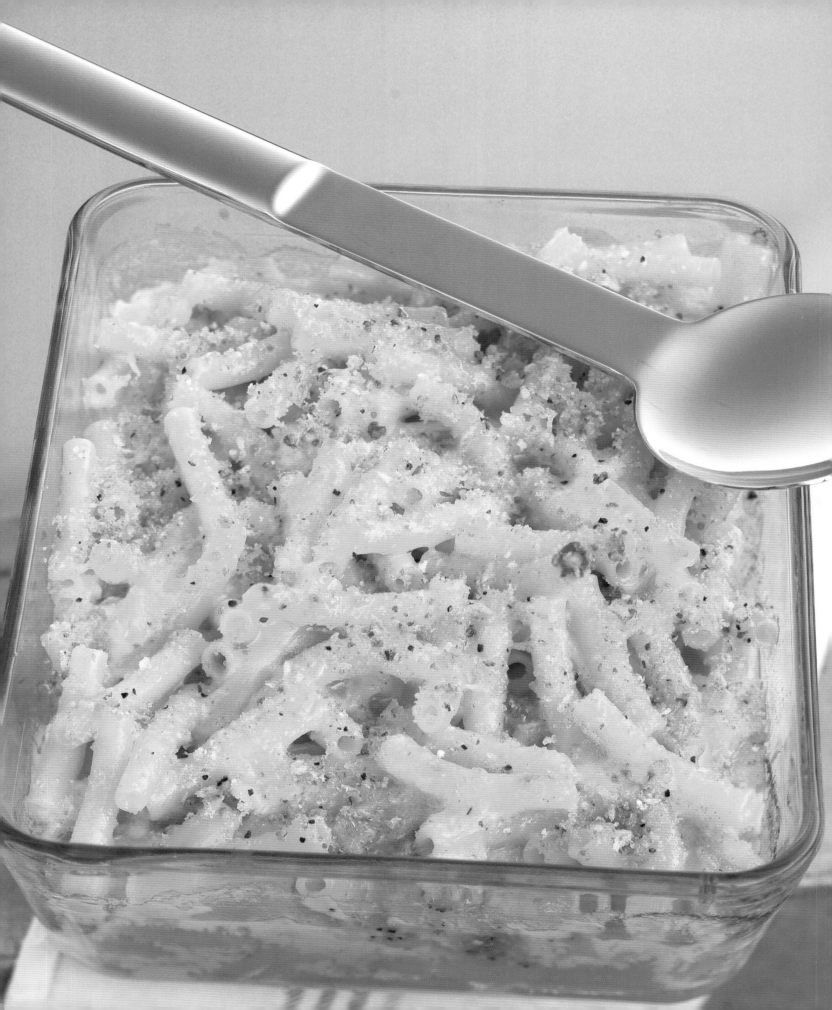

Maccheroncini with cheddar cheese au gratin
USA

500 g / 18 oz short macheroncini

500 ml / 16 fl oz / 2 cups of béchamel sauce (see recipe on page 64)

350 g / 12 ½ oz cheddar cheese, grated

100 g / 3 ½ oz breadcrumbs

40 g / 1 ½ oz butter

Salt
Freshly ground black pepper

Boil the macheroncini in plenty of salted water for half the cooking time given on the packet instructions, then drain and cool.
Make the béchamel sauce and melt the grated cheddar cheese in it.
Place in a buttered ovenproof gratin dish with the pasta.
Melt the butter and combine with the breadcrumbs, but do not brown them.
Season this mixture with pepper
and a little salt and spread over the macheroncini.
Bake at 180° C in a preheated oven for about half an hour. Cover with aluminium foil to prevent the buttered crumbs from turning too dark.

Tip
This dish goes well with grilled chicken or veal escalopes in tomato sauce.

Cheddar cheese is the favourite English cheese; in this recipe it is finely grated and sprinkled over the dish.

*40

Tagliatelle with green asparagus

Italy

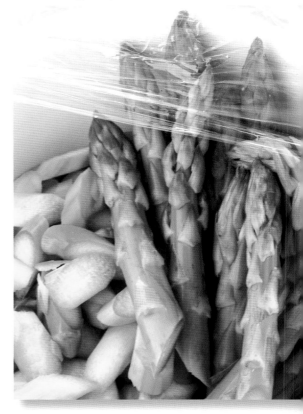

Cover the asparagus with a damp cloth and store in the vegetable rack of the fridge until you need it.

1 kg / 35 oz fresh green asparagus

60 g / 2 oz butter

Salt, sugar
Freshly ground black pepper

½ bunch of parsley leaves, finely chopped

600 g / 21 oz fresh tagliatelle made from pasta dough (see recipe on page 153)

50 g / 1 ½ oz chervil, finely cut

Peel the lower third of the asparagus stalks, then cut off 1 cm from the end. Cut the asparagus about 7 cm from the top. Cut the remainder of the stalks into thin diagonal slices.
Melt half the butter and fry the asparagus slices in it. Meanwhile, boil the asparagus tips in plenty of salted water with a good pinch of sugar, then add to the asparagus slices and season with salt and pepper.
Cook the tagliatelle until al dente and add to the asparagus. Sprinkle over the chopped herbs, add the rest of the cold butter and serve immediately.

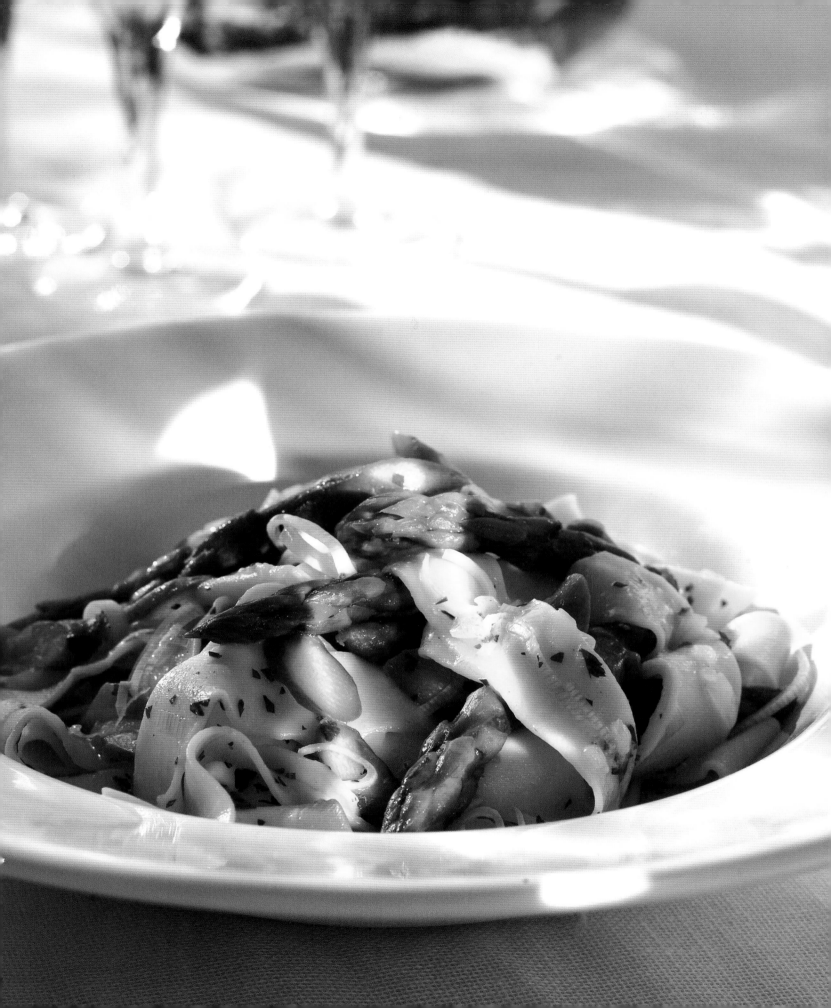

Bucatini all'amatriciana
Italy

3 white onions

2 garlic cloves

200 g / 7 oz rindless streaky bacon, cut into slices

3 tbsp olive oil

400 ml / 12 ¾ fl oz / 1 ½ cups of tomato sauce
(see recipe on page 10)

500 g / 18 oz bucatini

Freshly ground black pepper

Grated Parmesan

Bacon, onions, tomatoes and pasta: easy,
fast and delicious.

Peel, halve and chop the onions. Peel and finely chop
the garlic.
Slice the bacon into ½ cm thick strips.
Melt down the bacon in olive oil, add the onions and
garlic and fry until translucent.
Pour in the tomato sauce and simmer for around
10 minutes so the bacon adds its aroma to the sauce.
Cook the bucatini al dente following the packet
instructions, then drain and add to the sauce. Mix
well and arrange on plates.
Top with black pepper and grated Parmesan.

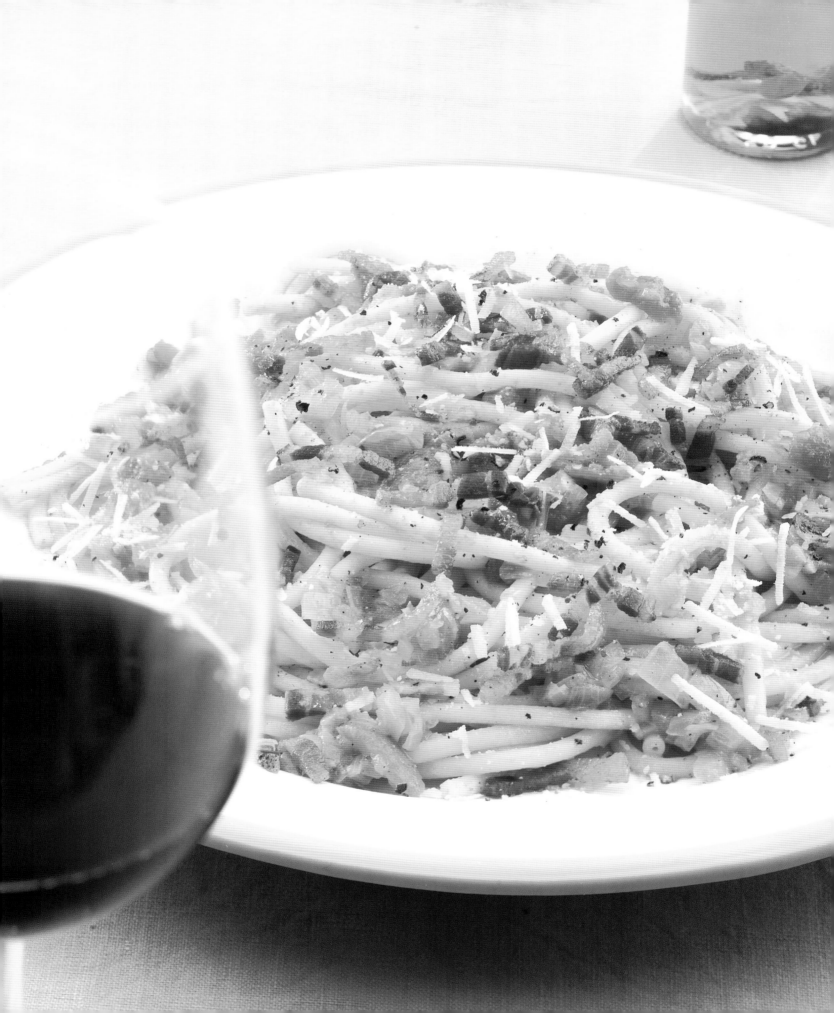

Penne lisce with diced aubergine and spicy salami

Italy

400 g / 14 oz aubergines, cut into 1 cm cubes

6 tbsp olive oil

Salt
Freshly ground black pepper

1 onion, finely chopped

1 garlic clove, finely chopped

1 sprig of rosemary

1 chilli, finely chopped

5 tomatoes, peeled, cut into quarters and seeds removed

200 g / 7 oz spicy salami

500 g / 18 oz penne lisce

200 g / 7 oz cherry tomatoes

1 tbsp butter

Cherry tomatoes stay crisp and fresh in cold water.

Heat the olive oil in a pan and fry the aubergine until light yellow, then season with salt and black pepper. Add the onions, garlic, rosemary leaves and chili and simmer gently for another 2 minutes. Chop the tomato quarters and add to the aubergine.
In a separate non-stick pan, dry-fry the salami and add to the aubergine and tomato sauce.
Meanwhile, cook the penne in plenty of salted water until al dente following the packet instructions, and drain in a sieve. Add the sauce, the tomatoes and the butter, and season with salt and pepper.
Combine and serve.

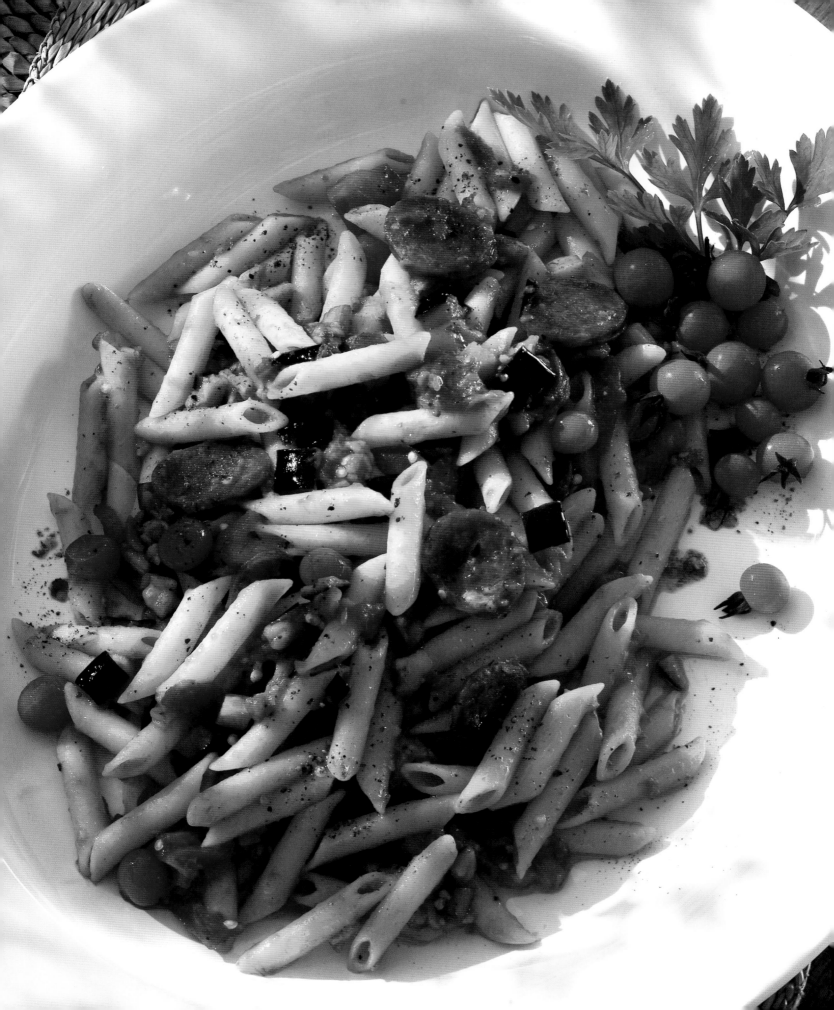

Linguine with vongole veraci

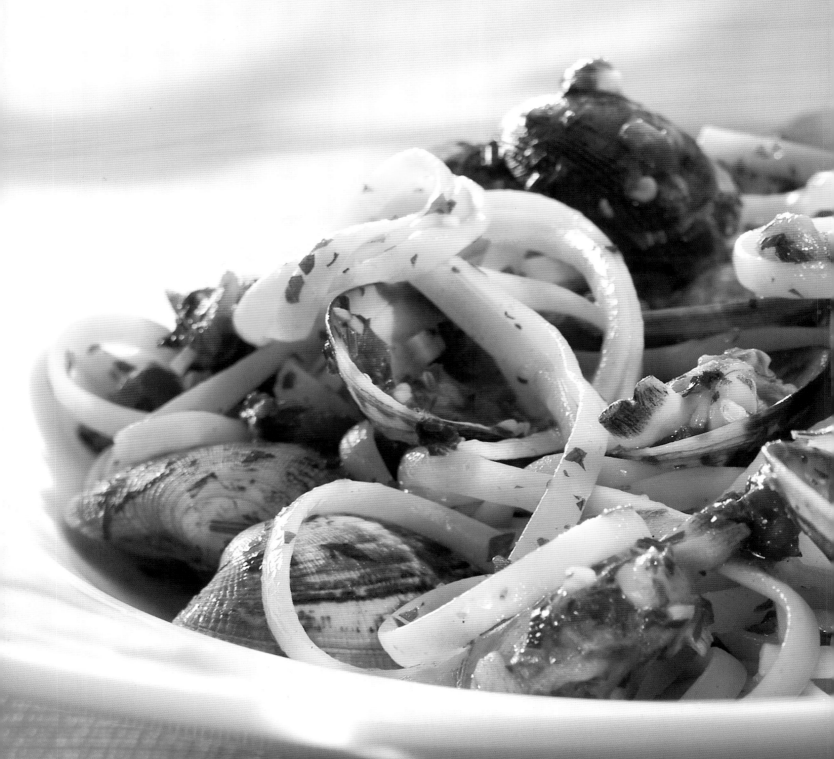

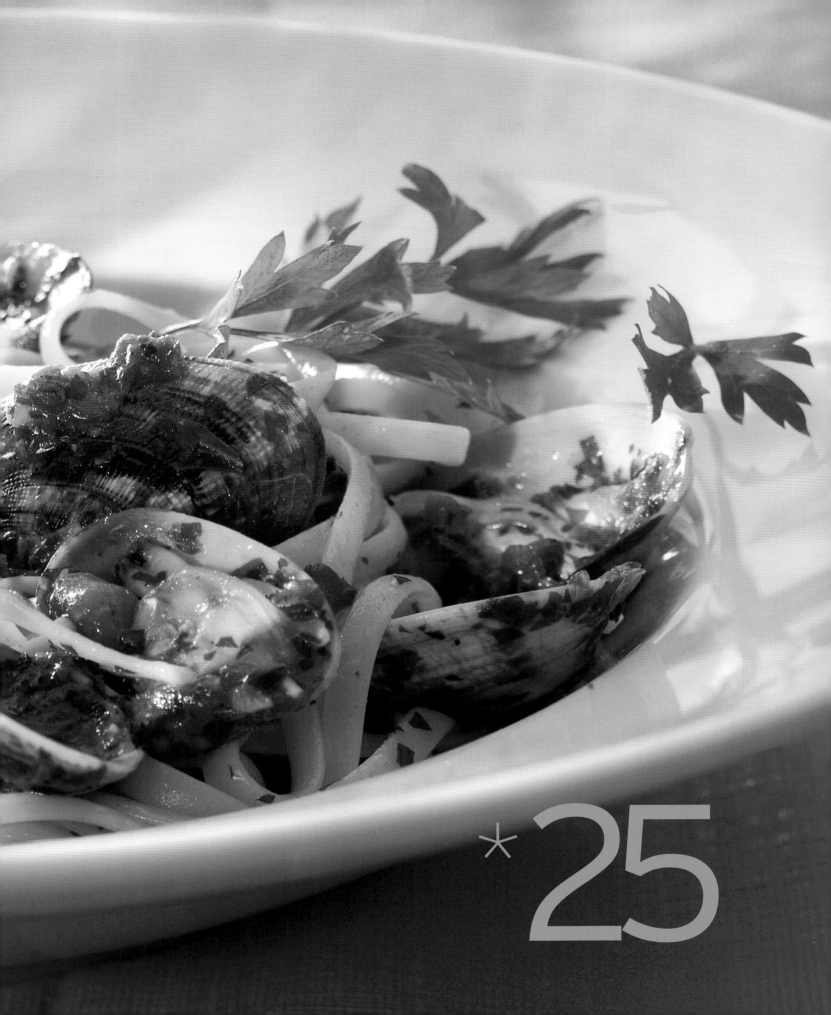

*25

Linguine with vongole veraci
Italy

500 g / 18 oz linguine

250 g / 9 oz washed vongole veraci

3 tbsp of extra virgin olive oil

1 garlic clove, finely chopped

1 shallot, finely chopped

100 ml / 3 ¼ fl oz / ½ cup white wine

3 tomatoes, peeled and chopped

1 teaspoon of peperoncino oil

1 bunch of parsley leaves, finely chopped
½ bunch of basil, finely chopped

20 g / ¾ oz cold butter, sliced

Cook the linguine in plenty of salted water until
al dente. Drain the washed vongole in a sieve.
Heat the olive oil and briefly fry the shallot and
garlic. Add the vongole and the white wine.
Cover with a lid and cook until the mussels open.
Remove the lid and add the chopped tomatoes.
Mix the herbs and peperoncino oil and then add
to the mussels with the linguine.
Add the butter slices and stir until the pasta liquid
has evaporated.
Arrange on a dish and serve.

Purists dip the mussels in herb infused oil.

Always peel the tomatoes: it takes time, but they taste much better.

* 30

50

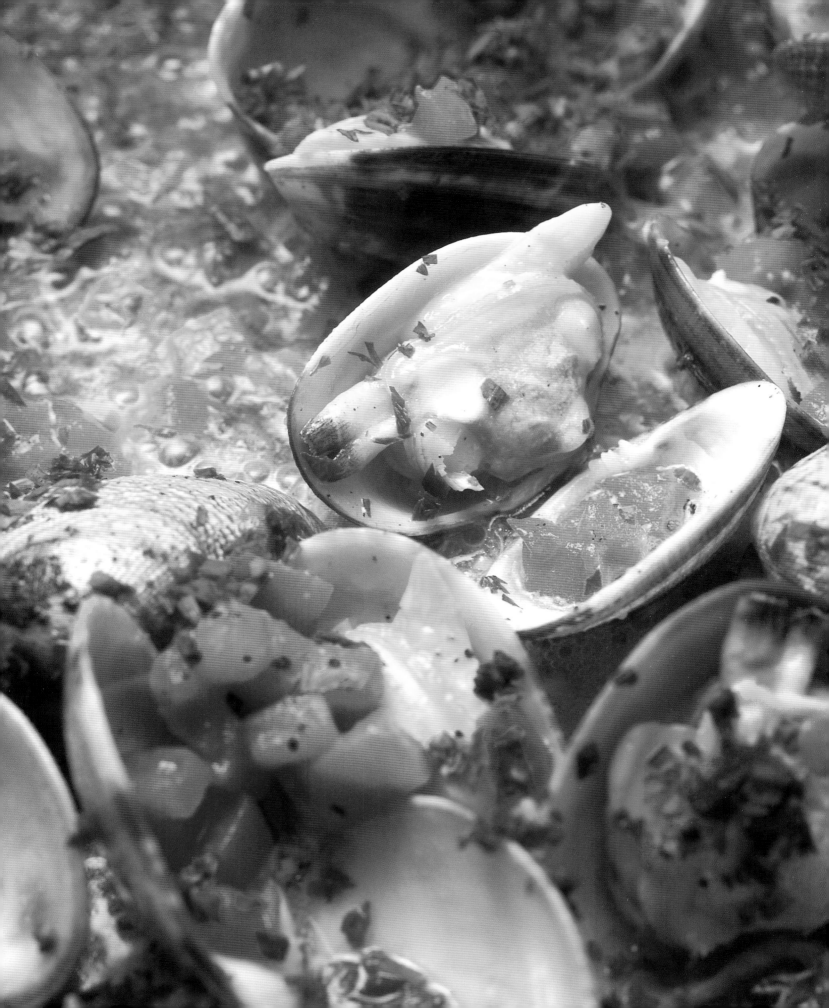

Deep-fried transparent noodles in melon purée
Thailand

It's better to remove the little black seeds before mixing.

1 ripe watermelon (around 2 kg)

200 ml / 6 ½ fl oz / ¾ cup white wine (Riesling or Sauvignon)

200 ml / 6 ½ fl oz / ¾ cup vodka

1 packet of transparent noodles

1 l / 32 fl oz / 4 cups corn oil for deep-frying

Icing sugar

125 g / 4 ¼ oz wild strawberries

Careful: Don't put too many noodles in the oil at once as they swell to five times their original size.

Slice open the watermelon, remove the green peel and chop the red flesh into large chunks.
Combine with the white wine and vodka in a mixer and strain through a sieve. Pour into a jar and place in the fridge for at least an hour.
Heat the oil in a milk pan (tall and thin with a diameter of approximately 20 cm) at 160°C.
Cut the transparent noodles in four with scissors and deep-fry each batch. As the noodles increase to five times their original size, make sure that the pot is only half-filled with oil. Frying takes only a few seconds.
Drain the fried noodles on kitchen paper and dust with icing sugar while still warm.
Place some of the watermelon purée in chilled bowls and add the noodles.
Garnish with wild strawberries and sprinkle with a little more icing sugar.

Tip
Serve immediately, as the noodles quickly absorb the liquid and lose their crispness.

30

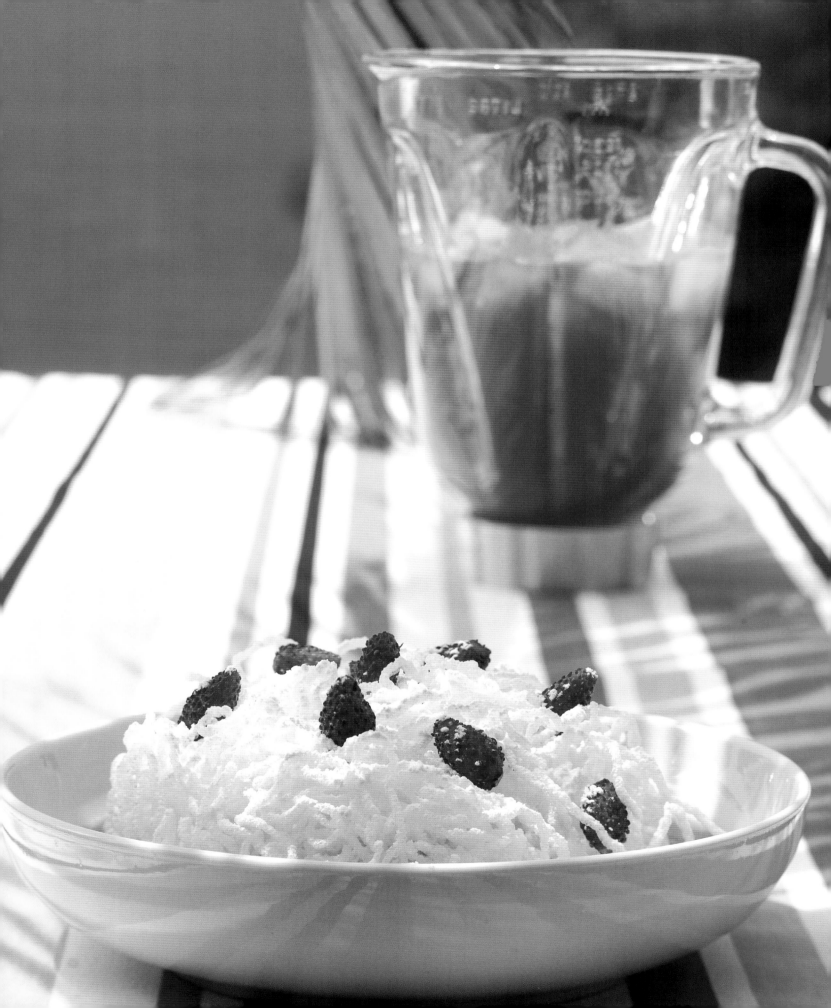

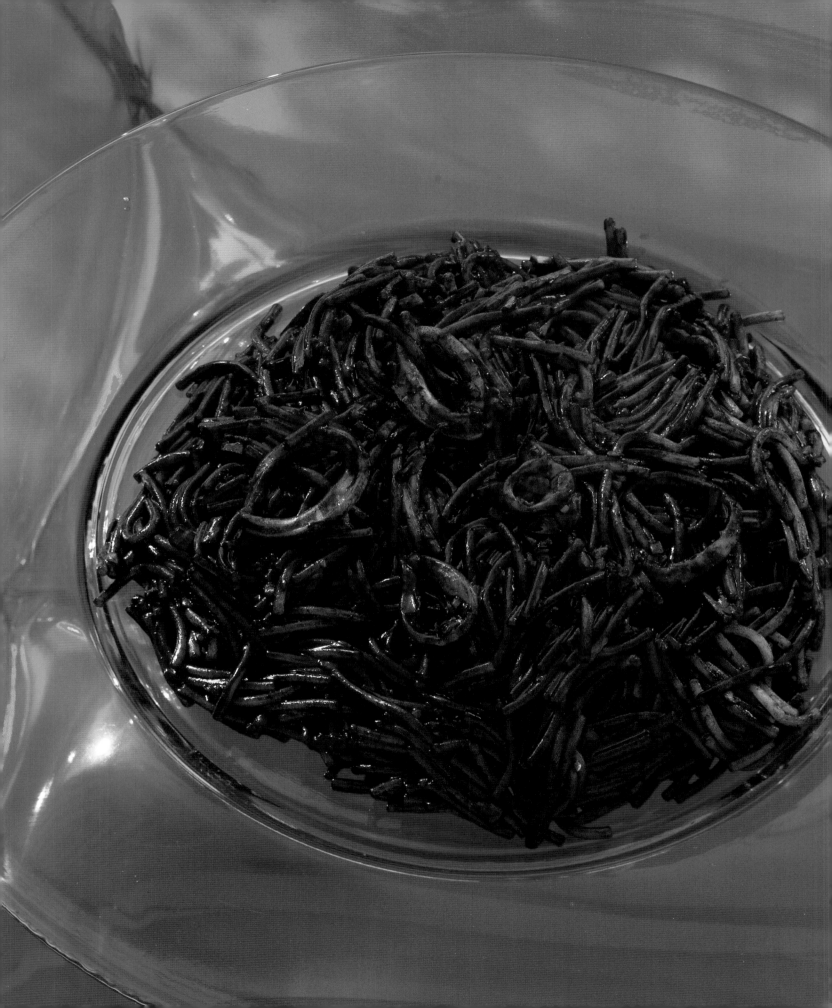

Fideo pasta cooked in ink
Spain

2 medium-sized calamari, the tubes washed

30 g / 1 oz butter

1 white onion, finely chopped

1 garlic clove, finely chopped

500 g / 18 oz fideo pasta

4 sachets of calamari ink

1 ½ l / 48 fl oz / 6 cups of chicken stock
(see recipe on page 16)

Salt
Freshly ground black pepper

2 slices of cold butter

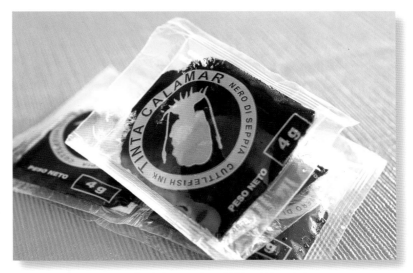

Ready-to-use calamari ink is sold in sachets.

Cut the calamari tubes into 1 cm thick rings
and halve the heads. Fry briefly in melted
butter, add the onion and garlic and season
with salt and pepper. Add the uncooked fideos,
then open the sachets of ink and add them to
the noodles. Pour in the chicken stock and cover
the pan with a lid.
Preheat the oven to 160° C and bake for 15 to
20 minutes. Remove from the oven and stir in
the cold butter slices with a meat fork until the
noodles are wonderfully shiny. Season with salt
and pepper if required, and arrange on plates.

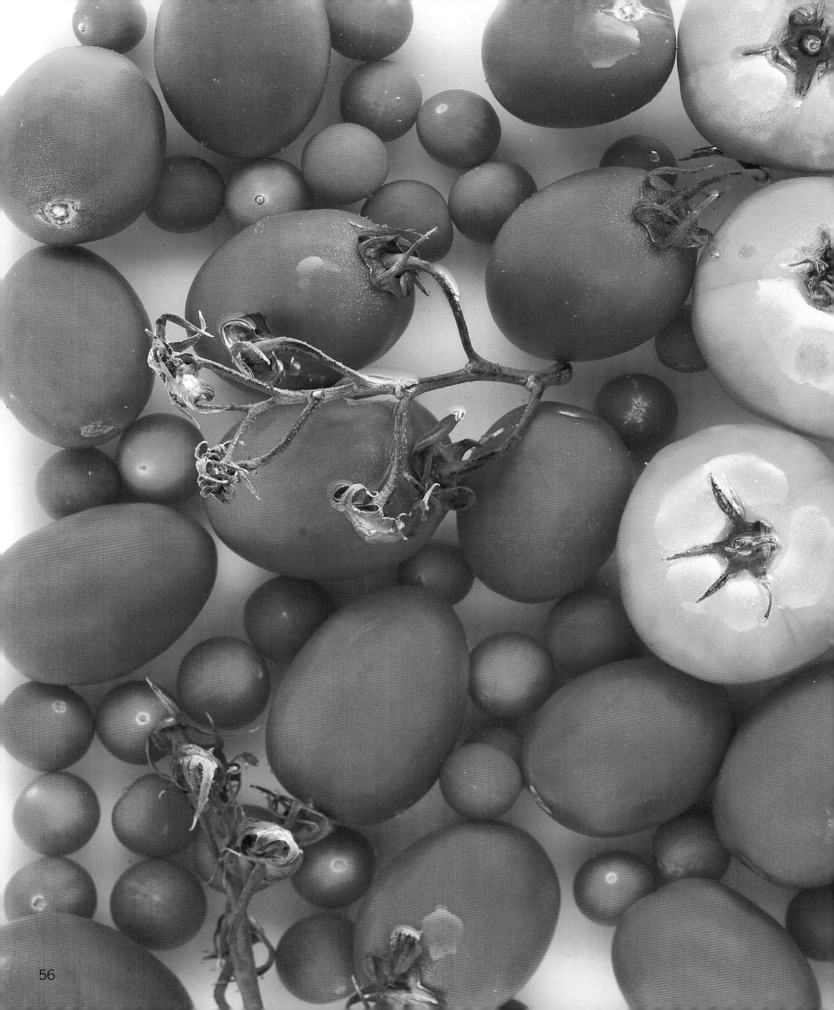

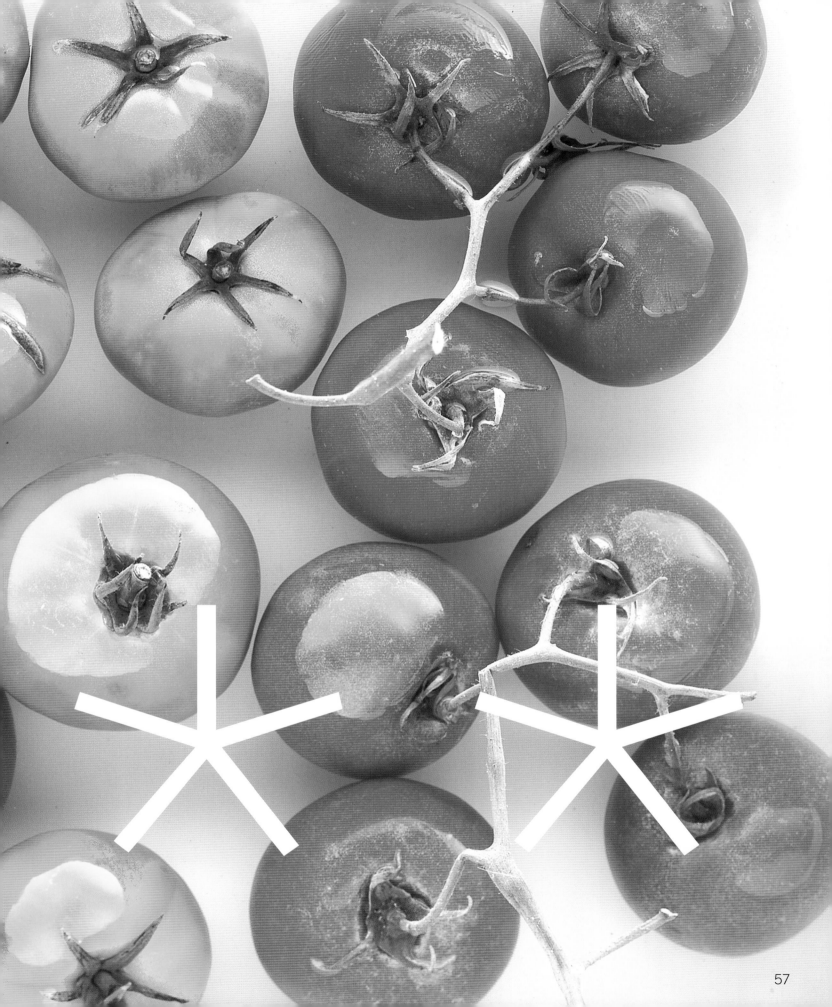

Tofu curry with asparagus and cherry tomatoes
Thailand

1 tbsp red curry paste

6 tbsp peanut oil

1 tbsp palm sugar

4 tbsp clear soy sauce

400 ml / 12 ¾ fl oz / 1 ½ cups coconut milk

500 g / 18 oz trimmed broccoli

150 g / 5 oz cherry tomatoes

250 g / 9 oz rice noodles

½ bunch of fresh Thai basil

300 g / 10 ½ oz tofu, side length 2 cm

Exotic aromas combined in a delicious sauce.

Heat the red curry paste in 2 tbsp of peanut oil and the palm sugar. Add the soy sauce and a little coconut milk, and reduce.
Add the rest of the coconut milk and simmer gently for 10 minutes.
Peel the lower third of the asparagus stalks, cut 1 cm off the end, then slice the asparagus into 4-cm-long pieces.

Fry in a wok with the rest of the oil for two minutes and then add to the curry sauce with the cherry tomatoes.
Simmer gently for another 5 minutes.
Finally, add the roughly chopped Thai basil, the tofu cubes and the cooked rice noodles to the curry and serve immediately.

Tip
For an even more aromatic dish, add some wafer-thin strips of lemon leaves and sliced fresh chillies before serving.

Store spices in the dark in sealed containers so they retain their aroma and colour.

✳✳45

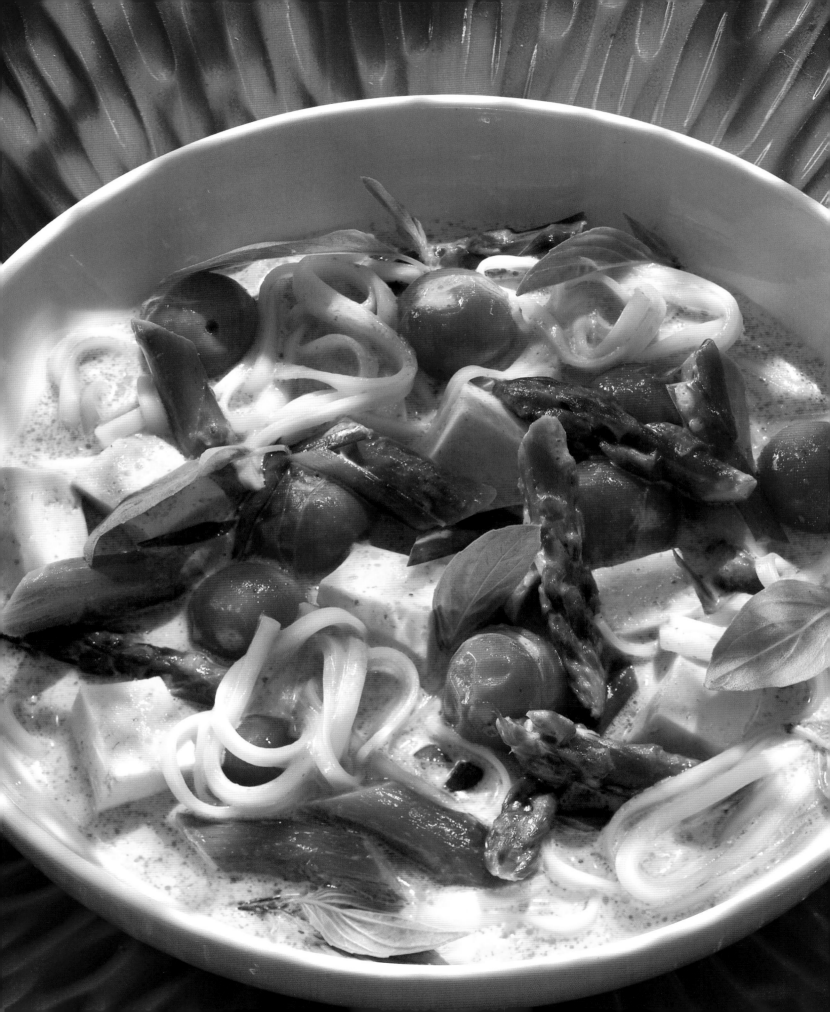

Bolognese sauce
Italy

Makes about 1 ½ litres (48 fl oz / 6 cups) of sauce

1 white onion, finely chopped

2 shallots, finely chopped

4 tbsp olive oil

1 garlic clove, crushed

2 bayleaves

80 g / 3 oz carrots, finely chopped
80 g / 3 oz celery, finely chopped
80 g / 3 oz celeriac, finely chopped

2 tbsp tomato paste

1 teaspoon marjoram, dried

600 g / 21 oz minced meat

1 tin of peeled tomatoes
(about 800 g / 28 oz)

6–8 basil leaves

Salt
Freshly ground black pepper

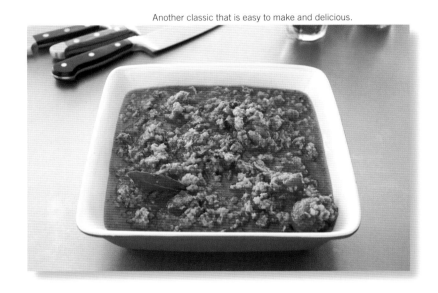

Another classic that is easy to make and delicious.

Heat the olive oil in a pan and fry the onion and shallots until transparent (1).
Add the crushed garlic clove and the bayleaves and fry for a little longer (2).
Add the chopped carrots, celeriac and celery and fry until light brown (3).
Add the tomato paste and marjoram and fry for a further 2 to 3 minutes (4).
Then add the minced meat and break it up using a wooden spatula to cook it thoroughly (5).

Season the minced meat with salt and pepper, pour over the tomatoes and add the basil leaves.
Stir and then simmer gently at a low heat for about 45 minutes (6).
Stir occasionally to prevent the sauce from sticking to the pan.
Finally, remove the garlic clove and bayleaves, and store the sauce in a container until required.

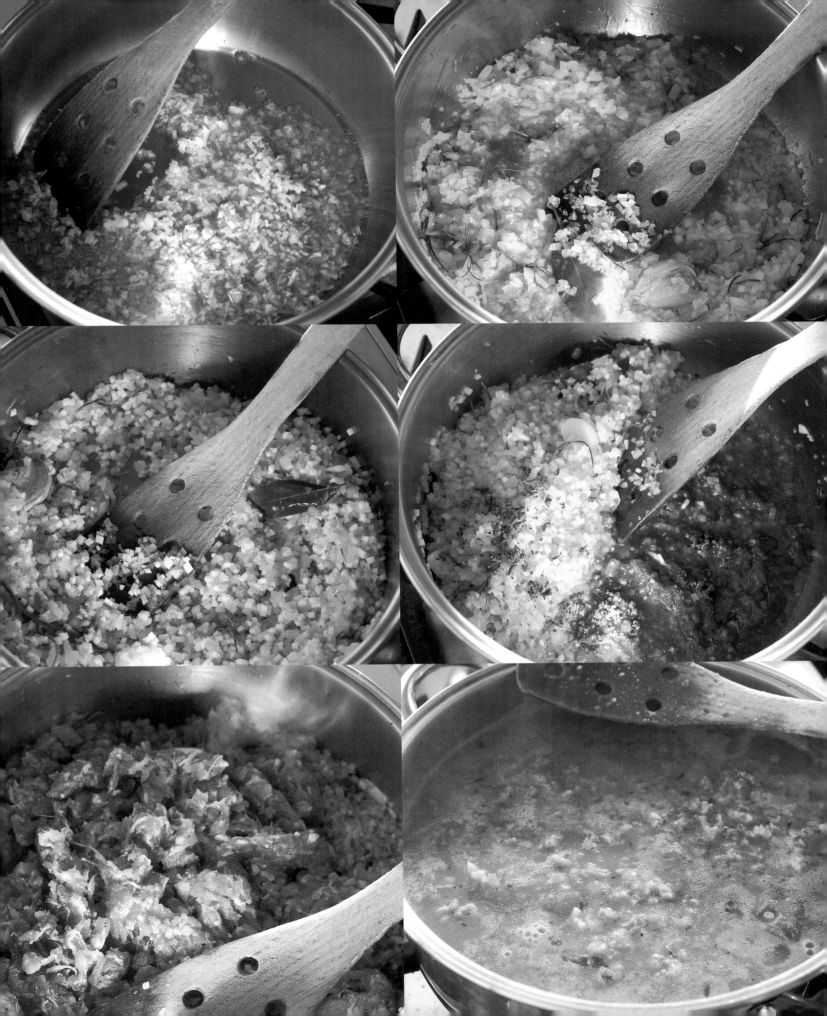

Spaghetti Bolognese

Italy

500 g / 18 oz spaghetti

500 ml / 16 fl oz / 2 cups of bolognese sauce
(see recipe on page 60)

1 slice of cold butter

Salt
Freshly ground black pepper

½ bunch of basil leaves

Parmesan to taste

Bring a pot of salted water to the boil and cook the
spaghetti for 8 minutes until al dente.
Place in a sieve to drain. Meanwhile, heat the sauce
and stir in the spaghetti.
Finally, add the butter to the spaghetti and stir again.
The butter adds a delightful finishing touch to the flavour
of the sauce.

Arrange on hot plates and sprinkle over some sliced
basil leaves and freshly ground pepper.
Serve with finely grated Parmesan if desired.

✳✳ 60

The minced meat should be half pork and half beef to give
the sauce a fuller flavour.

Everything chopped finely – and into the sauce.

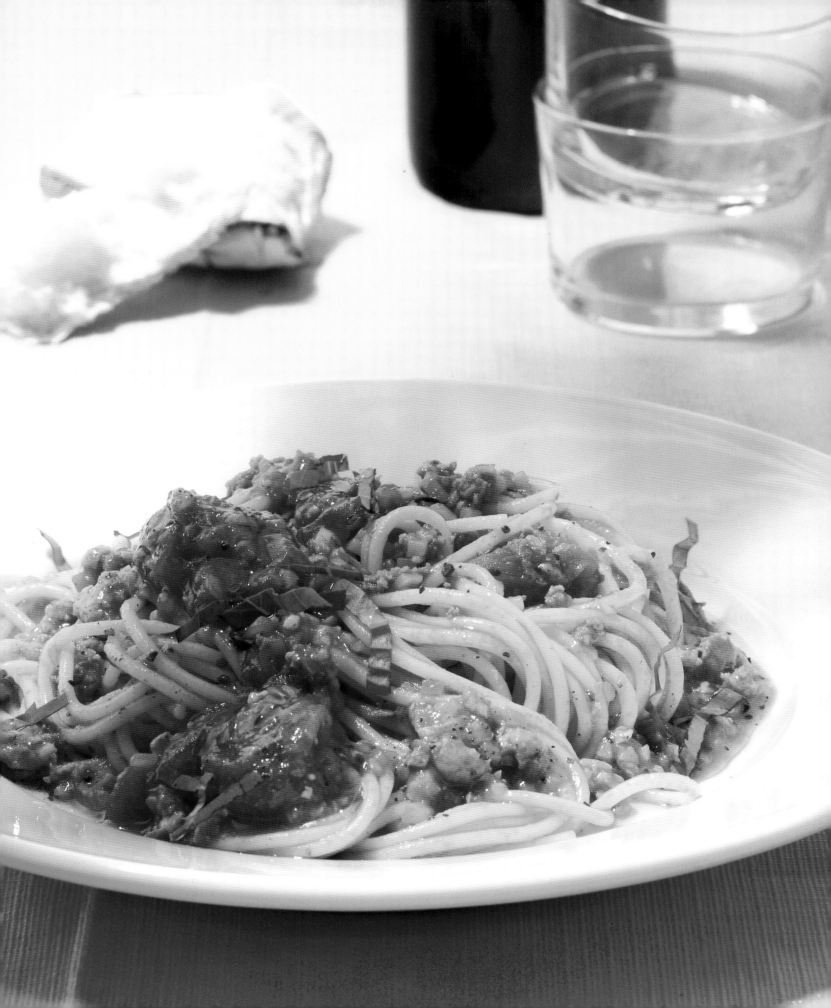

Béchamel sauce

Makes about 750 ml / 24 fl oz / 3 cups

500 ml / 16 fl oz / 2 cups of milk
60 g / 2 oz butter
30 g / 1 oz flour
250 g / 9 oz cream

1 onion, buttered and with a bayleaf and 2 cloves (1)

Salt
Ground nutmeg

The juice of ½ lemon

Fry the butter and flour until light in colour (2+3). Pour over the cold milk and bring to the boil, stirring constantly (4+5).
Add the onion and simmer for 30 minutes (6), stirring occasionally. Pass the sauce through a fine sieve, stir in the cream and season to taste with salt, nutmeg and lemon juice (7). Use as a base for other sauces, for example Gorgonzola sauce, gratin sauce, etc.

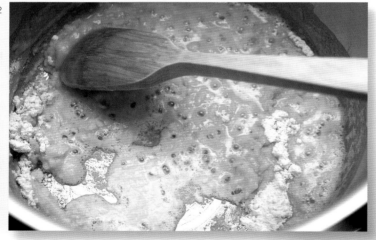

**40

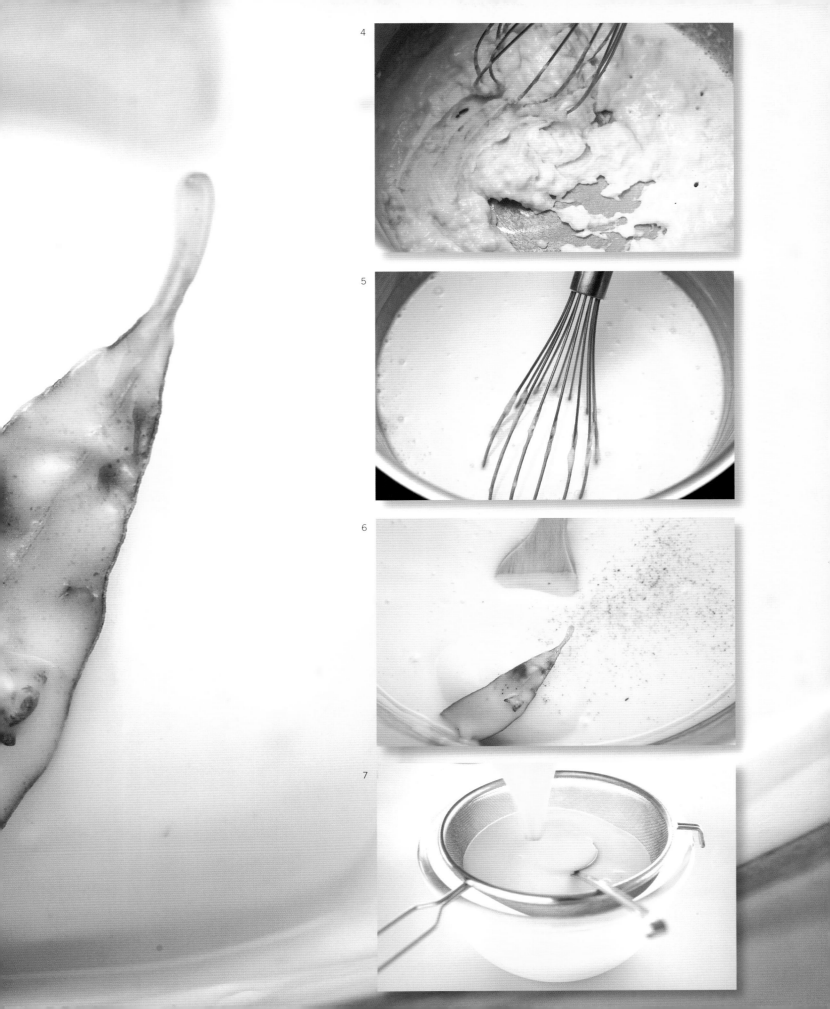

Lasagne with meat sauce and Mozzarella
Italy

1 l / 32 fl oz / 4 cups of béchamel sauce
(see recipe on page 64)

750 ml / 24 fl oz / 3 cups of Bolognese sauce
(see recipe on page 60)

Butter to grease the dish

250 g / 9 oz green lasagne sheets (16 pieces)
or freshly-made green pasta sheets (see recipe
on page 157)

100 g / 3 ½ oz Edam, grated

1 piece of Mozzarella

2 tbsp of extra virgin olive oil

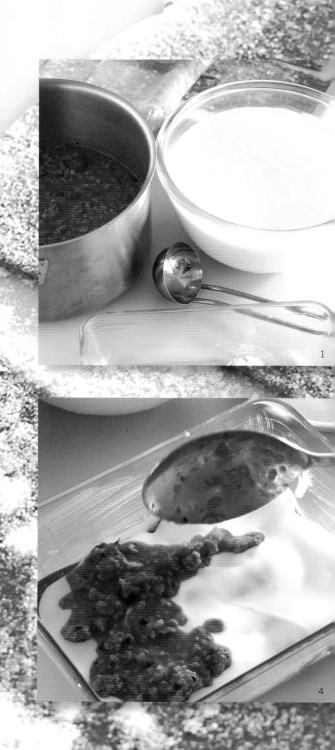

Butter a rectangular baking dish, spread half a ladle
of Béchamel sauce over the bottom and top with
lasagne sheets (2).
Then spread another ladle of Béchamel sauce over
the pasta sheets (3), and top that with a layer of
Bolognese sauce (4).
Repeat this process until the dish is filled to the top,
finishing with a layer of Béchamel sauce (5+6).
Cut the Mozzarella into small pieces and sprinkle
over the lasagne with the grated Edam. Preheat the
oven to 180° C. Finally, drizzle over a little olive oil
and bake for 50 minutes.
Cover with aluminium foil if the lasagne shows signs
of turning too brown, removing it 5 minutes before
the end of the cooking time.

**120

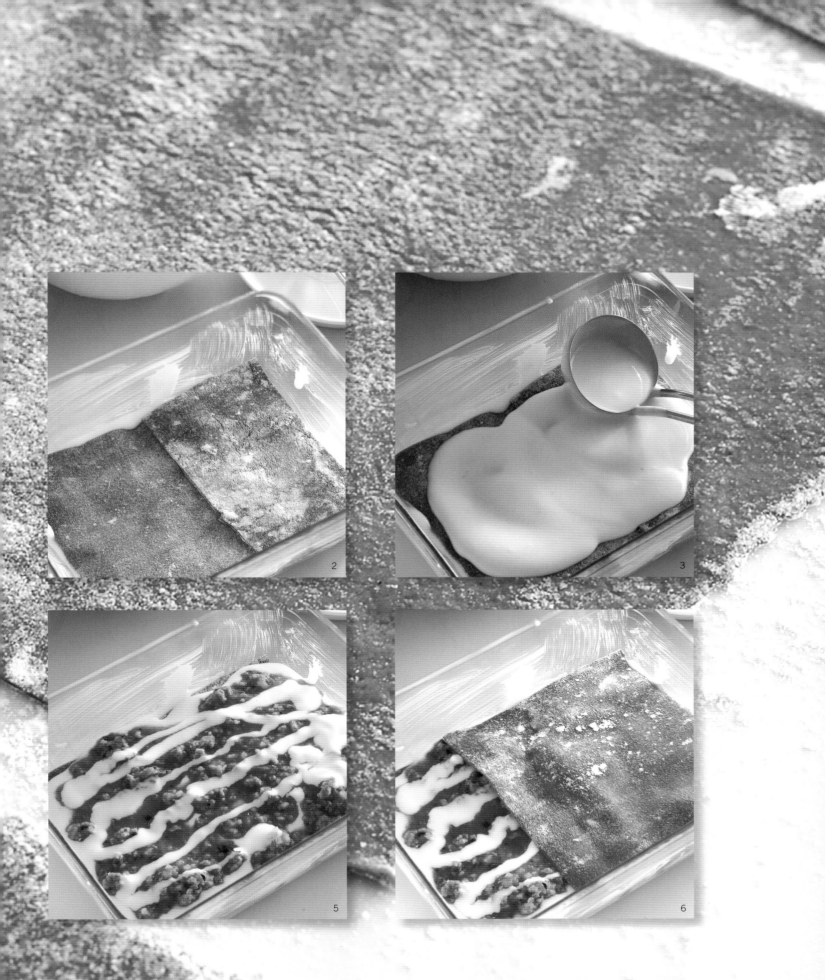

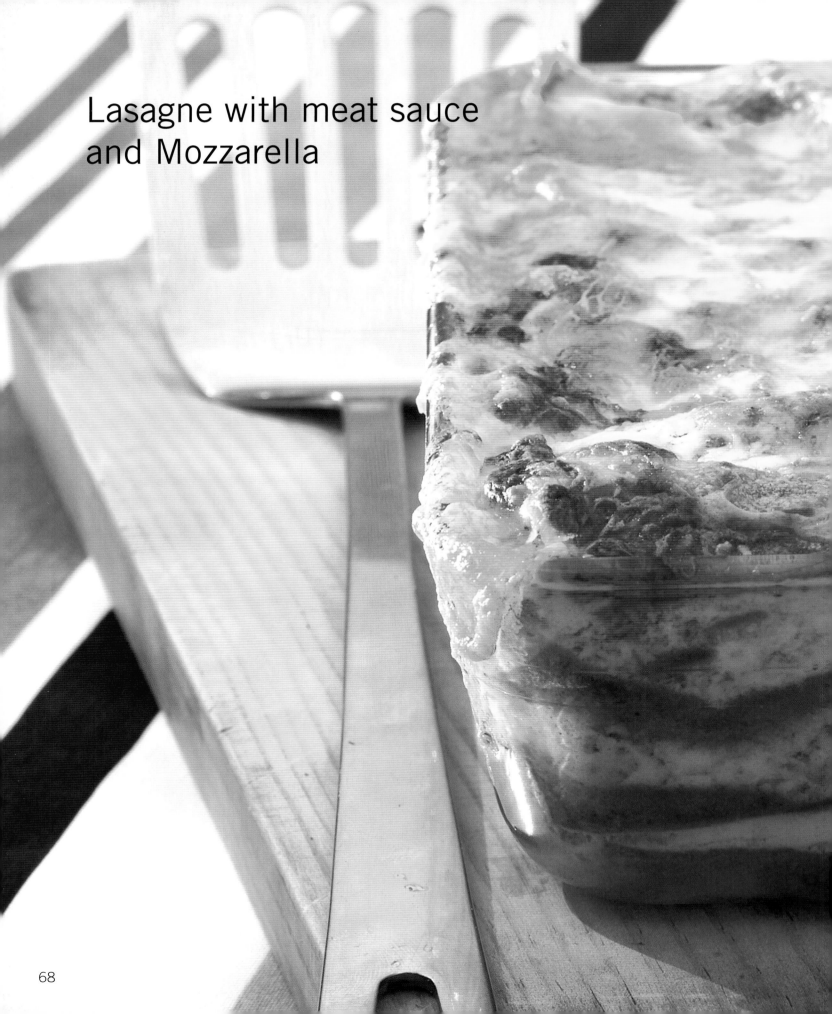

Lasagne with meat sauce
and Mozzarella

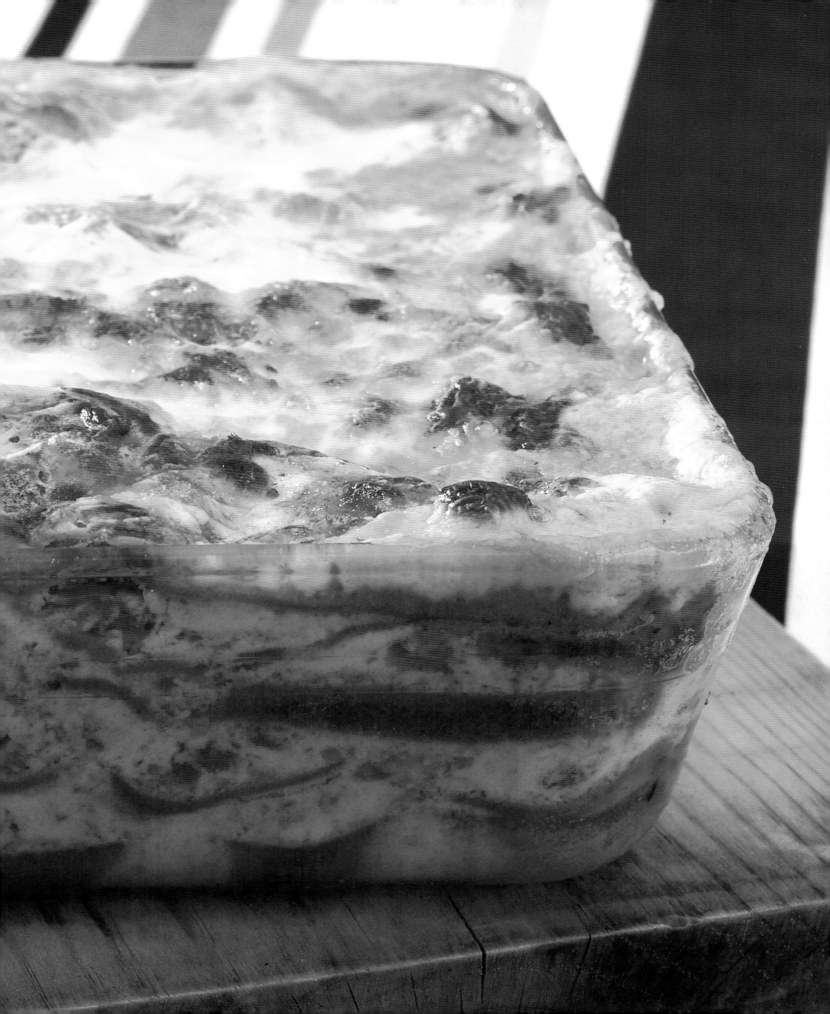

Penne with tomato sauce and Italian sausage
Italy

1 shallot, finely chopped

½ garlic clove, finely chopped

2 tomatoes, peeled and seeds removed

300 ml / 9 ½ fl oz / 1 ¼ cups of tomato sauce (see recipe on page 10)

500 g / 18 oz penne rigate

400 g / 14 oz salsiccia (raw, coarse Italian sausage)

3 tbsp of extra virgin olive oil

1 tbsp butter

Salt
Freshly ground black pepper

Fennel for the garnish

Fry the shallots and garlic in a pan with 2 tbsp olive oil until transparent. Chop the tomatoes into small pieces, add to the pan and season with salt and pepper. Pour over the tomato sauce and bring to the boil.
Cook the penne in salted water al dente following the packet instructions, and then mix with the sauce.
Cut the salsiccia in 1-cm-thick slices and fry in 1 tbsp olive oil and butter until golden brown.
As the sausage is already salted, season with just freshly ground black pepper.
Arrange the penne on plates and top with the fried salsiccia.
You can drizzle some of the frying oil over the pasta, as it will have acquired plenty of its flavour.

Tip
If you can't get hold of salsiccia, use German bratwurst or lamb sausages instead – better order them from your butcher.

35

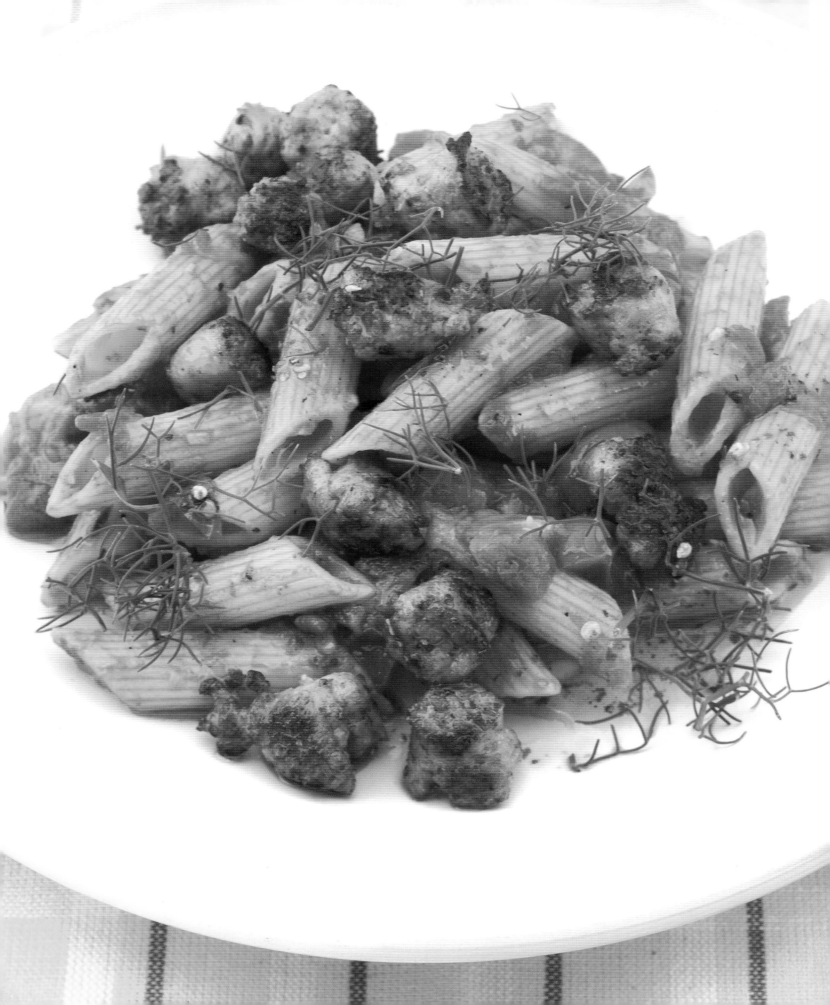

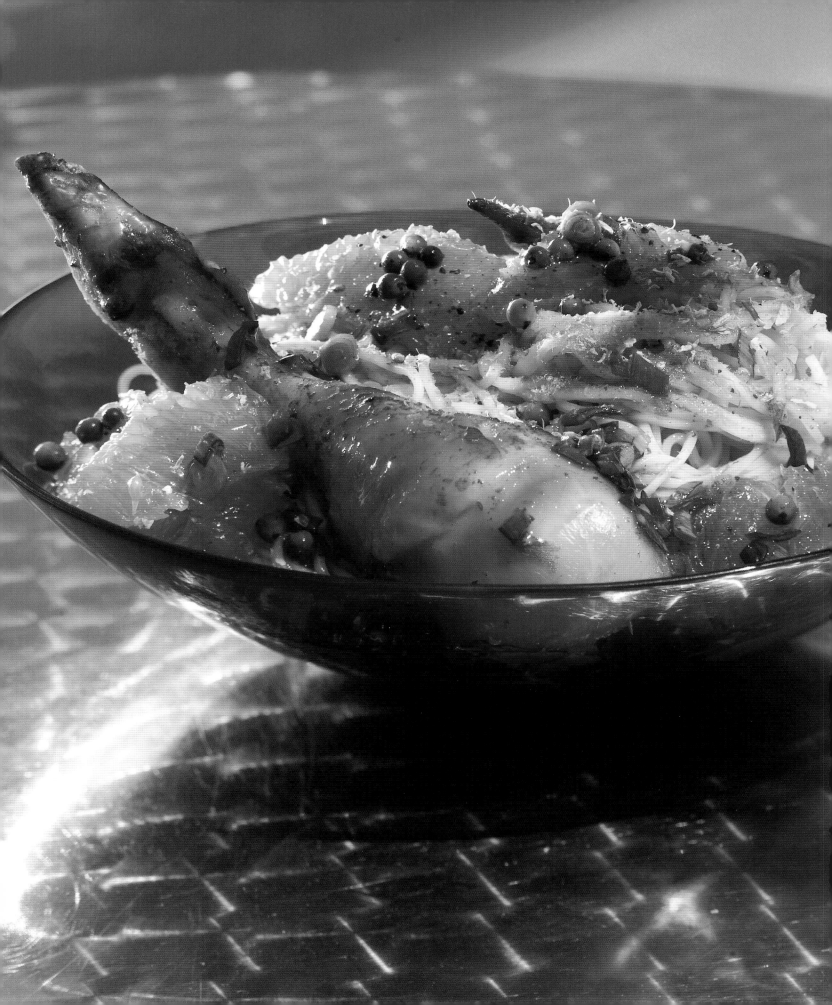

Chinese shrimp noodles with grapefruit, green pepper and grilled chicken
California

4 chicken drumsticks

2 tbsp maize oil
½ tsp curry powder
½ tsp hot paprika powder
1 teaspoon ginger powder
Freshly ground black pepper
Salt

2 pink grapefruits

500 g / 18 oz fine shrimp noodles (available from any Asian food shop)

4 tbsp of extra virgin olive oil

2 tbsp green peppercorns, in brine

1 bunch of small spring onions, sliced in rings

1 tbsp shrimp chilli flakes

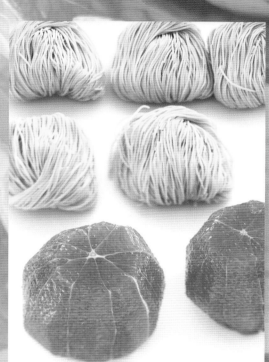

This dish consists of the combination of shrimp noodles and grapefruit. The citrus fruit adds freshness to the dish.

Halve the drumsticks at the joint and marinate in the corn oil, curry powder, paprika, ginger powder, pepper and salt for around 10 minutes.
Grill or fry on a griddle for 10 to 15 minutes on each side.
Cut the tops and bottoms off the grapefruits. Peel the grapefruits with a sharp knife, removing the white pith completely. Separate the fillets, saving the juice in a bowl.
Cook the shrimp noodles, then coat with the olive oil and grapefruit juice while still hot. Add the grapefruit flesh, the crushed green peppercorns, sliced spring onions and shrimp chilli flakes, and combine carefully.
Arrange in bowls and garnish with the grilled drumsticks.

✳✳ 60

Cold coconut soup with rice pasta and pineapple
Thailand

2 vanilla pods

800 ml / 25 ½ fl oz / 3 ¼ cups coconut milk, unsweetened

4 tbsp brown cane sugar

2 cl / 6 ½ fl oz / ¾ cups rum

200 g / 7 oz thick rice noodles

250 g / 9 oz fresh pineapple pieces

Halve the vanilla pods and scrape out the vanilla marrow. Add to the coconut milk with the sugar and bring to the boil. Strain through a fine sieve into a container and add rum to taste.
Boil the rice noodles, drain and add to the coconut milk while still warm.
Put in the fridge to cool.

Arrange in bowls and garnish with pieces of pineapple.
If you have any of the pineapple leaves to hand, wash them and use to garnish.

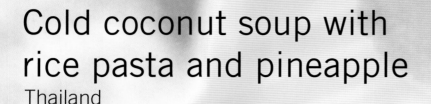

45

Spaghetti with cold tomato sauce

Italy

500 g / 18 oz tin tomatoes, peeled
and seeds removed

2 white onions, finely chopped

½ garlic clove, finely chopped

2 tbsp small capers, roughly chopped

½ bunch of parsley leaves, finely sliced

½ bunch of basil, finely sliced

Light green celery leaves

1 tbsp hot Dijon mustard

2 tbsp liquid from the capers

1 tbsp white wine vinegar

8 tbsp of extra virgin olive oil

Salt
A pinch of sugar
Freshly ground black pepper

500 g / 18 oz spaghetti

A handful of parsley, basil and celery leaves
for the garnish

Chop the tomatoes in small pieces. Combine
in a large bowl with the onions, garlic,
capers, herbs, mustard, vinegar and liquid
from the capers, plus the olive oil, salt,
pepper and sugar, and adjust to taste.
Place in the fridge for at least an hour until
thoroughly chilled.
Cook the spaghetti until al dente in salted
water following the packet instructions, then
drain and arrange on plates.
Pour the cold tomato sauce over the hot
pasta and sprinkle with herb leaves. Grind
over some black pepper if you like.

What is clever about this dish: finely chopped
tomatoes, onions, garlic and herbs are combined
with mustard and vinegar and poured over the
warm pasta.

Tip
On hot summer days, this dish is a good
alternative to cool fresh salads and hot
pasta – in a way it is a combination of
both. The slightly sour, spicy mustard
flavour of the tomatoes makes this
particularly light and extremely enjoyable.

** 25

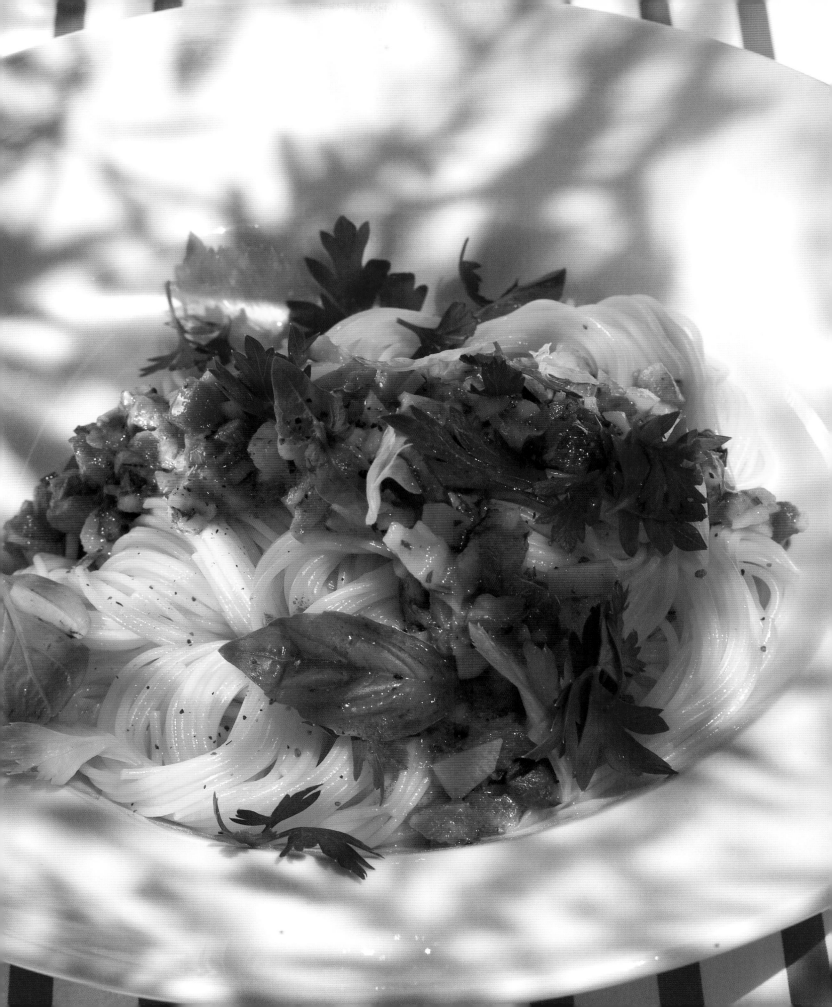

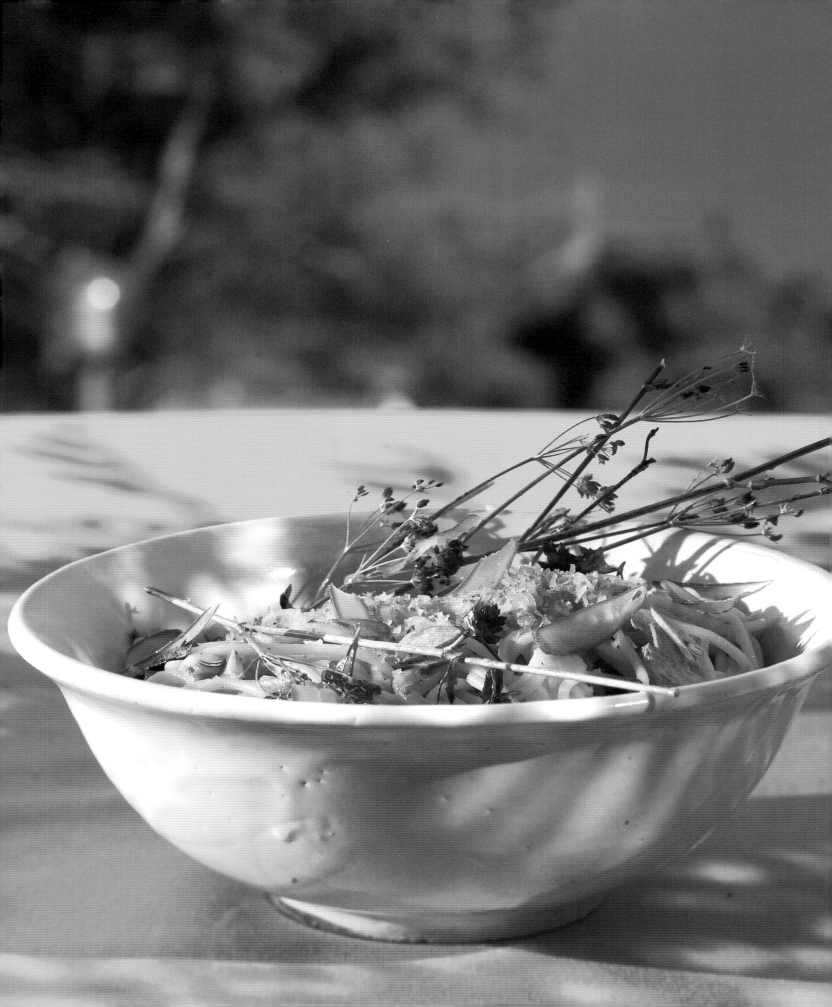

Spaghetti with fennel and bottarga

Spain

5 fennel stems

1 tsp fennel seeds, chopped

4 tbsp of extra virgin olive oil

1 garlic clove, finely chopped

200 ml / 6 ½ fl oz / ¾ cup white wine

500 g / 18 oz spaghetti

½ bunch of parsley

40 g / 1 ½ grated bottarga (tuna roe)

30 g / 1 oz butter

Freshly ground black pepper

The dried salty tuna roe gives this dish its piquant, fishy flavour.

Fry the fennel and fennel seeds in olive oil, add the garlic and pour over the white wine. Simmer gently for 5 minutes.
Meanwhile, cook the spaghetti until al dente, then drain and add to the fennel. Stir in the parsley leaves, grated bottarga and butter, season with black pepper and serve.
Leave the fennel in the pasta and top the pasta with some finely cut bottarga if you like.

** 30

Conchiglie with calamari and mussels

Italy

300 g / 10 ½ oz calamari, thoroughly washed

500 g / 18 oz small mussels, washed
and cleaned

1 shallot, thinly sliced

2 garlic cloves, crushed in their skins

6 tbsp of extra virgin olive oil

2 large ladles of tomato sauce
(see recipe on page 10)

500 g / 18 oz conchiglie

A bunch of basil, half thinly sliced

Salt
Freshly ground black pepper

Slice the calamari tubes in 3 cm long pieces.
Heat the olive oil in a non-stick pan, then salt
the calamari tubes and fry briefly in the hot
oil at high heat.
Add the sliced shallot, garlic and drained
mussels and pour over the tomato sauce.
Put the lid on the pan and let the mussels
open up.
Meanwhile, cook the conchiglie until al dente
in plenty of salted water, add to the sauce in
the pan, and then stir carefully.
Sprinkle with chopped basil leaves and
stir carefully until the conchiglie are well
combined with the tomato sauce.
Arrange on plates, garnished with the rest
of the basil leaves, and sprinkle with black
pepper.

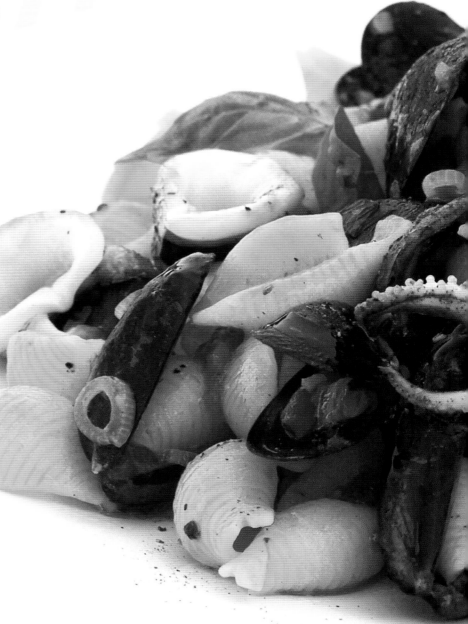

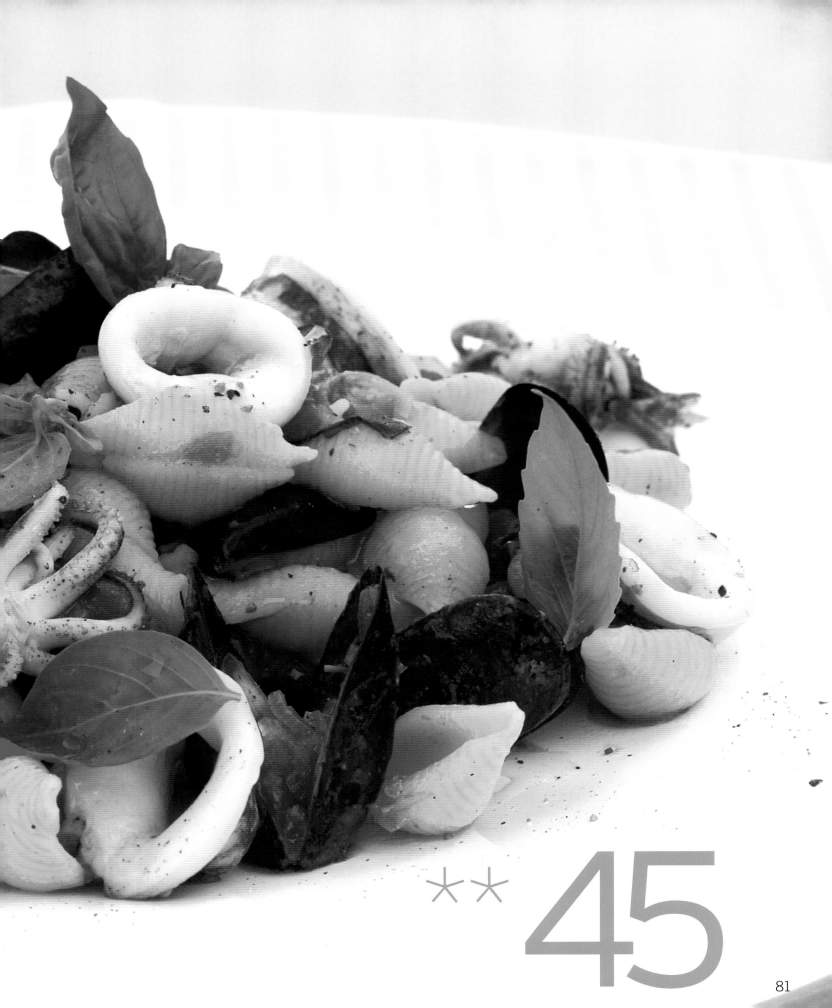

** 45

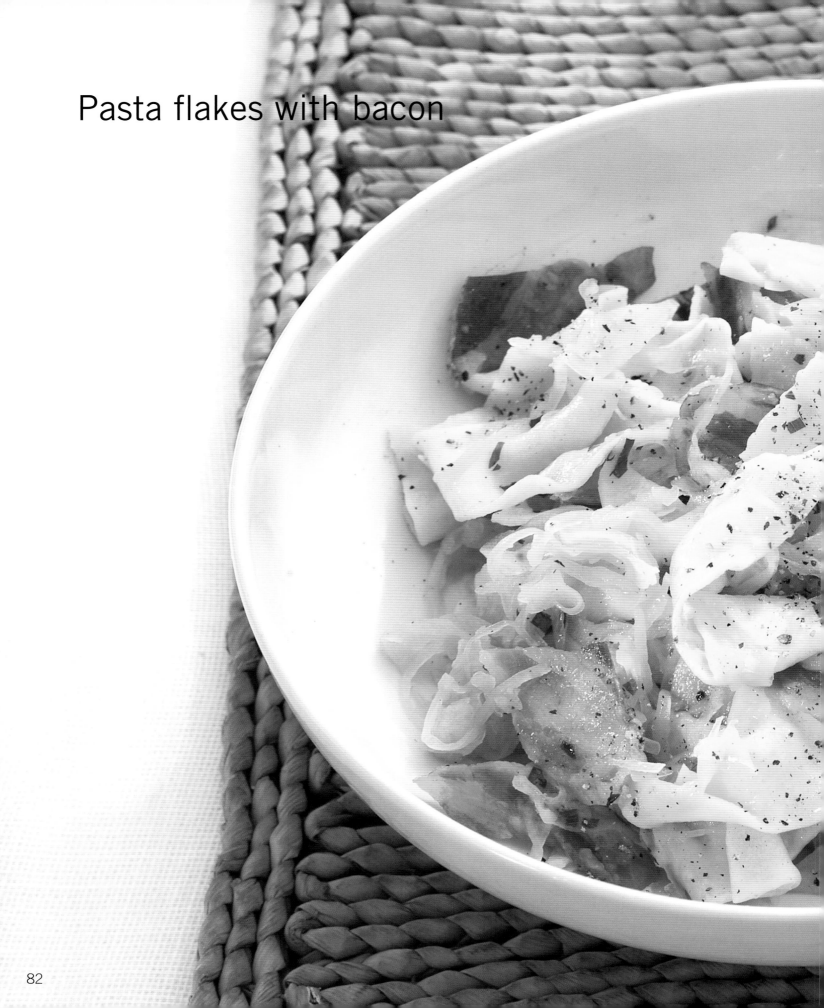

Pasta flakes with bacon

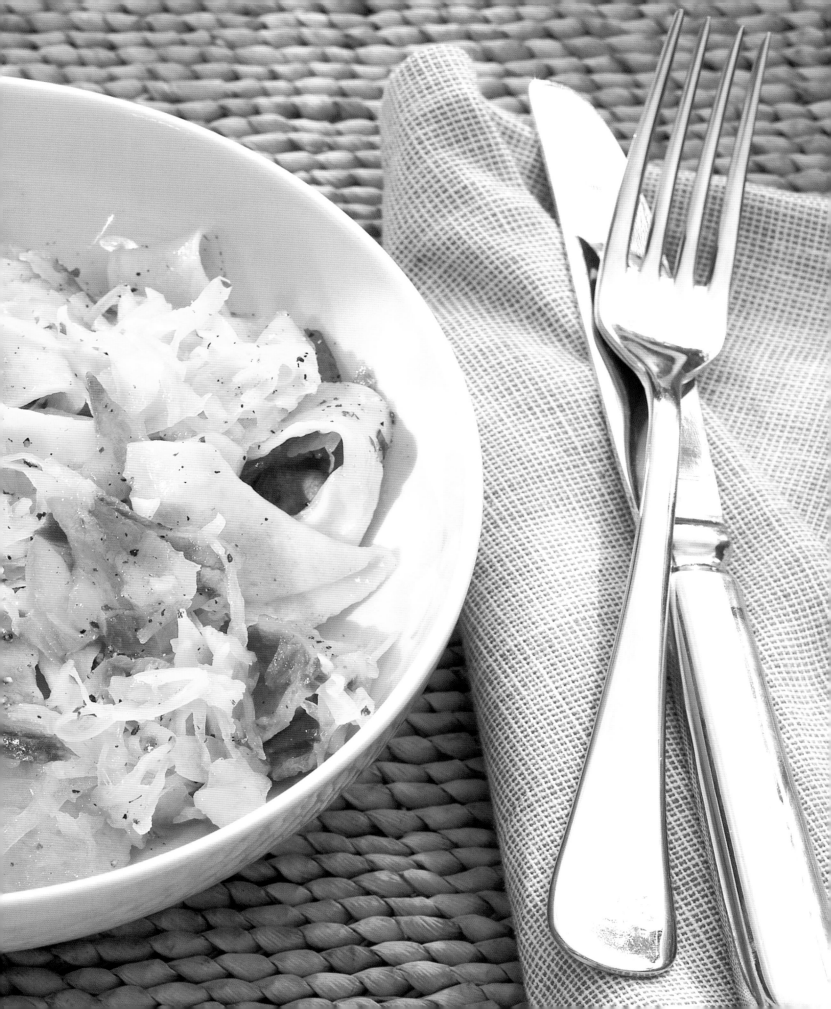

Pasta flakes with bacon

Austria

1 young white cabbage

40 g / 1 ½ oz refined sugar

300 g / 10 ½ oz onions, sliced lengthwise

60 g / 2 oz lard

200 ml / 6 ½ fl oz / ¾ cup white wine

500 ml / 16 fl oz / 2 cups water

40 g / 1 ½ oz butter

½ tsp caraway seeds, crushed

1 garlic clove, finely chopped

100 g / 3 ½ oz rindless smoked bacon, cut into rhombus shapes

250 g / 9 oz white pasta dough, cut into rhombus shapes (see recipe on page 153)

Salt
Freshly ground black pepper

1 tbsp parsley leaves, finely chopped

Cut the white cabbage in 2 cm long rhombi, blanch in salted water, then plunge into cold water and drain. Melt the sugar in a casserole with a small quantity of water and allow it caramelize until golden yellow.
Add the lard and the onion strips and melt gently for about 10 minutes. Add the cabbage and the white wine.
Fry gently for 20 to 30 minutes, and keep adding water so that the cabbage doesn't burn. Knead half the butter with the caraway seeds and garlic and use to season the cabbage.

Dust the pasta lightly with flour; this prevents it from sticking.

** 45

Fry the ham rhombi in the remainder of the butter, boil the pasta rhombi in salted water for 2 minutes, then add both to the cabbage. Combine, season to taste with salt and pepper, and sprinkle with finely chopped parsley before serving.

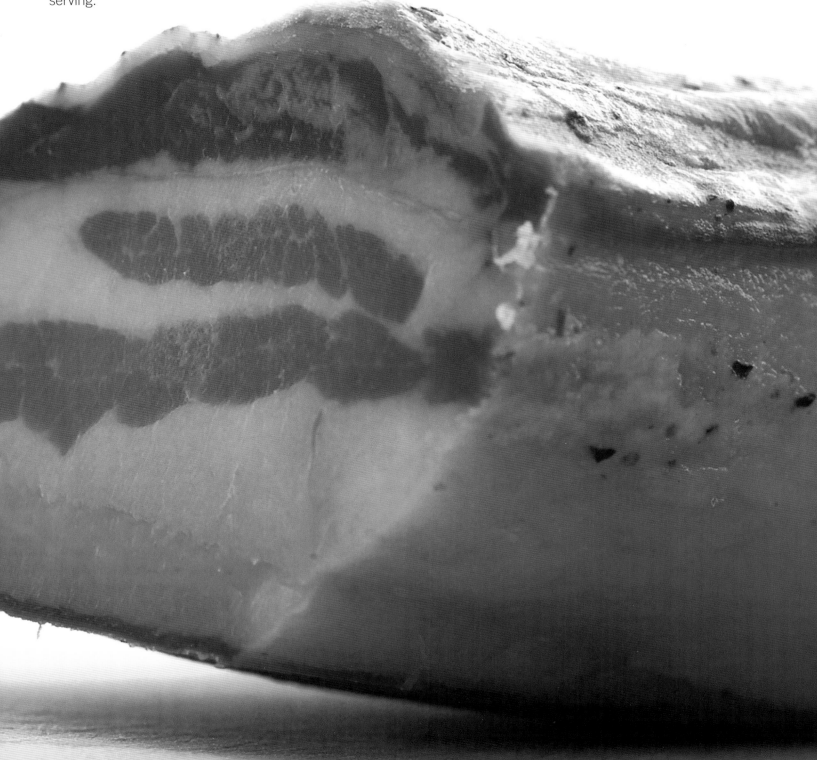

Tomato tagliolini with chilli crevettes and mushrooms

Italy

250 g / 9 oz mushrooms, quartered

6 tbsp of extra virgin olive oil

1 shallot, finely chopped

2 garlic cloves, finely chopped

400 g / 14 oz small raw crevettes, shelled

2 large ladles of tomato sauce (see recipe on page 10)

1 – 2 tsp chilli oil, according to taste

1 bunch of basil, half thinly sliced

600 g / 21 oz fresh tomato taglioni (see recipe on page 158)

Salt
Freshly ground black pepper

Heat the oil in a pan, fry the mushrooms quickly and season with salt and pepper. Add the shallots and garlic, heat through and add the raw crevettes. Pour over the tomato sauce and bring to the boil. Add chilli oil to taste and stir in the basil leaves.
Meanwhile, place the tomato taglioni in plenty of boiling salted water, bring back to the boil, and drain immediately. Add to the sauce and combine gently. Using a meat fork, roll the taglioni up in portions and arrange on plates. Pour the sauce and remaining crevettes over the taglioni portions and garnish with basil leaves.

Tip
Since the taglioni are fresh and very thin, they cook as soon as they come to the boil. If they are still too hard for your taste, leave them in the sauce a little longer rather than boiling them for longer. This way the flavour of the sauce develops fully in the pasta.

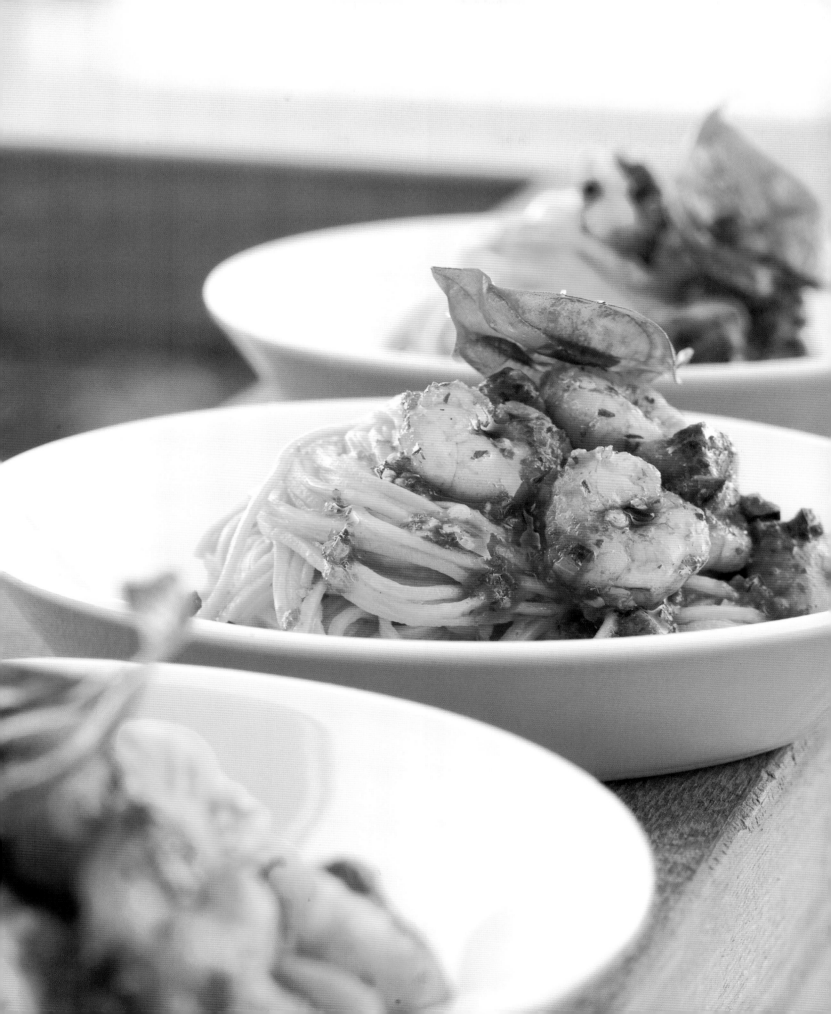

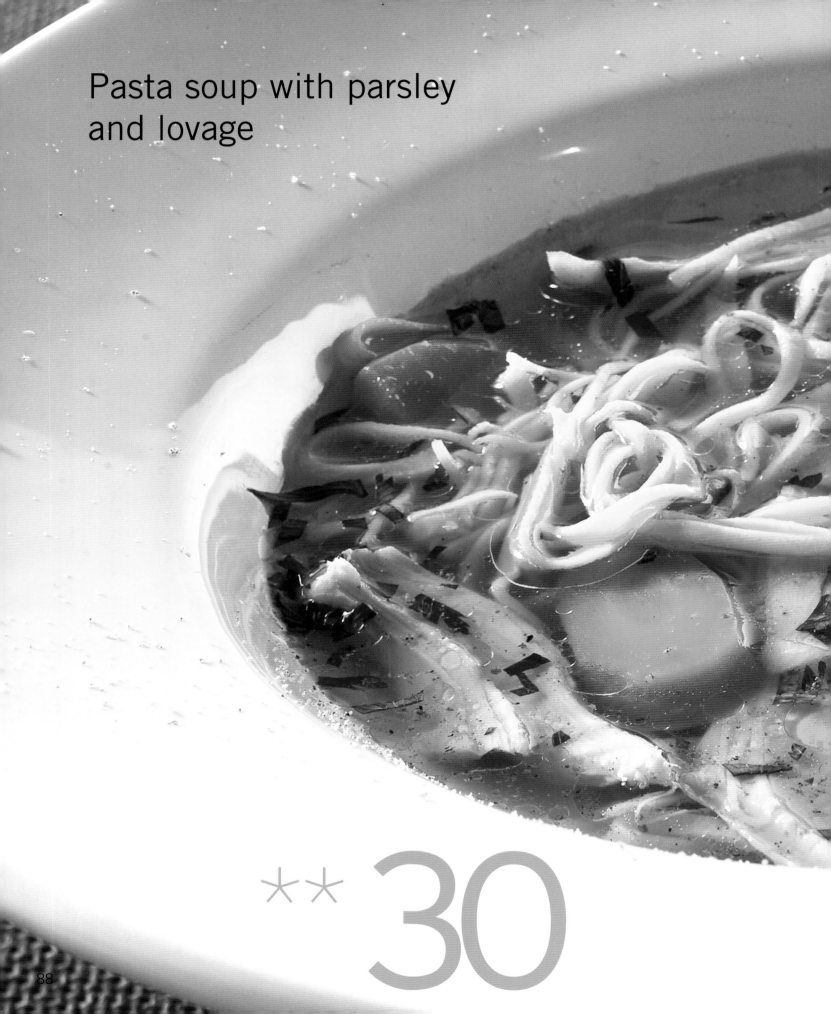

Pasta soup with parsley and lovage

** 30

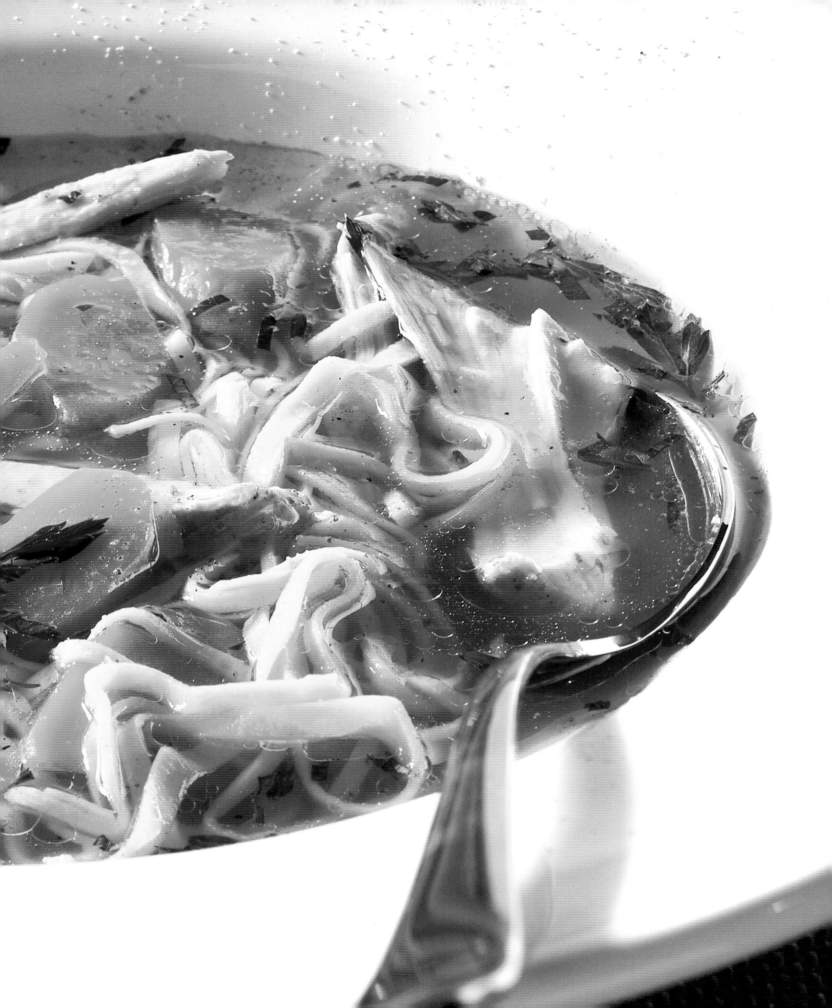

Pasta soup with parsley and lovage

Germany

1 boiling fowl (1.3 kg)

3 l / 24 fl oz / 3 cups water

200 g / 7 oz onions

150 g / 5 oz carrots, peeled
3 celery stalks
1 leek
1 bunch of fennel

1 garlic clove, cut in half

4 bayleaves
2 cloves
8 juniper berries
4 pimento corns
10 black peppercorns
1 tbsp sea salt

1 bunch of parsley stalks
1 bunch of fennel
A few celeriac leaves

250 g / 9 oz freshly cut soup noodles
(see recipe on page 153)

Salt (or sea salt)

½ bunch of parsley

½ bunch of lovage

Freshly grated nutmeg

Wash the soup chicken thoroughly, both outside and inside, and remove all traces of blood. Place in a saucepan of cold water, add sea salt and slowly bring to the boil.
Remove the foam and any white matter with a ladle, then simmer gently for half an hour without removing the fat.
Add the vegetables, spices and herbs and simmer gently for another hour, adding more water if necessary.
Carefully remove the chicken and vegetables and cover until needed later. Strain the soup through a fine sieve and set aside.
Chop the cooked vegetables and return to the stock. Skin from the chicken and remove the flesh from the bones with a knife. Cut into pieces and return to the stock.
Cook the pasta in plenty of salted water for 2 minutes, drain and add to the stock. Serve in bowls, sprinkling with nutmeg, finely chopped parsley and lovage.

Tip
The chicken fat that remains on the surface of the soup is a sort of protection layer. Use instead of butter and oil for frying vegetables.

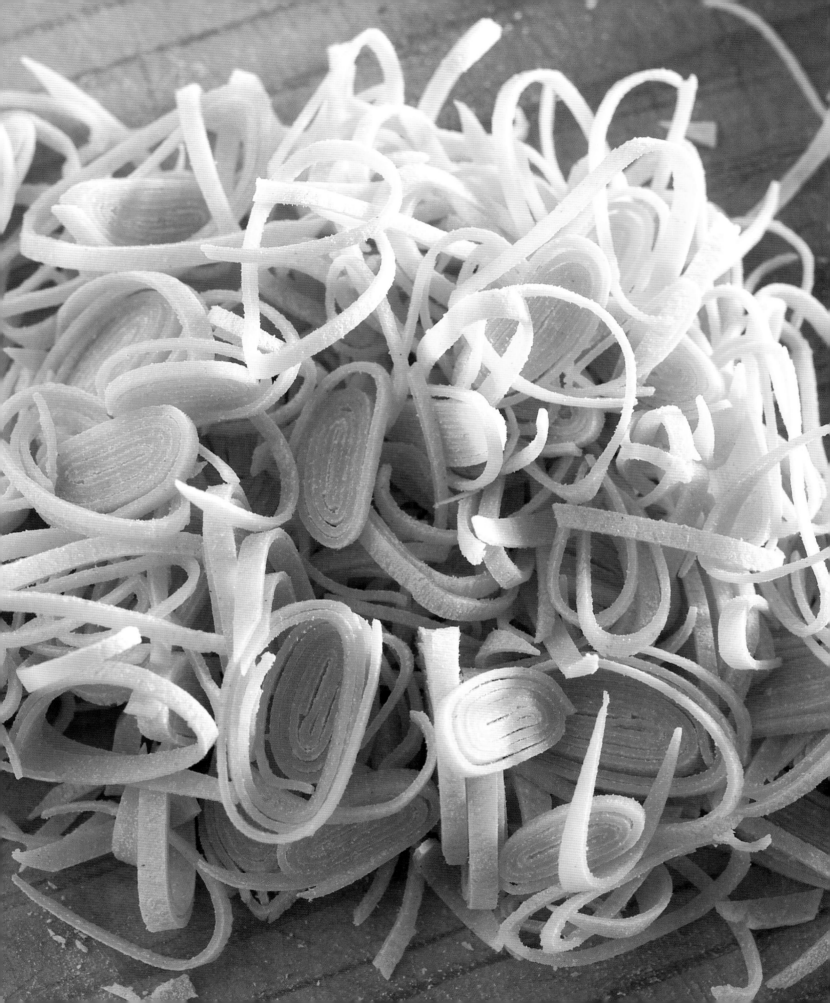

Pesto

Italy

2 bunches of basil

1 bunch of parsley

3 garlic cloves

5 tbsp roast pine nuts

150 g / 5 oz Parmesan, freshly grated

200 ml / 6 ½ fl oz / ¾ cups olive oil

Salt
Freshly ground black pepper

Remove the basil and parsley leaves from the stalks, peel the garlic cloves and put everything in a mixer and blend with the pine nuts, grated Parmesan and half the oil.
Season with salt and pepper and pour the remainder of the oil through the opening in the mixer until it is of a paste-like consistency.

Tip
This popular cold sauce is ideal with spaghetti and other types of long pasta. Pesto will keep for a few days if stored in a sealed jar in the fridge.

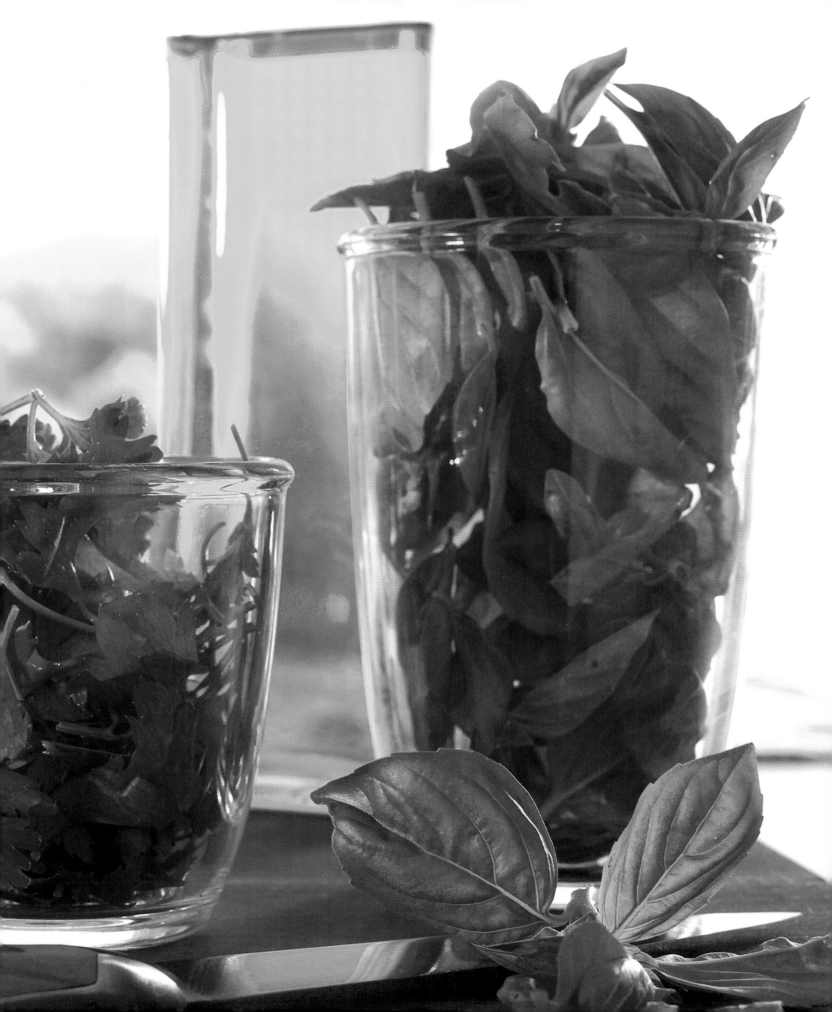

Linguine al pesto
Italy

500 g / 18 oz linguine

120 g / 4 oz pesto (see recipe on page 92)

2 tbsp roasted pine nuts

½ bunch of basil

Salt

Bring some salted water to the boil and cook the linguine for 8 minutes until al dente. Drain in a sieve, keeping some of the pasta water for later. Place the pasta in a wide pot, add the pesto and mix with a generous amount of pasta water.
Heat until the pesto binds with the pasta. This will happen when the cheese from the pesto melts in enough liquid.
Arrange on plates and add some roast pine nuts and basil leaves.

Fresh pesto keeps well in the fridge if stored in a screw-top jar – that is, if there is any left

You can crush the ingredients in a mortar, although it is easier to use a blender.

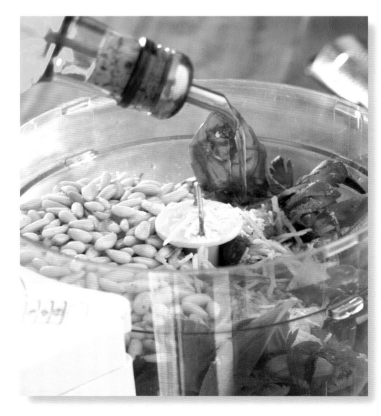

✳✳30

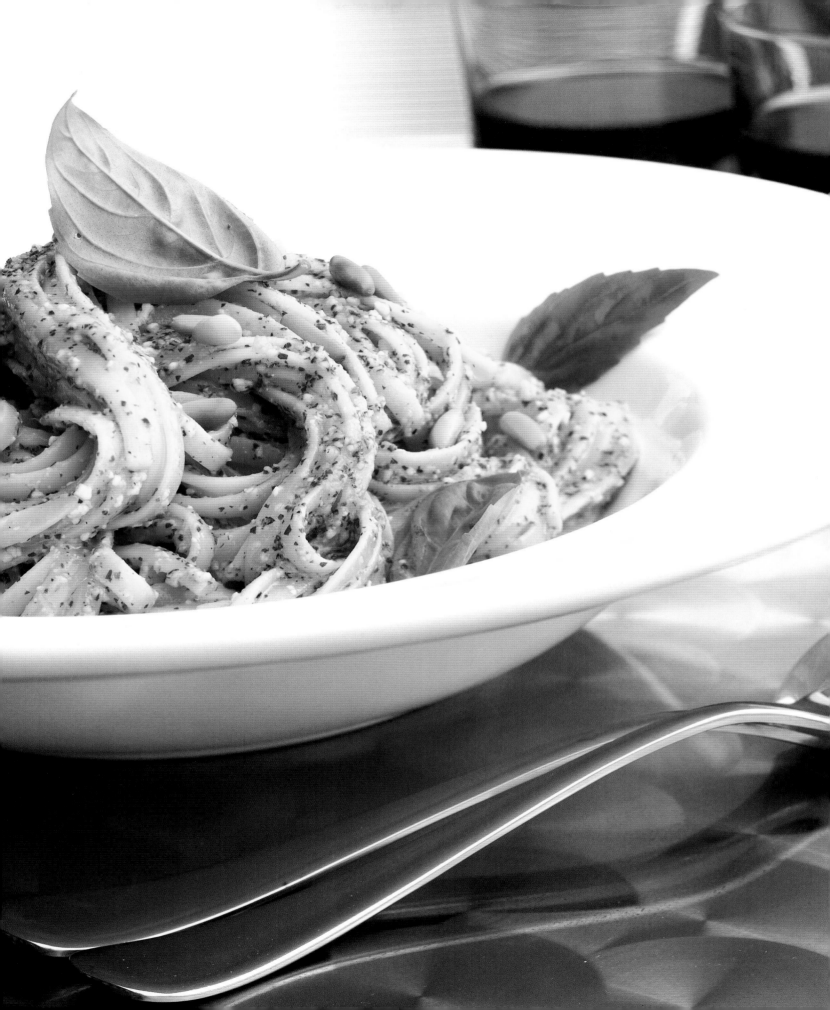

Maize rigatoni with chilli beans
Mexico

20 g / ¾ oz sugar

60 ml / 2 fl oz / ¼ cup fruit vinegar

40 g / 1 ½ oz lard

300 g / 10 ½ oz white onions, chopped

1 garlic clove, finely chopped

250 g / 9 oz borlotti or kidney beans, soaked
for 2 hours

1 tbsp tomato paste
1 tin of peeled tomatoes (about 400 g / 14 oz)

500 ml / 16 fl oz / 2 cups water

250 g / 9 oz chopped red and yellow peppers

150 g / 5 oz sweetcorn

Tabasco sauce

500 g / 18 oz maize rigatoni

200 g / 7 oz sour cream

Salt
Freshly ground black pepper

Drain the beans after soaking.

Caramelize the sugar until golden yellow, then pour
in the fruit vinegar. Let it reduce until almost gone.
Add the lard, onion and garlic and allow to become
light brown. Add the soaked beans, then season
with salt and pepper and fry briefly.
Add the tomato paste and heat through, then pour
over the peeled tomatoes and water.
Cover and bake in the oven at 180° C for
35 minutes.
Add the peppers and maize after 15 minutes.
The chilli beans will be ready when the consistency
is thick and glossy. Season with Tabasco if you like.
Cook the maize rigatoni in salted water following
the packet instructions and combine with the chilli
beans. Heat through quickly and arrange on plates.

To give the pasta a fresh touch, top with some
sour cream or crème fraîche and freshly ground
pepper at the end.

**60

Pizzoccheri with potatoes and white cabbage

Switzerland

** 30

It's easier if you use a big knife to halve the cabbage, cutting it and removing the stalk.

300 g / 10 ½ oz potatoes in their skin, cooked the day before

2 tbsp corn oil

20 g / ¾ oz butter

White cabbage, medium sized

Salt

2 onions, thinly sliced lengthwise

½ garlic clove, finely chopped

1 tsp caraway seeds, crushed

400 g / 14 oz wholewheat horn-shaped pasta

150 g / 5 oz mature Gruyere, grated

1 tbsp parsley leaves, finely chopped

Peel the boiled potatoes and cut into 2-cm dice. Fry in a non-stick pan in half the oil and butter until crisp and brown. Remove from the pan and set aside. Quarter the cabbage and remove the thick stalk. Remove any limp and discoloured leaves.
Cut in 2–3 cm sized pieces and blanch in salted water for around 2 minutes. Plunge briefly in the boiling water, then remove using a spoon.
Meanwhile, heat the rest of the oil and butter and fry the garlic and onions until light brown. Add the blanched white cabbage and cook gently for a further 5 minutes.

Add the caraway seeds and potatoes and mix with the pasta horns previously cooked in salted water. Cook for a little longer, so that the aromas of the individual ingredients blend together.
Finally, mix in some grated cheese and chopped parsley and stir until the cheese melts.
Cold beer goes well with this dish – ideally with a small glass of kirsch!

Tip
The caraway seeds are easier to crush if you add some oil. This makes the seeds stick together, which stops them from shooting out in all directions.

Finely sliced young cabbage cooks quickly – blanch briefly to retain some bite.

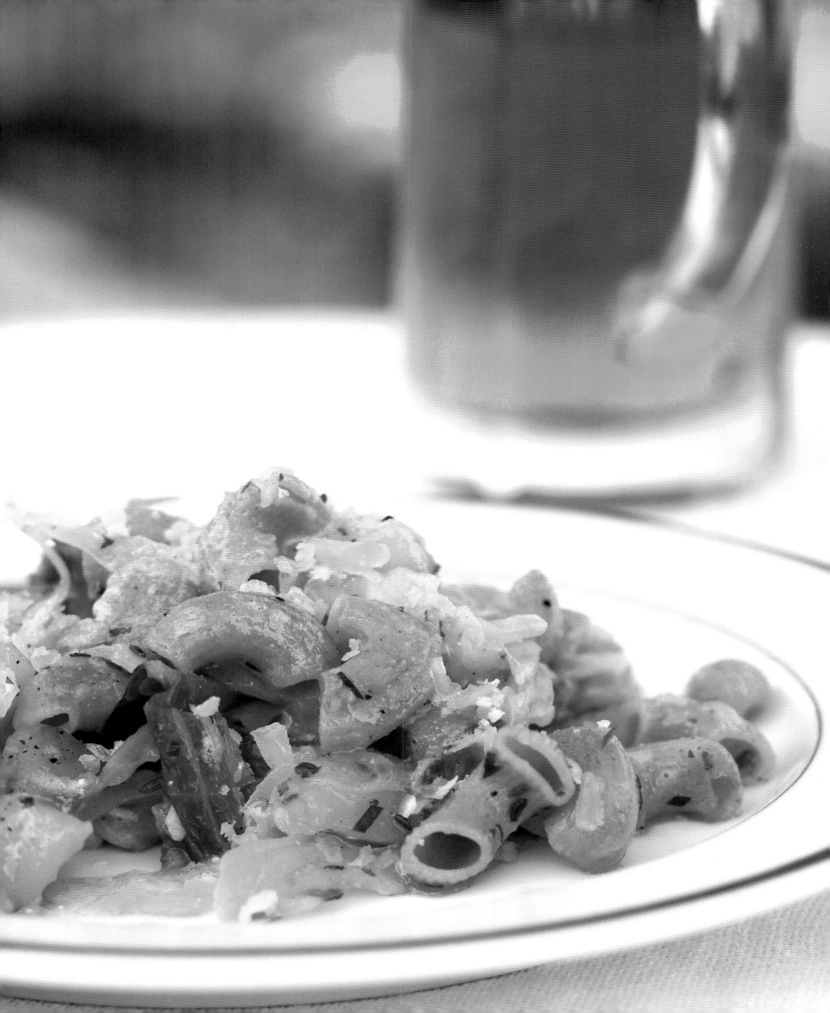

Rice vermicelli salad with peppers and shrimp chilli flakes

Thailand

The well-whisked vinaigrette goes on top of the vermicelli.

400 g / 14 oz rice vermicelli

1 red and 1 yellow pepper, halved and seeds removed

1 bunch of spring onions

½ tsp ginger root, freshly grated

3 tbsp fish sauce

2 tbsp oyster sauce

1 pinch of sugar

Juice of 2 limes

½ bunch of coriander

½ garlic clove, finely chopped

Sesame oil

5 tbsp peanut oil

1 tbsp shrimp chilli flakes (available from any Asian food shop)

Cook the rice vermicelli in boiling water, then rinse immediately under running cold water. Place in a large bowl and add the peppers, sliced spring onions and chopped coriander. To make the vinaigrette, whisk the fish and oyster sauces together with the sugar, lime juice, chopped coriander, garlic, sesame oil and peanut oil.
Combine with the remainder of the ingredients and marinate for half an hour. Serve the glass noodle salad either in portion-sized bowls or on a large dish. Top with shrimp-chilli flakes and serve.

Tip
If you like, you can add some fried shrimps, mushrooms or chicken to this salad.

✳✳30

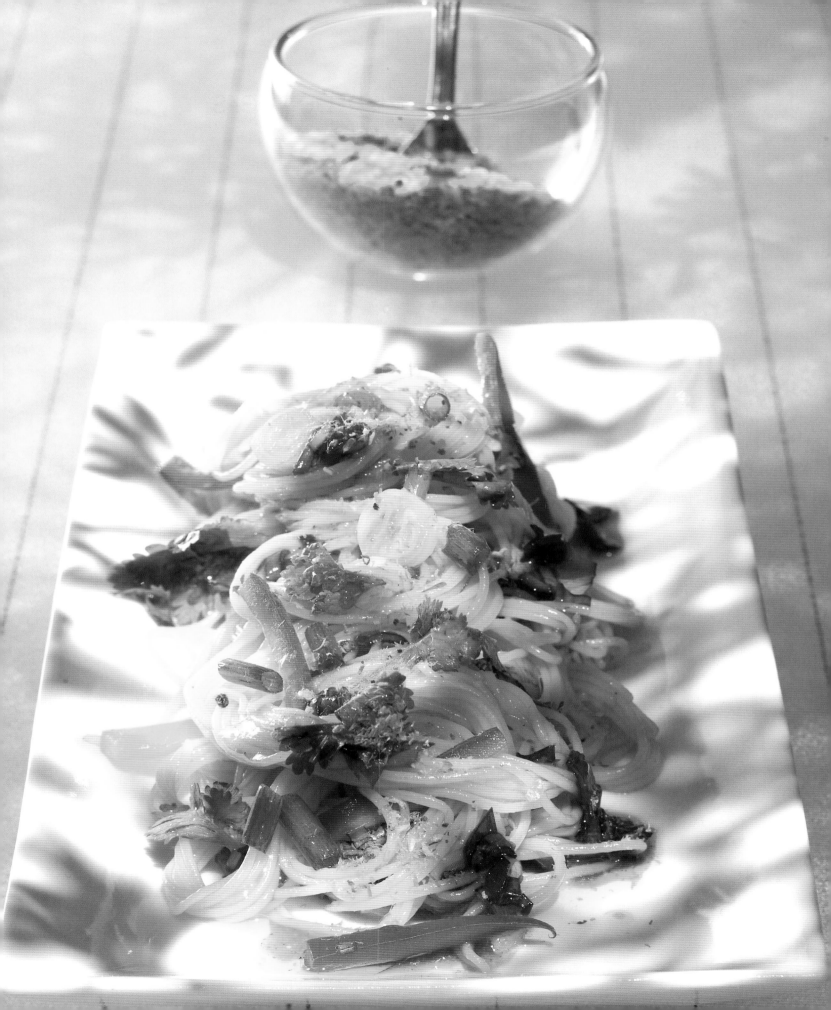

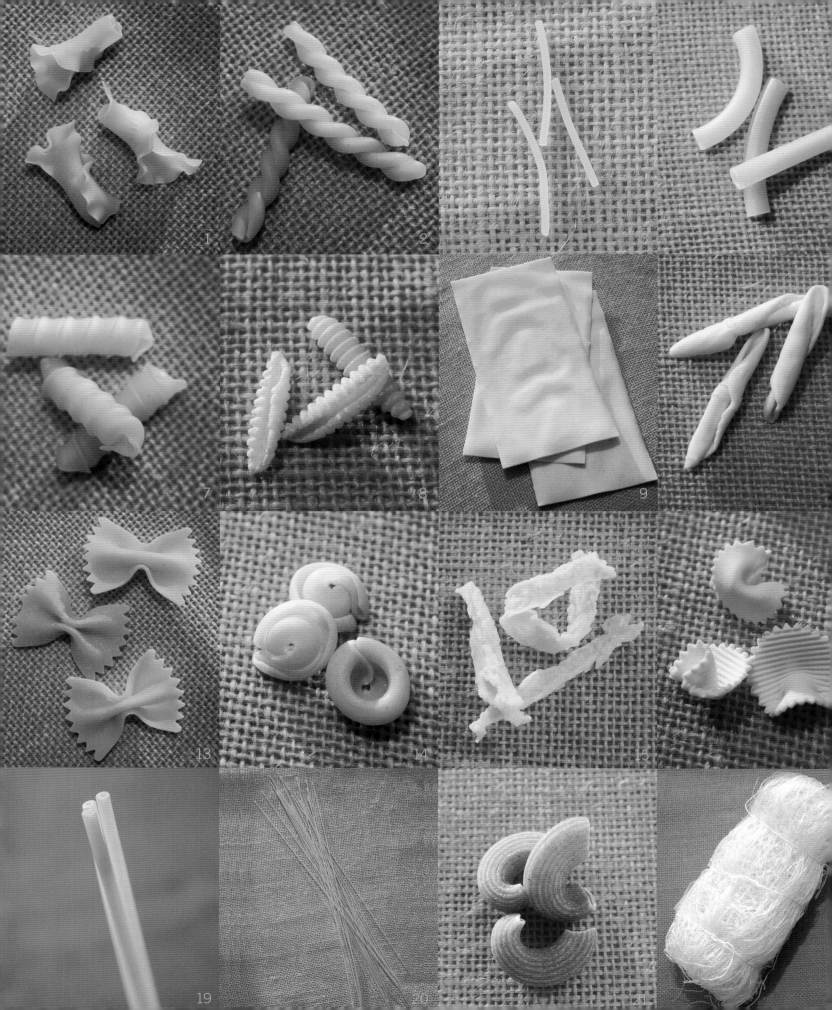

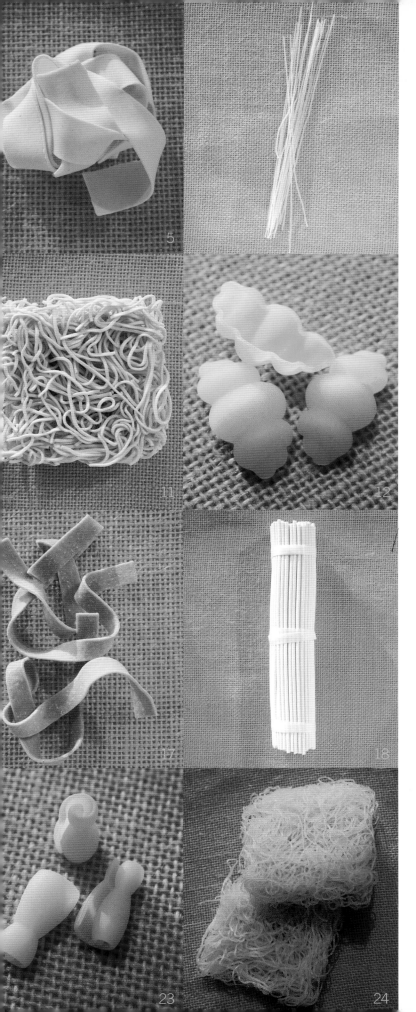

Pasta varieties

1 Fiorelli
2 Gemelli
3 Fideo
4 Maccheroncini
5 Swiss rolled noodles
6 Fine rice vermicelli
7 Riccioli
8 Gnocchette
9 Lasagne
10 Caserecci
11 Chinese fast-cooking noodles
12 Gnocchi
13 Farfalle
14 Trulli
15 Spätzle
16 Shell-shaped pasta
17 Cep noodles
18 Inaka udon noodles
19 Bucatini
20 Capellini
21 Wholewheat horn-shaped pasta
22 Transparent noodles
23 Swiss rollini
24 Rice vermicelli

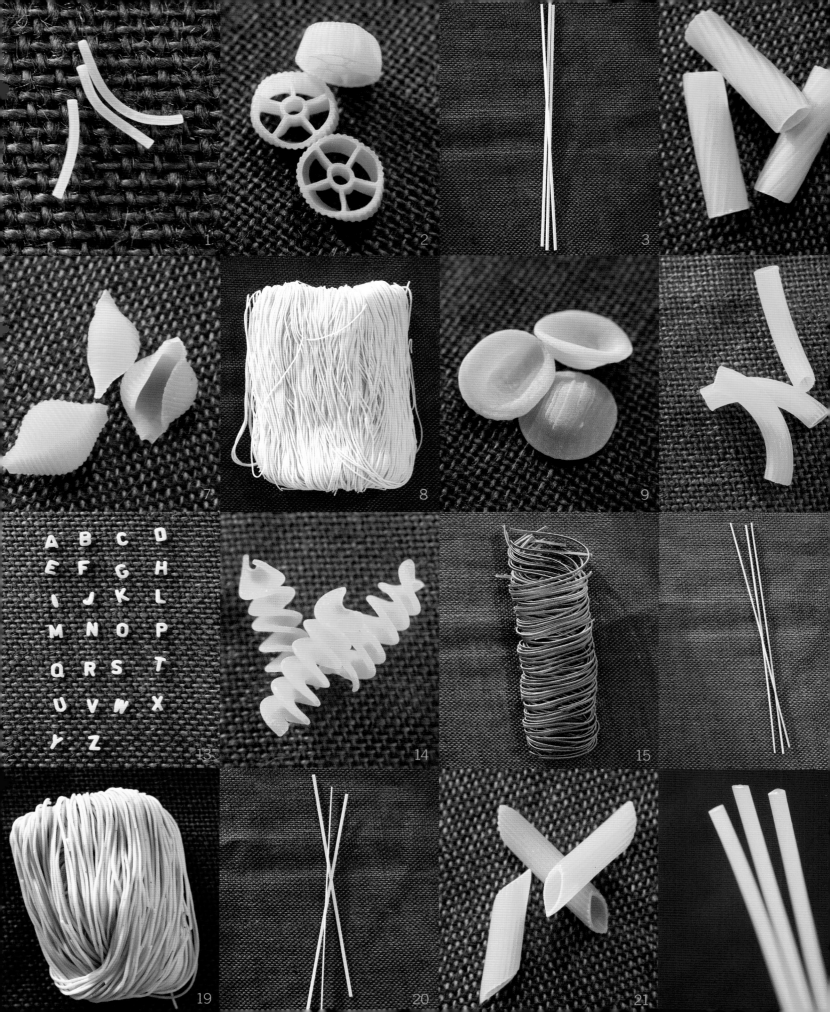

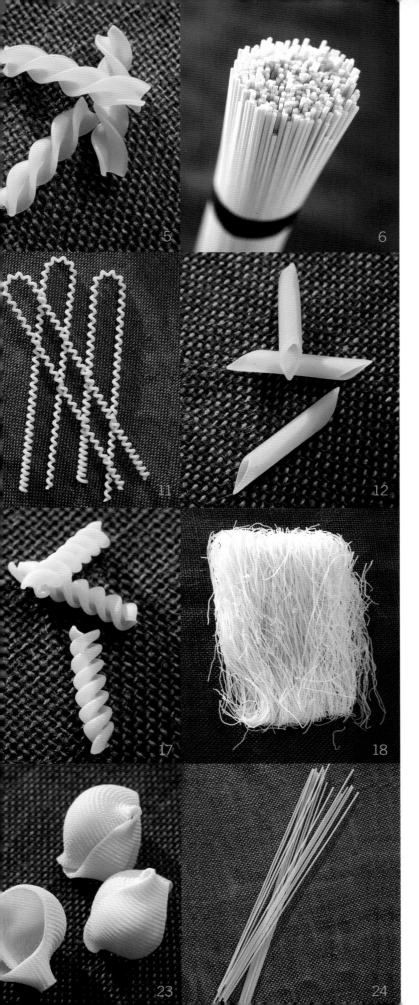

Pasta varieties

1 Soup noodles
2 Rotelle
3 Japanese wheat noodles
4 Tortiglionni
5 Fusilli
6 Tomoshiraga somen
7 Conchiglie rigate
8 Thin dried noodles
9 Orecchiette
10 Tubetti rigate
11 Fusilli bucati lunghi
12 Macaroni
13 Alphabet noodles
14 Helices
15 Tagliolini
16 Japanese buckwheat noodles
17 Spirals
18 Rice vermicelli
19 Shrimp noodles
20 Oriental style
21 Penne rigate
22 Bavette
23 Lumaconi
24 Spaghetti

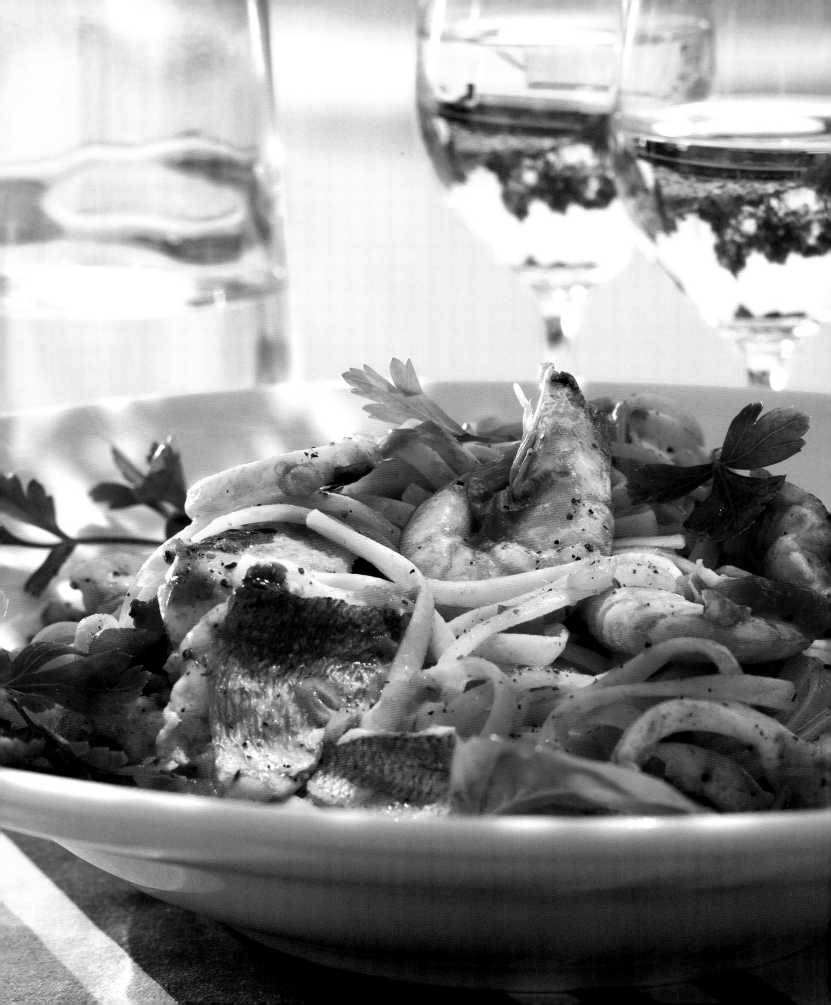

Bavette livornese
Italy

2 gilt-headed bream fillets

2 red mullet fillets

2 sea wolf fillets

300 g / 10 ½ oz shrimps, heads on

2 garlic cloves, crushed in their skins

Freshly ground black pepper

1 handful of parsley leaves

6 tbsp of extra virgin olive oil

Juice of ½ lemon

2 large ladles of tomato sauce (see recipe on page 10)

500 g / 18 oz bavette

Basil leaves, finely cut

Salt

The shrimps and fish pieces acquire some of the aroma of the herbs, garlic and lemon from the marinade.

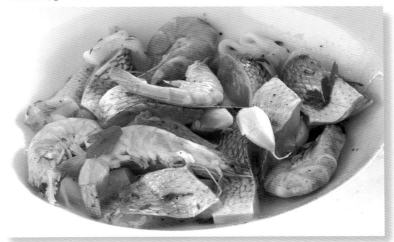

Scale the bream, red mullet and sea wolves and remove the bones. Cut into 3-cm-long pieces. Combine with the shrimps, garlic cloves, pepper, parsley leaves and 3 tablespoons of olive oil, and marinate in the lemon juice for an hour.
Heat the remainder of the olive oil in a non-stick pan, salt the marinated fish and fry quickly at high heat. Add the tomato sauce and bring to the boil.
Meanwhile, cook the bavette until al dente in plenty of salted water, then add to the pan and stir carefully. Sprinkle some chopped basil leaves and stir carefully until the bavette is well combined with the tomato sauce.
Finally, garnish with a few basil leaves.

Tip
Find your own favourite combination of fish and seafood for this pasta dish.
Anything goes: from shrimps to calamaretti, octopus, scallops to sardines – it just has to taste good!

✳✳ 45

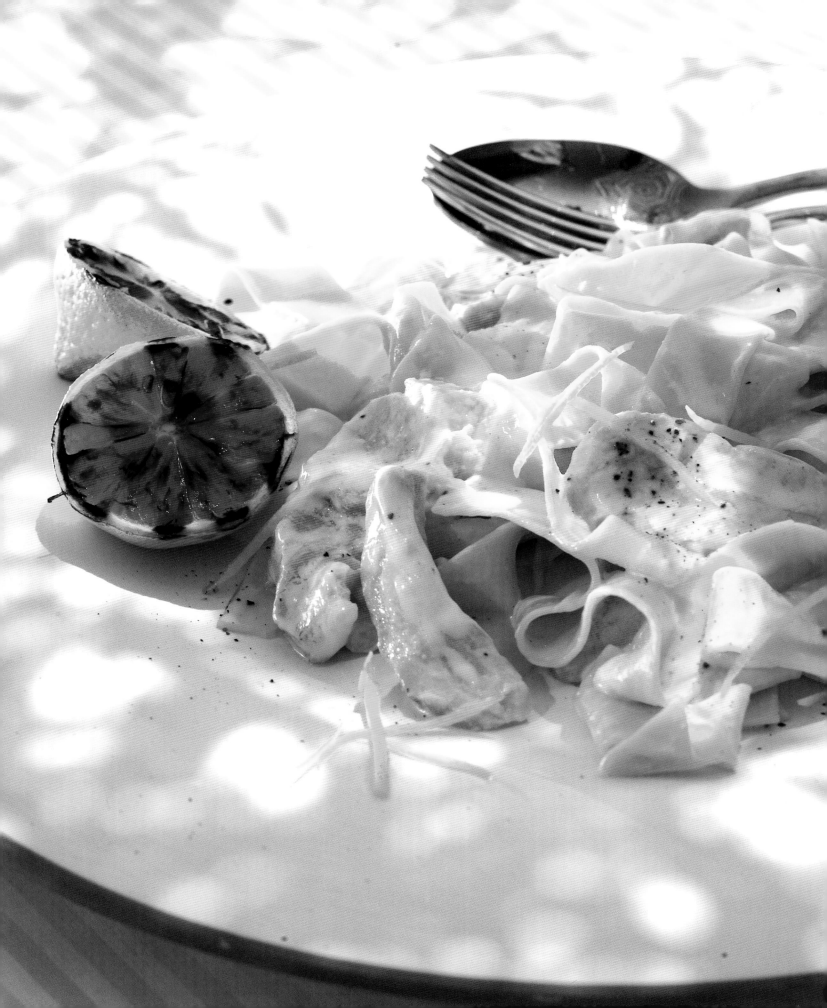

Tagliatelle with salmon in lemon sauce
France

350 g / 12 ½ oz salmon fillet, skinned

Juice of 2 lemons

Zest of 1 lemon, boiled and cut in strips

2 tbsp of extra virgin olive oil

Salt
Freshly ground black pepper

300 ml / 9 ½ fl oz / 1 ¼ cups white wine sauce (see recipe on the right)

500 g / 18 oz fresh tagliatelle (see recipe on page 153) or you can use 400 g / 14 oz of dry tagliatelle instead

Cut the salmon into thin slices and marinate in a little lemon juice, some of the lemon peel strips and 1 tablespoon of olive oil.
Heat the white wine sauce and add the remainder of the lemon juice, salt and lemon peel to taste. Cook the fresh tagliatelle in salted water for 2 minutes; if you are using dry tagliatelle, follow the instructions on the packet.
Add the salmon to the lemon and white wine sauce. Add the cooked and drained tagliatelle and combine carefully to prevent the salmon from breaking up. Arrange on plates and serve with half a grilled lemon.

White wine sauce

1 shallot, peeled

2 small mushrooms

1 tsp butter

100 ml / 3 ¼ fl oz / ½ cup white wine
4 cl / 12 ¾ fl oz / 1 ½ cups Noilly Prat

250 ml / 8 fl oz / 1 cup fish stock

125 g / 4 ¼ oz cream

100 g / 3 ½ oz crème fraîche

Salt
Cayenne pepper

Lemon juice

Cut the shallots and mushrooms in thin slices and fry in butter. Add the white wine and Noilly Prat and let it reduce until almost completely gone. Pour in the fish stock, then let it reduce and thicken until the sauce has a syrupy consistency to concentrate the flavours.
Add the cream and crème fraîche and bring to the boil, then add salt, cayenne pepper and lemon juice to taste. Combine the sauce with a stick blender and pass through a fine sieve.

If you use a potato peeler, you will find it much easier to peel the lemons.

It is best to cut the lemon peel very thinly and blanch briefly before sprinkling over the pasta.

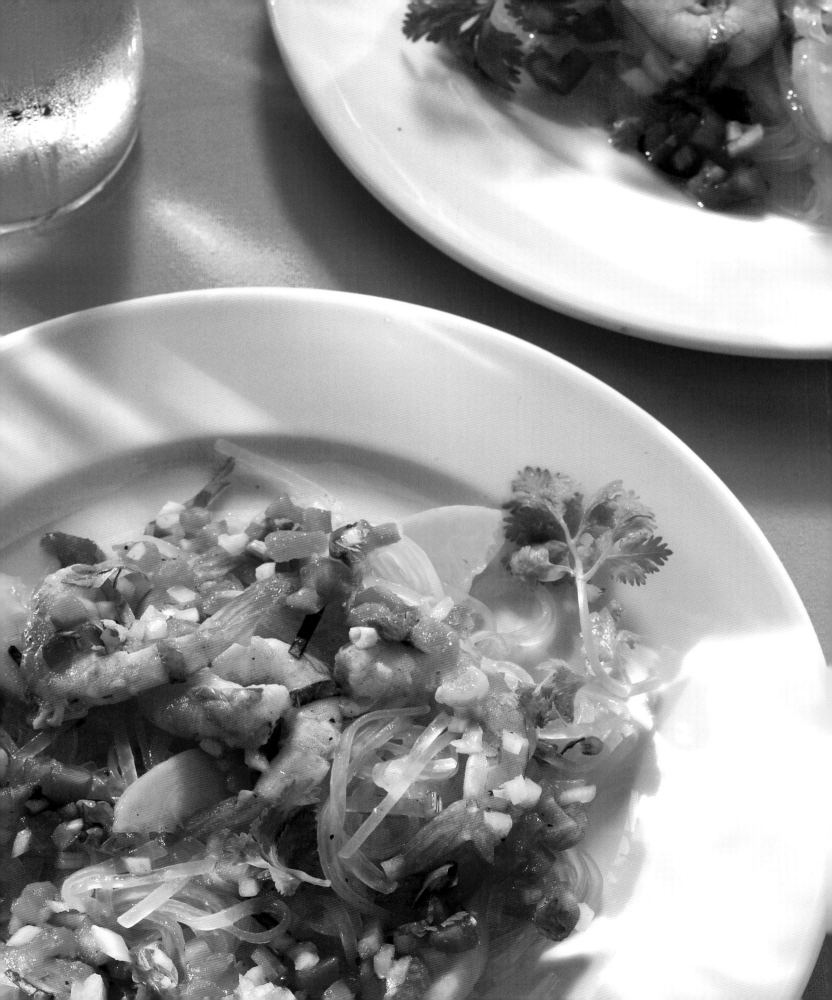

Transparent noodle salad with tomato chutney, peach and shrimps

Thailand

400 g / 14 oz transparent noodles

2 tomatoes, peeled and seeds remove

1 white onion, chopped

Juice of 2 limes

4 tbsp of extra virgin olive oil

Salt
Freshly ground black pepper

2 ripe peaches

200 g / 7 oz cooked shrimps, peeled

1 bunch of coriander
½ bunch of chives

Put the transparent noodles in boiling water for a short while and then immediately plunge into cold water.
Set aside in a big bowl for later use.
Chop the tomatoes into small pieces and marinate in the onions, lime, olive oil, salt and black pepper.
Score a cross in the peach skin with a sharp knife and plunge into boiling water for a few seconds to remove the skin.
When the skin begins to detach, plunge immediately into ice cold water to prevent the peach from cooking further.
Remove the skin, halve the peach and cut into small strips.
Add to the transparent noodles with the shrimps and the cold tomato chutney.

Finely chop the chives and the coriander and add to the salad.
Marinate for half an hour in the fridge and then arrange on plates, adding some coriander leaves as garnish.

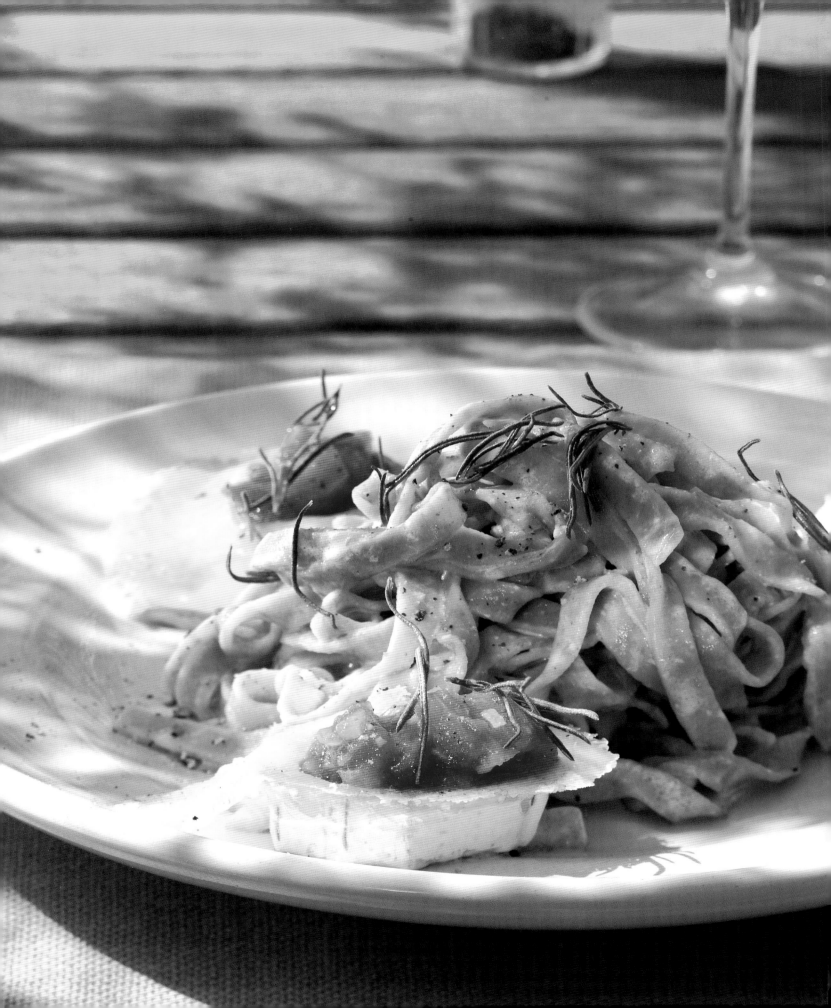

Mushroom tagliatelle with fried goat's cheese and rosemary butter

France

4 tomatoes, peeled and seeds removed, and chopped in small pieces

4 tbsp of extra virgin olive oil

2 pieces of mature goat's cheese rolls, 125 g / 4 ¼ oz each (St Maure)

150 g / 5 oz crème fraîche

1 tbsp rosemary leaves

600 g / 21 oz freshly cut soup mushroom tagliatelle (see recipe on page 158)

Salt
Freshly ground black pepper

Season the tomatoes with salt, black pepper and some oil and set aside.
Cut the goat's cheese into about 12 2-cm thick slices and set the remainder aside for later use. Fry the slices in a non-stick pan on one side until the cheese forms a crust and turns golden yellow. Meanwhile, cook the tagliatelle in plenty of salted water until al dente, then add to a pan with the crème fraîche and the remainder of the goat's cheese, cut into small pieces. Season generously with black pepper. Arrange the tagliatelle on four plates.
Carefully arrange three slices of fried goat's cheese, crusty side up, around each portion of tagliatelle.

Place the marinated tomato pieces on top and garnish with crisp-fried rosemary leaves.

Tip
Ideally, the goat's cheese should be half dry and have no ash. If the cheese is too mature, it may well melt completely in the pan.

Fusilli bucati lunghi with fried quail and fairy ring mushrooms

Italy

Marinate the quail breasts and legs for an hour in herbs, mushrooms and spices.

4 quail, legs and breasts removed

200 g / 7 oz fairy ring mushrooms (you can use chanterelles or St George's mushrooms instead)

3 cloves, finely ground
1 tsp fresh marjoram leaves
1 bayleaf

6 tbsp maize oil

2 tbsp butter

1 large ladle of tomato sauce (see recipe on page 10)

500 g / 18 oz fusilli bucati lunghi

Salt
Freshly ground black pepper
Parmesan as garnish

Place the quail breasts and legs on a dish.
Marinate for half an hour in a few fairy ring mushrooms, some pepper, cloves, marjoram leaves, the bayleaf and 2 tbsp oil.
Heat 4 tablespoons of oil in a pan, place the salted quail pieces skin side down on the bottom, and fry gently on one side for 8 to 10 minutes. Keep spooning the fat over the quail.
Remove the quail pieces, put on a plate and keep warm. Melt some butter in the same pan until frothy, then add the prepared mushrooms and season with salt and pepper.
Pour over the tomato sauce.

Meanwhile, cook the pasta until al dente in accordance with the packet instructions and add to the pan.
Combine well and arrange on plates. Place two breasts and two legs on each plate.
Garnish with shaved Parmesan before serving.

Tip
The fairy ring is a very common mushroom, and it is one of the first to appear in spring. Its flavour is spicy. Whether fresh or dried it has a very intensive oak and clove aroma, and tastes best fried in butter.

**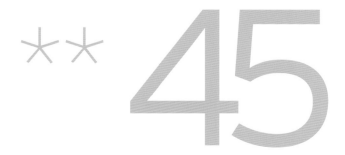

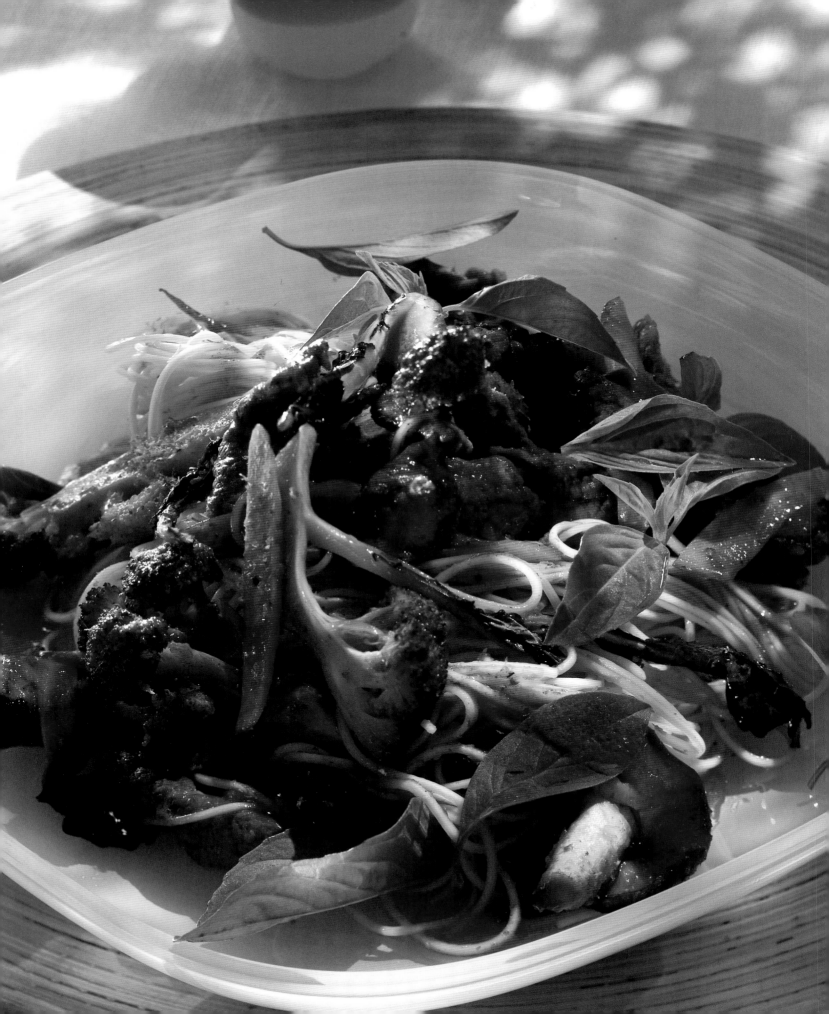

Chinese egg noodles with beef strips and fried shitake mushrooms

China

250 g / 9 oz Chinese egg noodles

500 g / 18 oz beef loin, cut into thin strips

Light soy sauce

4 tbsp hoisin sauce

2 medium-sized carrots, peeled

150 g / 5 oz shitake mushrooms

300 g / 10 ½ oz prepared broccoli florets

6 tbsp peanut oil

1 tsp sambal oelek

½ bunch of Thai basil

1 tbsp shrimp chilli flakes

Not to everyone's taste, but you can add more if required.

Cook the egg noodles according to the packet instructions. Drain in a sieve and rinse under running cold water. Drain well.

Marinate the beef strips in soy sauce and a few shakes of hoisin sauce.

Cut the carrots in strips and halve the shitake mushrooms depending on their size.

Heat 4 tablespoons of oil in a wok and stir-fry the vegetables one after the other, starting with the broccoli and carrots and finishing with the mushrooms.

Clean the wok with a dry cloth and heat the remainder of the oil.

Briefly fry the marinated beef at high heat and then add the cooked noodles and fried vegetables. The vegetables should be firm and crisp.

Season with hoisin sauce and sambal oelek, sprinkle some Thai basil leaves and chilli shrimp flakes on top and serve immediately.

Farfalle with smoked salmon, fresh peas and mint pesto

Italy

500 g / 18 oz peas

30 g / 1 oz butter

4 cl / 12 ¾ fl oz / 1 ½ cups Noilly Prat

125 g / 4 ½ oz cream
100 g / 3 ½ oz crème fraîche

Salt
Freshly grated nutmeg

Lemon juice

500 g / 18 oz farfalle

1 bunch of mint
½ bunch of parsley

2 tbsp ground almonds

1 tbsp grated Parmesan

8 tbsp of extra virgin olive oil

200 g / 7 oz thinly sliced smoked salmon, cut in 2 cm wide strips

Heat the peas in butter, season with salt and nutmeg and pour over the Noilly Prat. Add the cream and crème fraîche, then season with lemon juice and salt to taste. Cook the farfalle in salted water until al dente following the packet instructions.
Place the mint, parsley leaves, ground almonds and Parmesan in a blender.
Season with salt and pepper, then purée with olive oil until creamy. Chill immediately to prevent colour loss.
Add the farfalle to the sauce and stir thoroughly.
Add the smoked salmon at the last moment and arrange on plates. Finally, top each plate with a teaspoon of mint pesto, garnish with a few mint leaves and serve immediately.

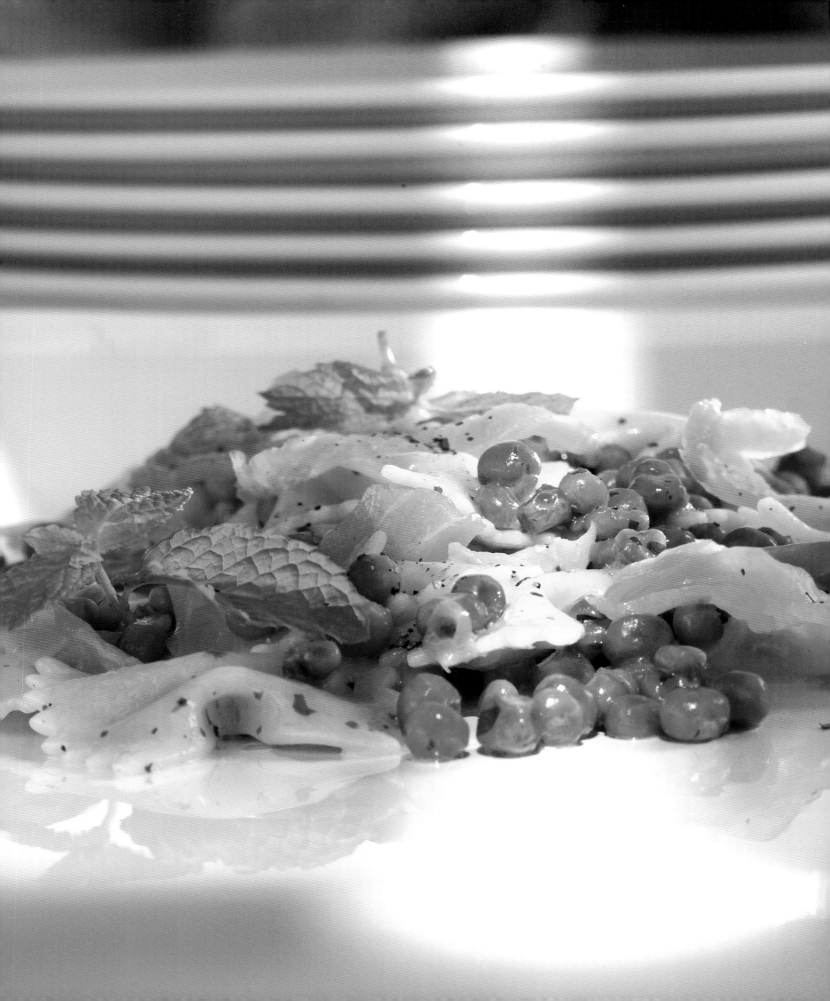

Rice noodles with broccoli and curried scrambled eggs
Thailand

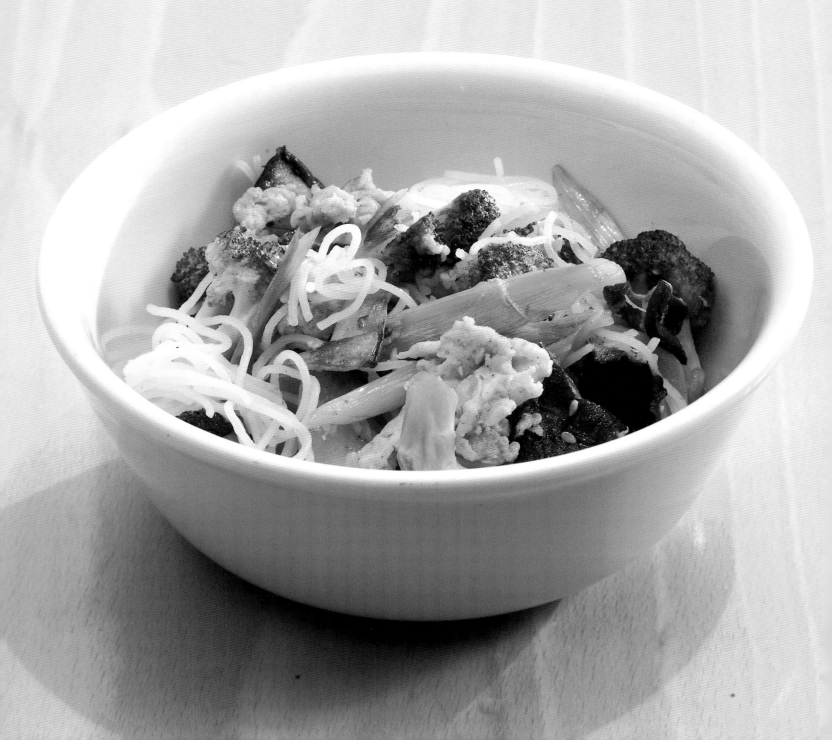

250 g / 9 oz transparent noodles

1 head of broccoli (around 500 g / 18 oz)

150 g / 5 oz shitake mushrooms

1 bunch of young leeks

1 garlic clove, sliced

1 tsp freshly grated ginger

6 tbsp peanut oil

3 eggs

½ tsp curry powder

2 tbsp soy sauce

½ bunch of coriander

Cook the transparent noodles in salted water, drain and rinse under running cold water.
Cut through a few times with kitchen scissors as the noodles are quite long, then set aside.
Trim the broccoli, peel the stalk, then halve it and cut it into strips.
Trim the shitake mushrooms and cut in half.
Cut the leek into 3-cm long pieces.
Heat 2 tbsp oil in a wok and fry the broccoli stalk for 2 minutes at high heat, then remove.
Repeat with the broccoli florets.
Fry the shitake, add the garlic, then the spring onions and return the broccoli to the wok.
Season with curry powder and freshly ground ginger.
Push the fried vegetables to the side of the wok.
Whisk the eggs with the soy sauce, curry, ginger and coriander and pour in the middle of the hot wok.
Leave the eggs to set for a few moments, then stir occasionally.
Finally add the transparent noodles, combine well and leave to cook for a little while longer.
Arrange in small bowls and serve.

Don't throw anything away – young leeks, fine mushrooms and the broccoli stalk.

The right aromas for rice noodles are curry powder and soy sauce.

** 40

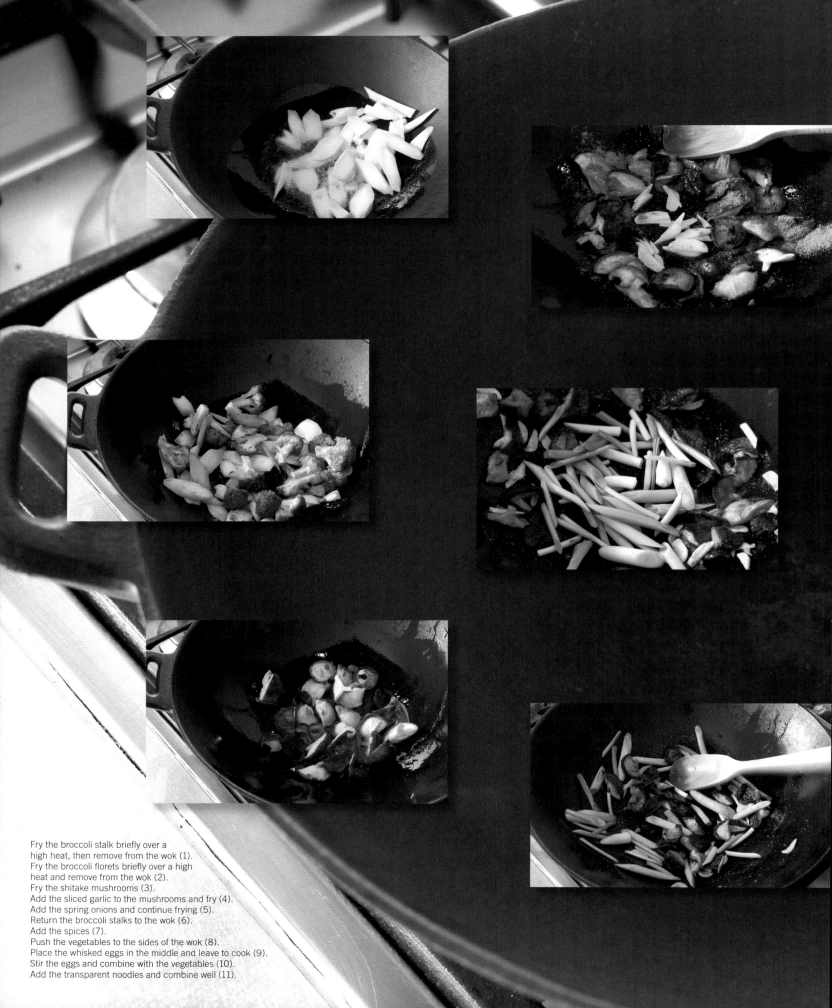

Fry the broccoli stalk briefly over a
high heat, then remove from the wok (1).
Fry the broccoli florets briefly over a high
heat and remove from the wok (2).
Fry the shitake mushrooms (3).
Add the sliced garlic to the mushrooms and fry (4).
Add the spring onions and continue frying (5).
Return the broccoli stalks to the wok (6).
Add the spices (7).
Push the vegetables to the sides of the wok (8).
Place the whisked eggs in the middle and leave to cook (9).
Stir the eggs and combine with the vegetables (10).
Add the transparent noodles and combine well (11).

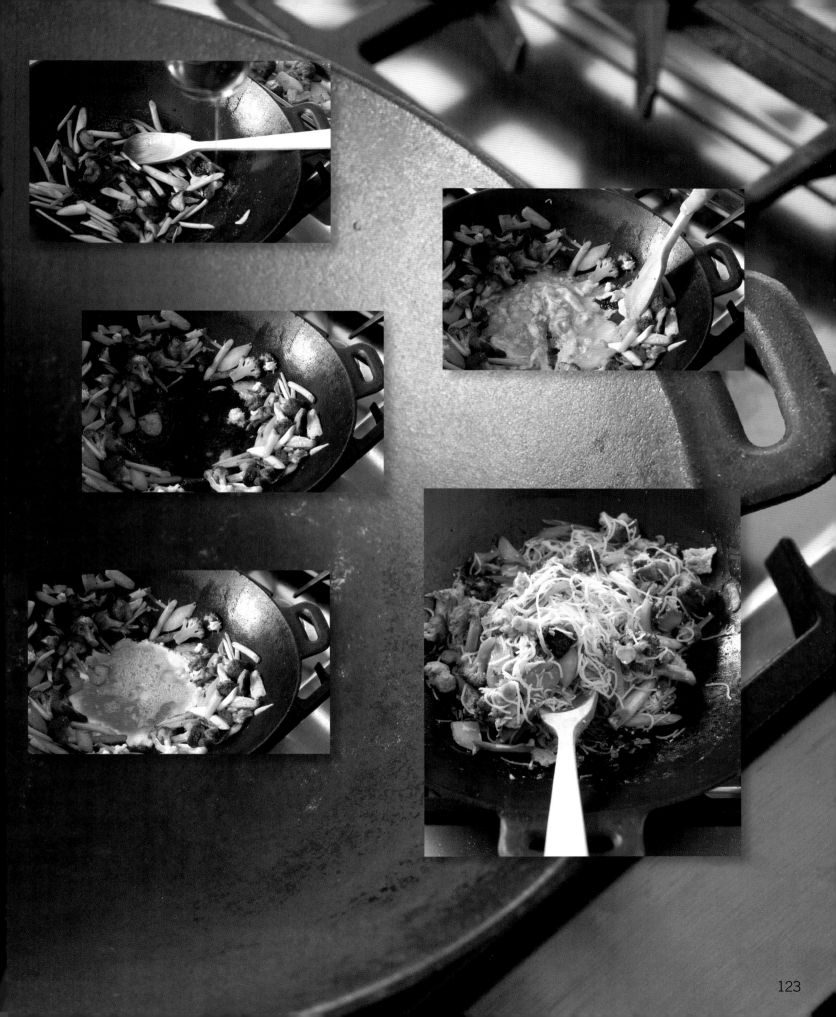

Caserecci with shrimps, cucumber and lemon

Italy

1 cucumber, peeled

1 garlic clove, finely chopped

1 dried peperoncino, finely chopped

4 tbsp olive oil

Salt

20 shrimps, without heads and shells

2 tbsp butter

500 g / 18 oz caserecci

1 bunch of parsley leaves, finely chopped

2 lemons, cut in wedges

Cut the cucumber in half lengthwise, then cut in pieces 4 cm long and 1 cm wide. Fry the garlic and peperoncino in olive oil. Add the cucumber and cook for a further 4 minutes. Add the butter and shrimps and simmer gently. Cook the caserecci in plenty of salted water for 8 minutes or until al dente. Drain in a sieve and add to the shrimps. Sprinkle the parsley over the pasta and arrange on a plate. Garnish with the lemon wedges, which you can also squeeze over the shrimps.

** 35

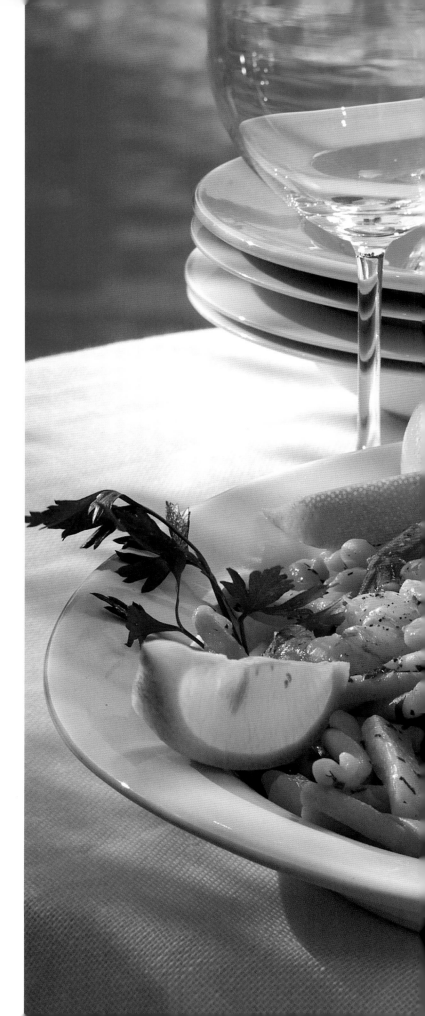

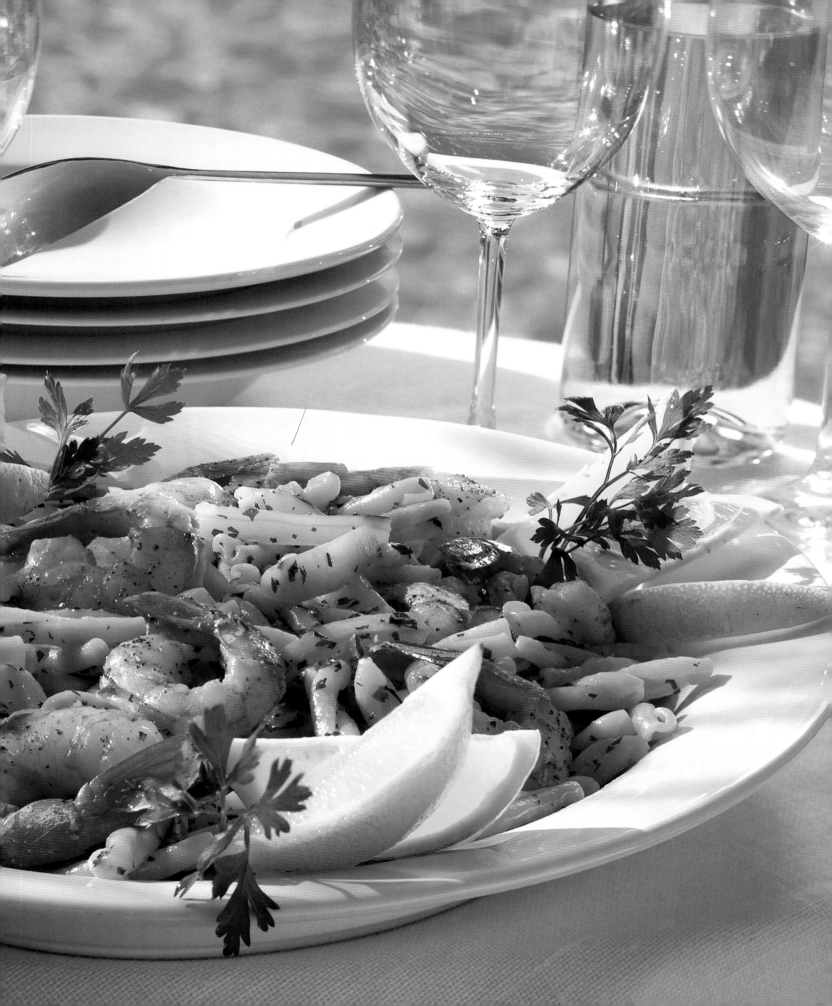

Tortellini al brodo
with celery

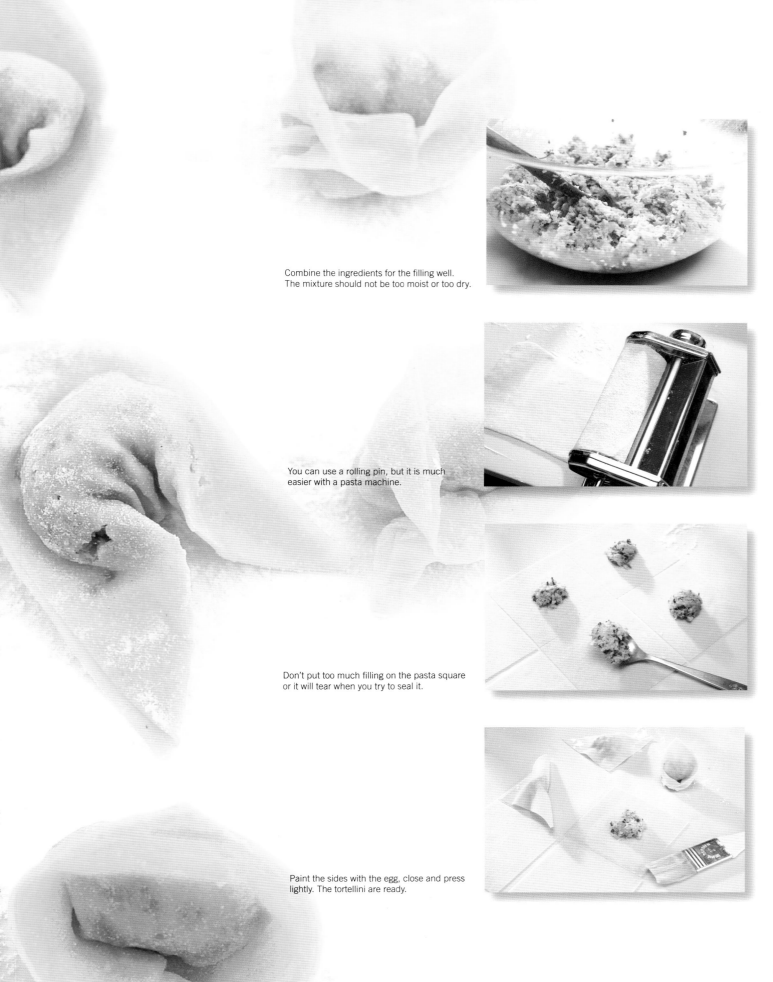

Combine the ingredients for the filling well. The mixture should not be too moist or too dry.

You can use a rolling pin, but it is much easier with a pasta machine.

Don't put too much filling on the pasta square or it will tear when you try to seal it.

Paint the sides with the egg, close and press lightly. The tortellini are ready.

Tortellini al brodo
with celery
Italy

Prepare a chicken stock following the recipe for the pasta soup with parsley and lovage (pages 6 and 90).

2 egg yolks

1 bunch of parsley

Salt
Freshly grated nutmeg
Freshly ground black pepper

500 g / 18 oz ravioli dough (see recipe on page 162)

1 egg
Light green stalks from the heart of the celery
Parsley stems

To make the filling, remove all the chicken flesh from the bones (without the skin) and cut into small pieces while still warm. Chop some cooked vegetables such as carrot, fennel and leek. Combine the ingredients with the egg whites while still warm. Season with finely chopped parsley, salt, black pepper and nutmeg and set aside until later.
Roll the ravioli dough out thinly on the pasta machine. It is important to pass the dough through the machine several times. Sprinkle some flour on each sheet, then fold and roll through the machine again so the dough has the right texture. Cut into squares measuring 10 to 12 cm and, using a teaspoon, place small amounts of filling on each square.

Whisk the egg with a tablespoon of water. Brush thinly on the pasta sides with a pastry brush.
Fold over diagonally and press firmly on the sides to make a triangle.
Place the triangle in front of you with right angle pointing upwards. Use your index finger and thumb to press the two sides together. Cook the ravioli in simmering chicken stock for 2 to 3 minutes.
Arrange in soup bowls and sprinkle with celery leaves, finely chopped parsley and black pepper.

Tip
In Italy you would add Parmesan and a few drops of olive oil – extra virgin, of course – at the table.

**120

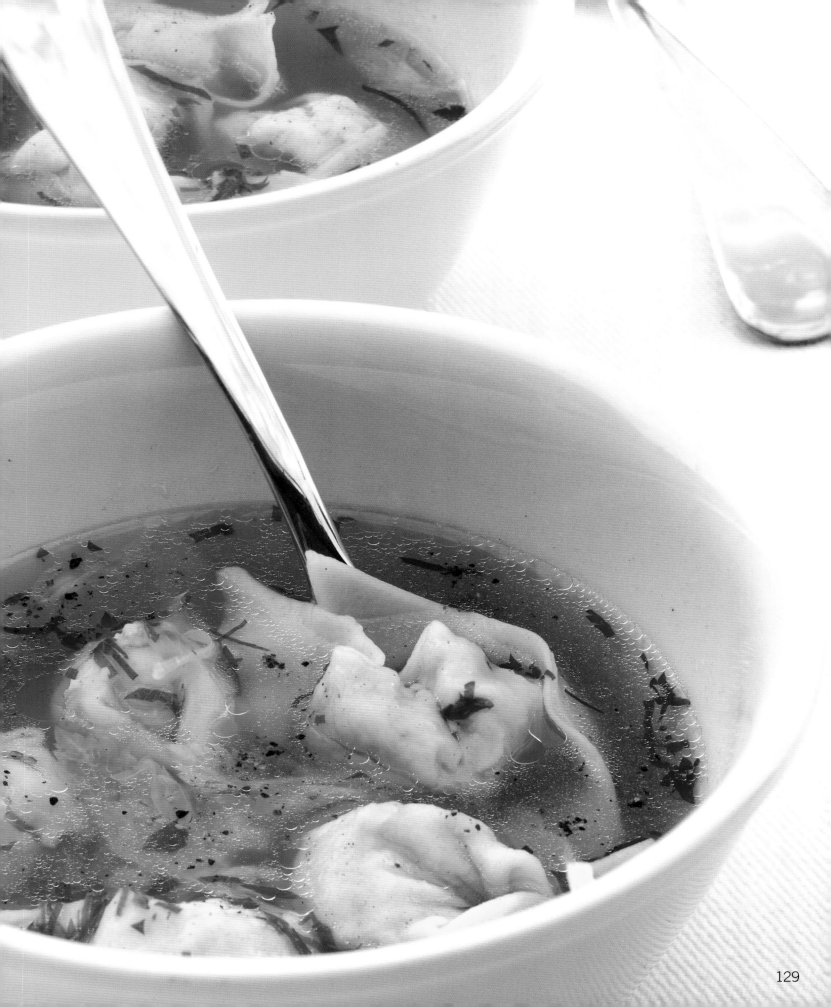

Green pappardelle with small chanterelles and salmon

Italy / France

250 g / 9 oz salmon fillet without the skin

Lemon juice

250 g / 9 oz chanterelles, trimmed

30 g / 1 oz butter

150 g / 5 oz cream
50 g / 1 ¾ oz crème fraîche

600 g / 21 oz green pappardelle (see recipe on page 157)

½ bunch of parsley leaves, chopped

Salt
Freshly ground black pepper
Freshly grated nutmeg

Cut the salmon fillet into strips 1 cm thick and 5 cm long, then marinate in lemon juice. Fry the chanterelles in butter. Season to taste with salt, pepper and nutmeg, then pour over the cream and crème fraîche. Bring to the boil and add the pappardelle, cooked previously in plenty of salted water for 2 minutes, and the marinated salmon strips and mix well.
Sprinkle some chopped up parsley over top and season with pepper and nutmeg.

Tip
This dish can be prepared also with tagliatelle or tagliolini. For a simpler version, slice two spring onions and fry with plum tomatoes instead of the cream sauce. It tastes just as good with the chanterelles.
If you have any ceps handy, the salmon will be equally happy!

Don't wash the chanterelles, just remove any sand and soil with a fine brush, then trim with a knife.

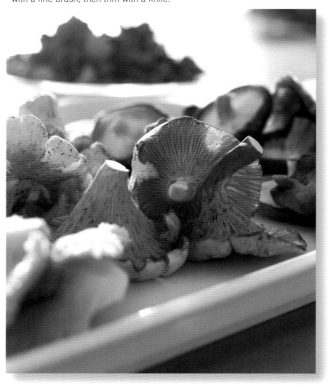

✳✳ 40

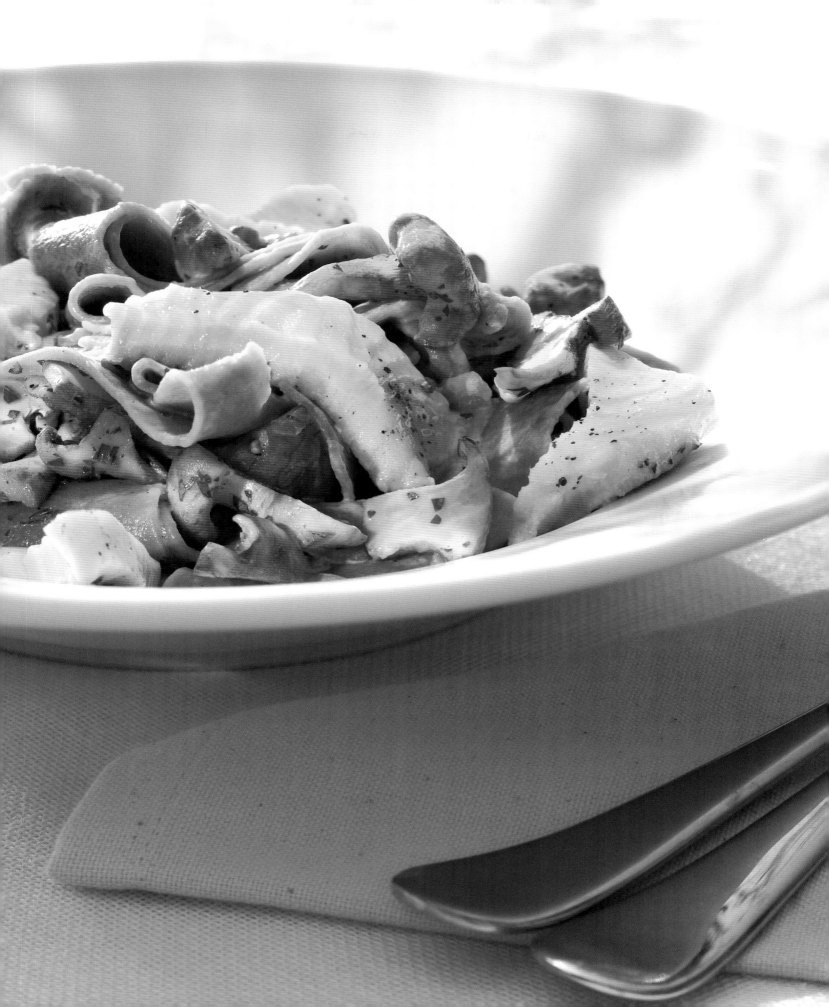

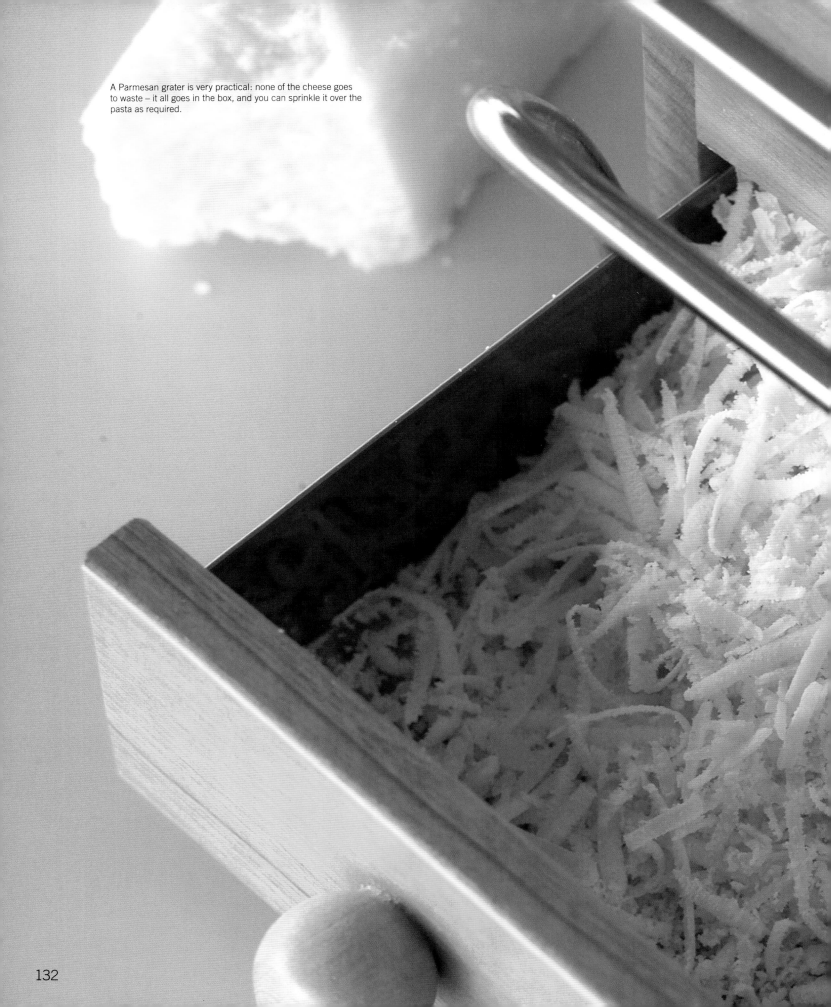

A Parmesan grater is very practical: none of the cheese goes to waste – it all goes in the box, and you can sprinkle it over the pasta as required.

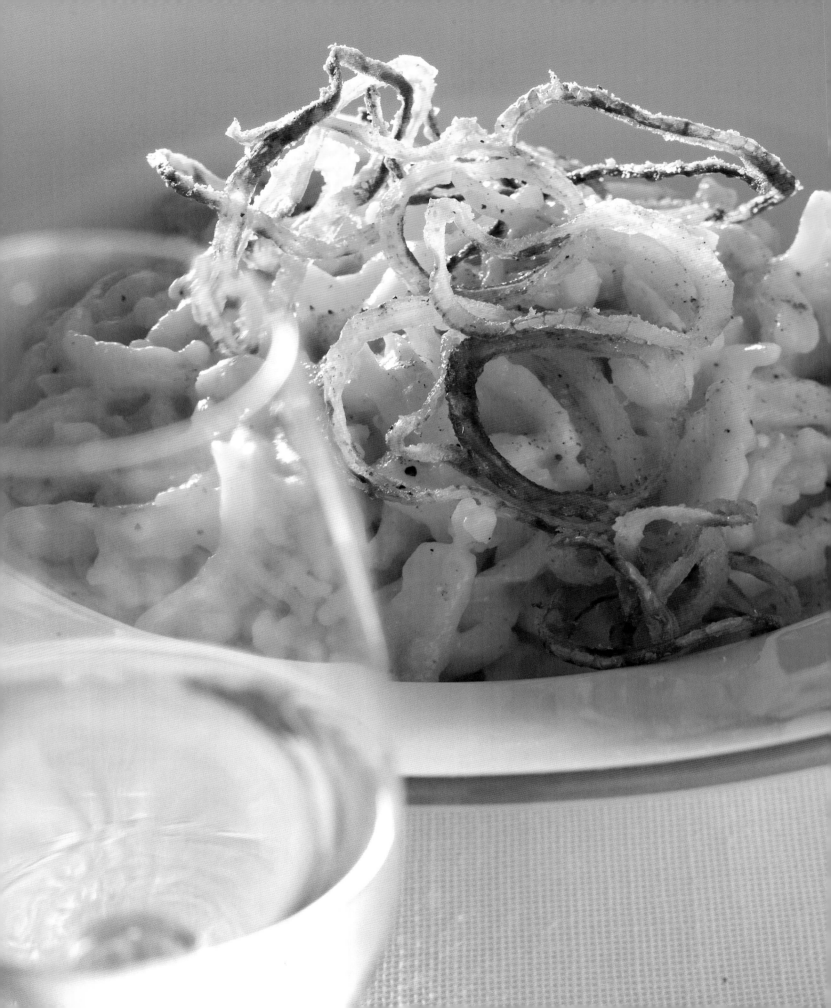

Cheese spätzle with fried onions

Southern Germany

7 eggs

350 g / 12 ½ oz flour

Salt
Freshly ground white pepper
Freshly grated nutmeg

200 g / 7 oz onions, cut across in strips

80 g / 3 oz butter

200 g / 7 oz Emmental cheese from Allgäu

2 white onions, sliced

1 tbsp flour

1 teaspoon sweet paprika

1 l (32 fl oz / 4 cups) peanut oil for frying

Make a smooth dough from the eggs, flour, 1 tablespoon of water, nutmeg and salt, then set aside to rest for 15 minutes. The dough should blister.
Melt the butter, add the onion slices and fry until they turn a nice golden brown.
Place the spätzle dough on a damp wooden board, allow it to expand over the sides and grate into the boiling salted water.
Allow the water to return to the boil and cook the spätzle briefly. Remove with a spoon as they rise to the surface and place lengthwise in an ovenproof dish with the freshly ground Emmental cheese. Add pepper and a little of the boiling water. Crisp briefly in an oven preheated to 200° C to allow the cheese to melt.
Meanwhile, spread the onion slices over a baking tray and break them up in rings. Sprinkle over flour and paprika and fry in oil at 160° C until golden yellow.

Place on plate lined with kitchen paper and salt lightly. Arrange the spätzle on plates and garnish with the fried onion rings.

Tip
If you want to spend less time cooking, have some dried cut spätzle to hand so that you can enjoy this spicy pleasure in no time.

**40

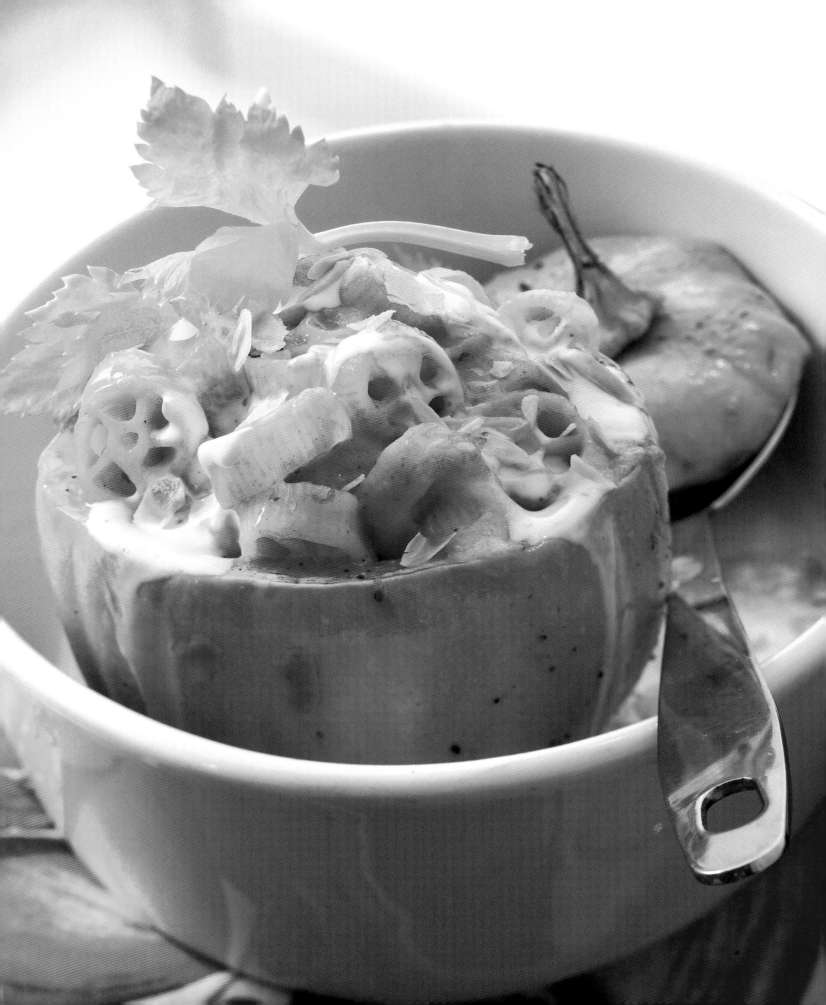

Rotelle in pumpkin sauce baked in a pumpkin

USA

1 Hokkaido pumpkin, about 1.5 kg

1 shallot, finely chopped

½ garlic clove, finely chopped

60 g / 2 oz butter

1 carrot, chopped

1 celery stalk, diced

1 tsp sweet paprika
1 tsp curry powder
1 tsp ginger powder
1 tbsp tomato paste

1 tbsp white wine vinegar

500 ml / 16 fl oz / 2 cups of chicken stock
(see recipe on page 16)

Salt
Freshly ground black pepper
Freshly grated nutmeg

400 g / 14 oz rotelle

100 g / 3 ½ oz cheddar cheese, grated

150 ml / 4 ¾ fl oz / ½ cup crème fraîche

Slice the top off the pumpkin, scoop out the flesh – and you are left with a nice soup bowl.

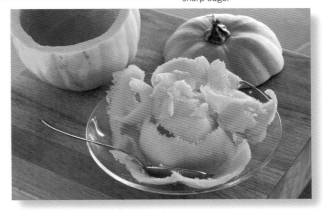

The flesh is easier to scrape out if you use a spoon with a sharp edge.

Remove the top of the pumpkin and level off the bottom so that it will stand. Scoop out the fibrous centre of the pumpkin with a spoon. Scoop out the pumpkin flesh, leaving about 1 cm all around, and cut into 1-cm sized cubes. Fry the shallots and garlic in butter, add the vegetables and fry for a further 5 minutes. Add the pumpkin flesh, salt and pepper. Cook briefly without letting it change colour. Sprinkle with paprika, curry and ginger, then add a little vinegar (to prevent the paprika from becoming bitter if the heat is too high).

Add the tomato paste and cook a little longer. Pour over the chicken stock and simmer for about 20 minutes with the lid on until the pumpkin starts to lose shape. Purée in a blender and season with salt and nutmeg to taste. Meanwhile, cook the rotelle in salted water for half the time written on the packet, then drain and combine with the pumpkin sauce.
Finally, add the grated cheddar cheese and spoon into the hollowed-out pumpkin. Place the pumpkin in an ovenproof dish and bake in a preheated oven at 190° C.
Remove from the oven and serve topped with crème fraîche.

**60

Black tagliatelle with fried lobster in the shell

France

2 live lobsters, 500 g (18 oz) each

2 tbsp of extra virgin olive oil

40 g / 1 ½ oz butter

1 shallot, finely chopped

½ garlic clove, finely chopped

150 ml / 4 ¾ fl oz / ½ cup tomato juice

500 g / 18 oz black dry tagliatelle

30 g / 1 oz cold butter

Salt
Cayenne pepper

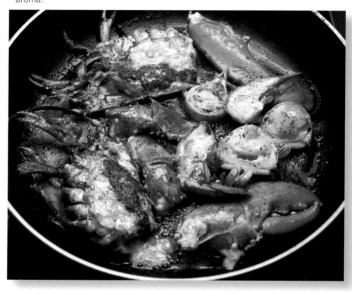

Because the lobster is cooked in its shell, it retains its aroma.

Plunge the lobsters in boiling salted water for 10 seconds, then remove and leave to cool. Remove the lobster tails and cut the head in half lengthwise with a heavy knife. Remove the stomach and intestines.
Cut the tail into medaillons as far as the third joint, and slice the rest lengthwise. Remove the intestines. Hit the lobster claws and joints a few times with the handle of a heavy knife.
Heat oil in a large pan, add the lobster pieces cut side down and fry gently for around 5 minutes. Season with salt and cayenne pepper. Add the lobster claws and joints. Add some butter and cook for a further 5 minutes at low heat, basting frequently. Remove the lobster pieces, put on a plate and keep warm. Fry the shallots and garlic in the oil and juices from the pan and then pour in the tomato juice and reduce slightly.
Fry the black tagliatelle – which you have cooked in accordance with the packet instructions – in some butter and arrange on a large dish. Place the lobster pieces over and around the pasta and pour over the sauce to finish.

Tip
You can use crayfish or langostinos instead of the lobster.
If you don't like black pasta, try it with plain spaghetti or green tagliatelle.

** 45

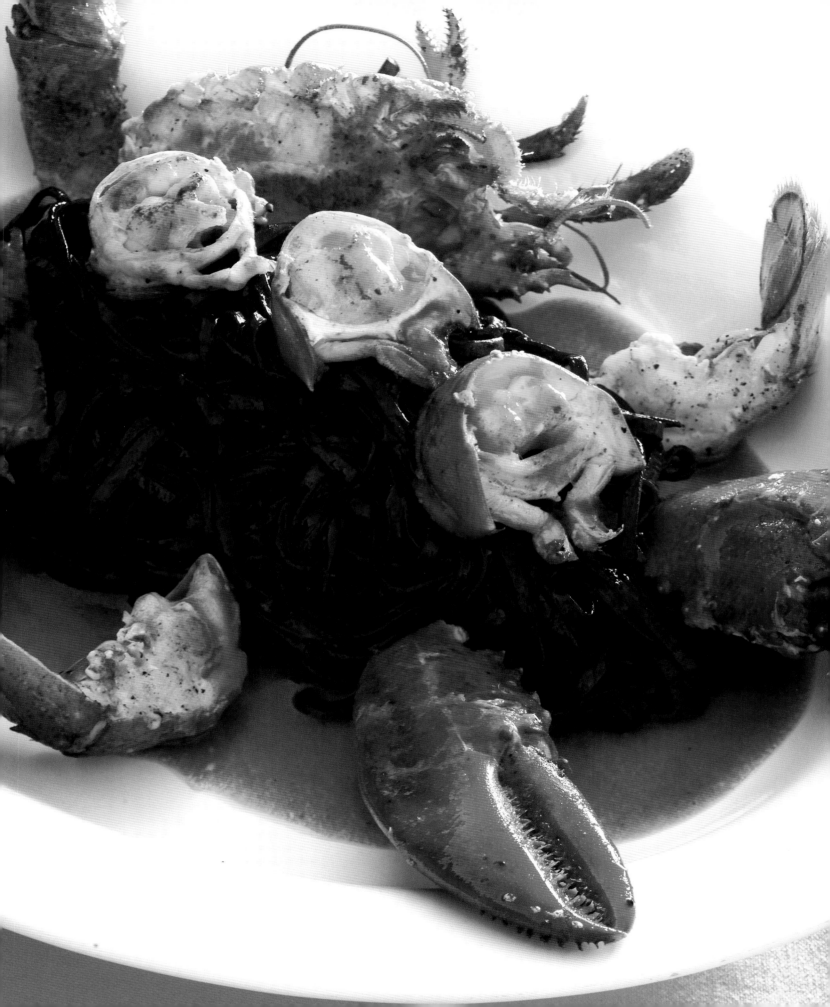

Fiorelli with anchovy and fennel sauce and grilled sardines

Sardinia

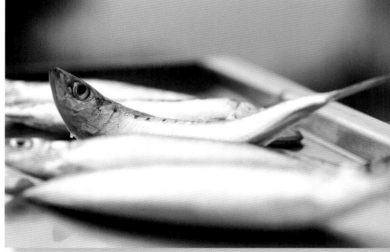

2 bunches of fennel

2 garlic cloves, finely chopped

10 anchovy fillets

½ tsp fennel seeds, chopped

4 tbsp of extra virgin olive oil

100 ml / 3 ¼ fl oz / ½ cup white wine

500 g / 18 oz fiorelli

12 fresh sardines, washed, spine removed

2 tbsp roast pine nuts

½ bunch of basil

Salt
Freshly ground black pepper

2 tbsp pesto (see recipe on page 92)

To make the sauce, cut the fennel lengthwise into thin strips and fry in olive oil.
Add the chopped garlic, anchovy fillets and fennel seeds, fry briefly and then pour in the white wine. Add the fiorelli – which you have cooked in the meantime – to the sauce and mix well.
Dry the sardine fillets with kitchen paper, season with salt and pepper and fry for 3 minutes on each side.

Arrange the fiorelli on plates, add the grilled sardines and sprinkle with roast pine nuts and fresh basil leaves. Add pesto to the sardines.

** 40

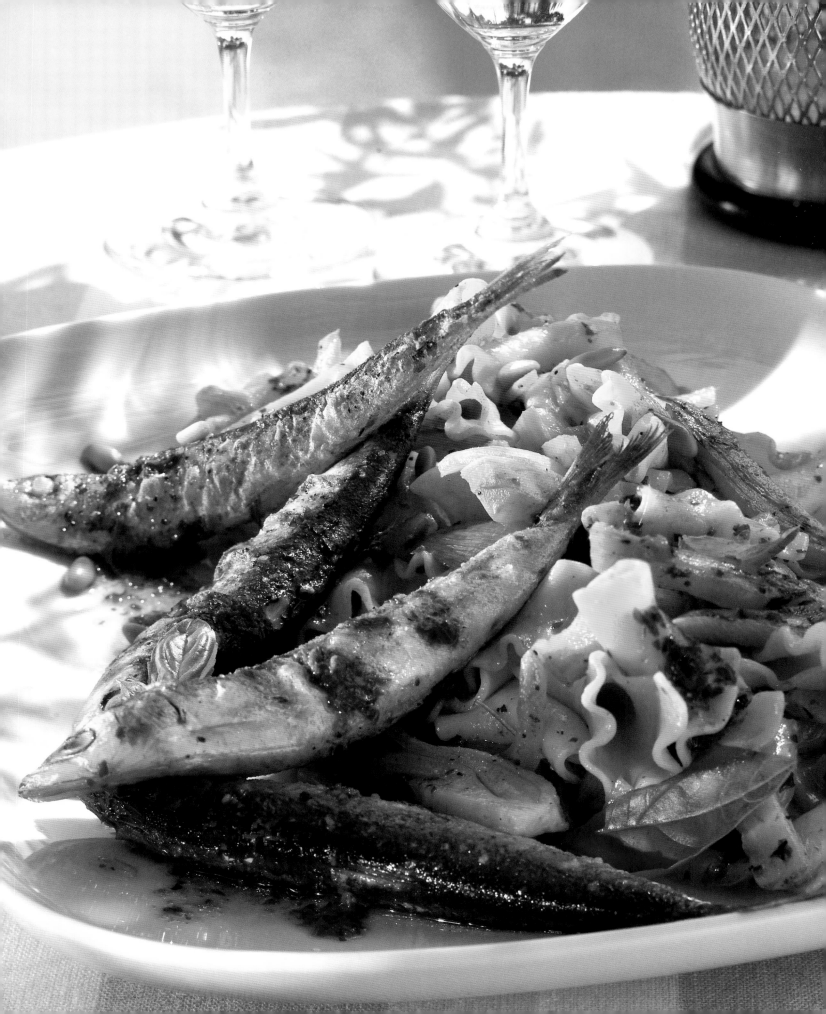

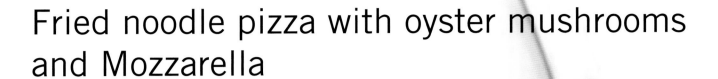

Fried noodle pizza with oyster mushrooms and Mozzarella

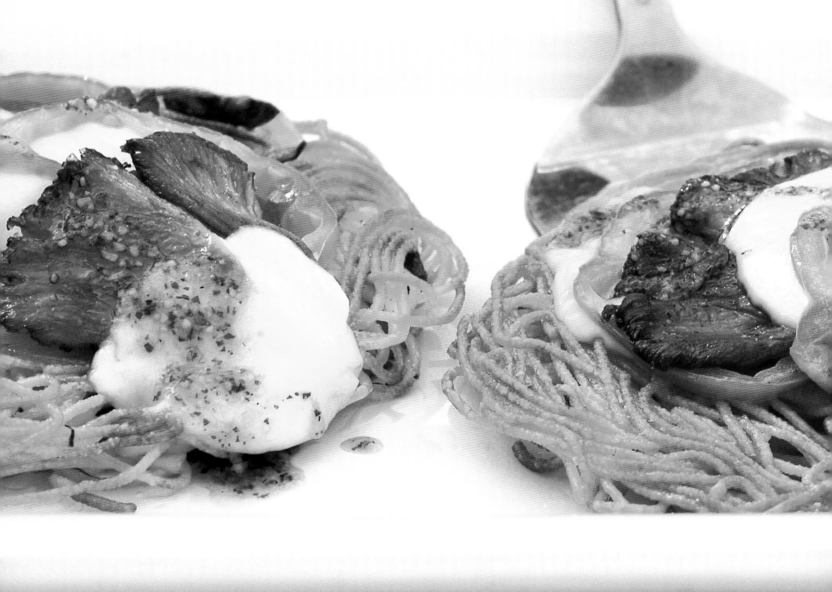

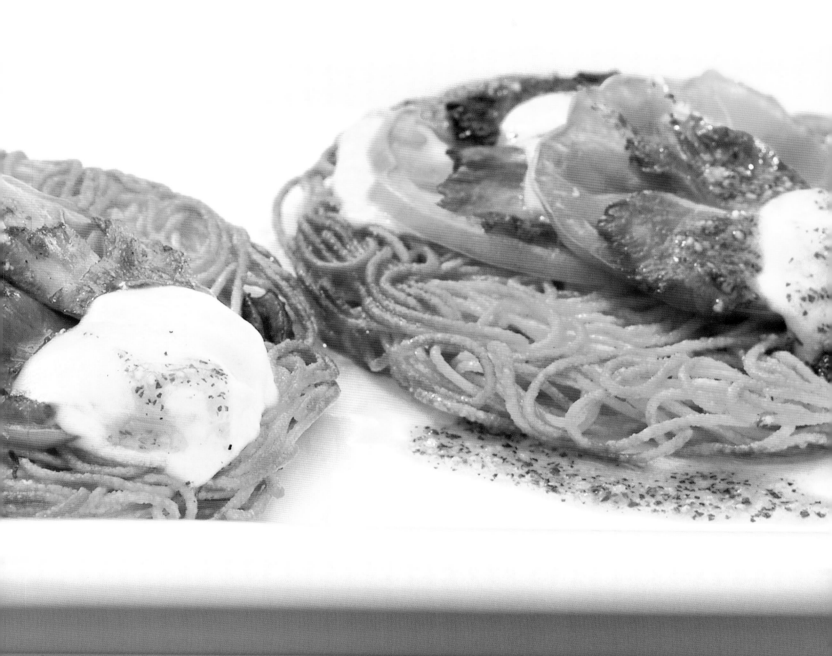

Fried noodle pizza with oyster mushrooms and Mozzarella

Italy

400 g / 14 oz spaghetti cooked the day before

30 g / 1 oz black olives, stones removed

100 g / 3 ½ oz oyster mushrooms

2 ripe tomatoes, if possible Montserrat

1 piece of Mozzarella

50 g / 1 ¾ oz butter

50 ml / 1 ½ fl oz / ¼ cups olive oil

Salt
Freshly ground white pepper

2 tbsp pesto (see recipe on page 92)

You can also make noodle pizzas with bucatini or linguine.

Combine the cooked spaghetti with the roughly chopped black olives and season to taste with salt and pepper. Heat some butter and oil in non-stick pan of 15 cm diameter. Shape the spaghetti into small pizzas and fry on both sides until golden yellow.
Place on a baking sheet and repeat the process until you have four noodle pizzas.
Melt some butter in a non-stick pan and fry, then season with salt and pepper.
Scoop the middle out of the tomato and cut into thin slices.
Stack the Mozzarella slices, tomato slices and mushrooms on top of the pizzas and bake in the oven for 5 minutes or until the Mozzarella has melted.
Arrange on plates and top with pesto.

Tip
If possible, use Spanish Montserrat tomatoes. They taste sweeter and have a more intense flavour than other varieties.

**35

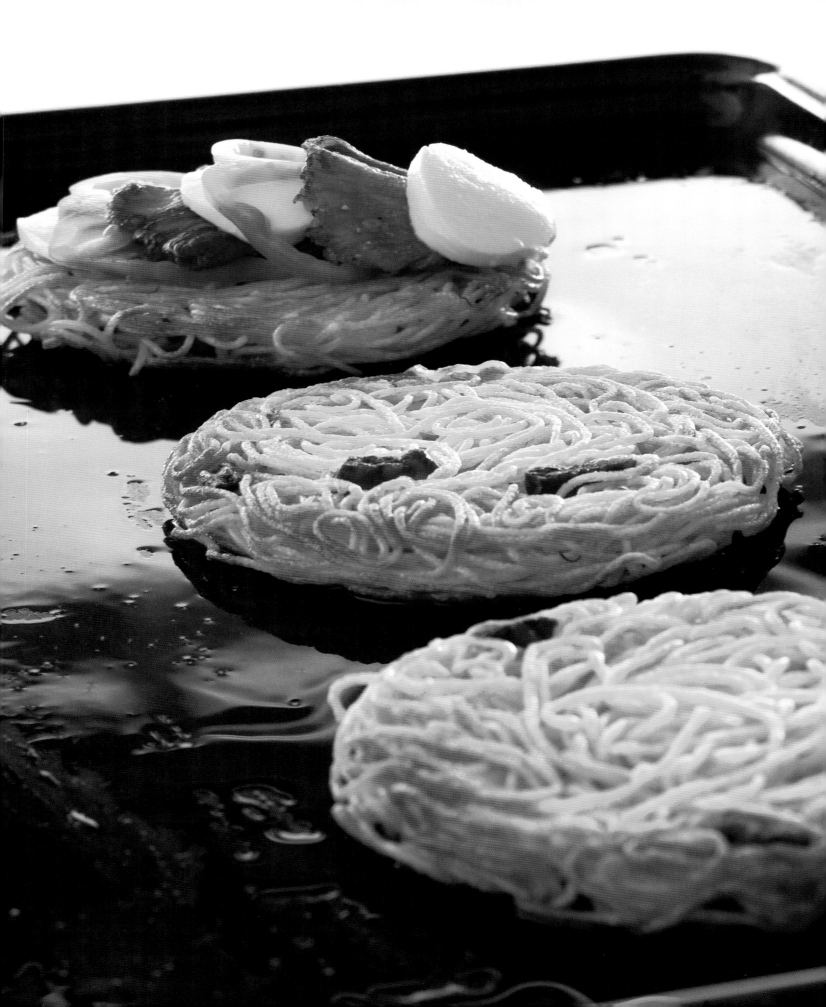

Pasta with hare ragout and rosemary apricots

France / Switzerland

The rosemary adds a special touch to the apricots.

400 g / 14 oz hare meat

1 tbsp flour for dusting

2 tbsp oil

1 carrot, peeled

¼ celeriac, peeled

4 onions, peeled

2 tbsp tomato paste

5 peppercorns
2 pimento corns
5 juniper berries
2 cloves
1 bayleaf

250 ml / 8 fl oz / 1 cup red wine

750 ml / 24 fl oz / 3 cups water

2 pieces of orange peel, cut in thin strips

500 g / 18 oz Swiss rollini

4 ripe apricots

2 tbsp butter

1 tsp sugar

1 tbsp rosemary leaves

1 tbsp white wine vinegar

Salt
Freshly ground black pepper

Remove the tendons from the meat and cut into small pieces. Season with salt and pepper, dust with flour and fry in the hot oil. Chop the carrot, celery and onions into small pieces, then fry with the tomato paste for 5 minutes.

Roughly crush the spices in a mortar and season the meat. Add some red wine and allow the liquid to reduce; repeat once. This gives the sauce a lovely sheen. Add 500 ml (16 fl oz / 2 cups) of water, cover and leave to braise in a preheated oven at 180° C for an hour. Stir occasionally and add the remainder of the water.
Season the cooked ragout with salt and freshly ground and add the orange strips to finish off; they lend a wonderfully fresh flavour to the dish. Cook the pasta in plenty of salted water, drain and add to the ragout. Combine carefully and serve on warm plates.
Meanwhile, place the apricot pieces in melted butter, season with sugar, pepper and rosemary and allow to caramelize. Pour over the vinegar and add to the pasta and ragout at the last moment. Combine well and serve immediately.

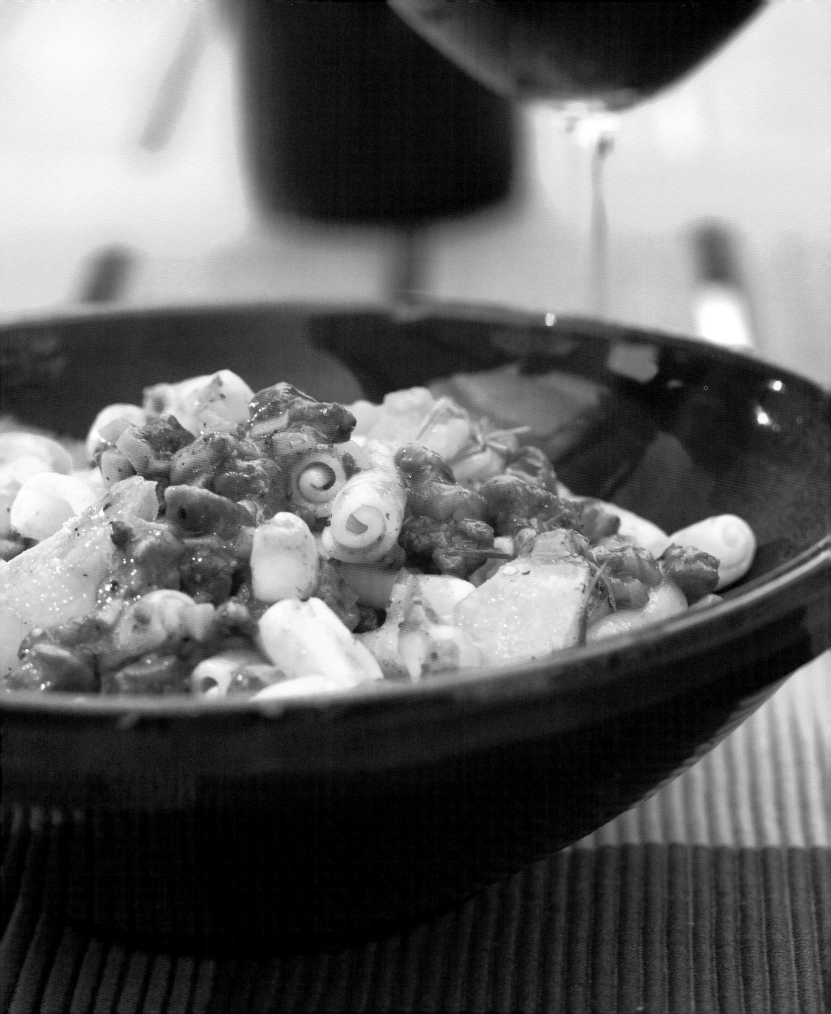

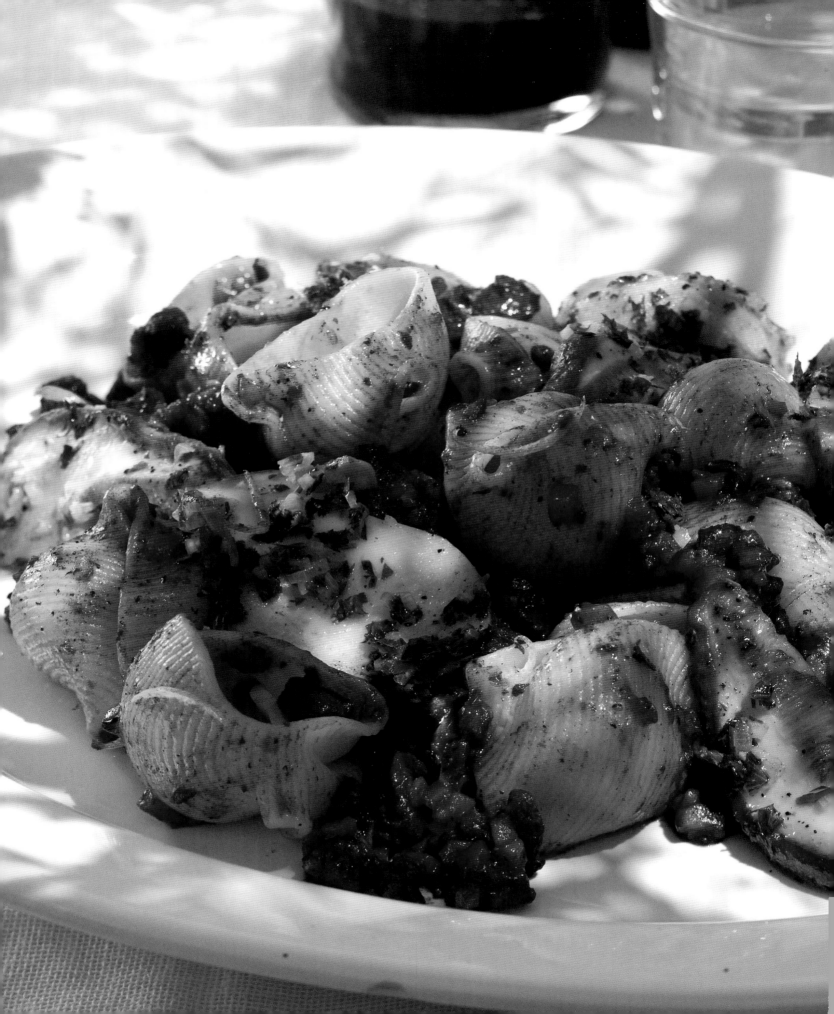

Lumaconi with wild boar ragout and fried ceps

France

Whole ceps freeze well – and then you will have fresh mushrooms all year round.

400 g / 14 oz wild boar shoulder

Salt
1 tbsp flour for dusting
Freshly ground black pepper

2 tbsp oil

1 carrot, peeled
¼ celeriac, peeled
4 onions, peeled

2 tbsp tomato paste

5 peppercorns
2 pimento corns
5 juniper berries
2 cloves
1 bayleaf

250 ml / 8 fl oz / 1 cup red wine
750 ml / 24 fl oz / 3 cups water

500 g /18 oz lumaconi

2 pieces of orange peel, cut in thin strips

4 ceps, cleaned and cut into fairly thin slices

2 tbsp of extra virgin olive oil

2 tbsp butter

1 shallot, finely chopped

½ garlic clove, finely chopped

1 tbsp parsley leaves, finely chopped

Freshly grated nutmeg

Grind the spices fairly coarsely in a mortar and use to season the meat. Add some red wine and allow the liquid to reduce. Repeat this process once; this gives the sauce a lovely sheen. Add 500 ml (16 fl oz / 2 cups) of water, cover and braise in a preheated oven at 180° C for an hour. Stir occasionally and add the remainder of the water.
Season the cooked ragout to taste with salt and freshly ground pepper and add the orange peel.
Cook the pasta in plenty of salted water, drain and add to the ragout. Combine carefully and arrange on warm plates.
Meanwhile, fry the ceps on both sides in olive oil and butter. Add the shallots and garlic and combine. Season with salt, pepper and freshly ground nutmeg, then sprinkle with parsley to finish.

Remove the tendons from the meat and cut into small pieces. Season with salt and pepper, dust with flour and then fry in the hot oil. Chop the carrot, celery and onions into small pieces, add to the meat with the tomato paste and fry for 5 minutes.

Tomato pasta dough

Mushroom pasta dough

Spinach pasta dough

Pasta doughs

Chocolate pasta dough

White pasta dough

400 g / 14 oz flour

200 g / 7 oz semolina

3 eggs

6 egg yolks

2 tbsp oil

A pinch of salt

Combine the flour with the rest of the ingredients
and knead until smooth.

Tip
The oil makes the pasta dough smoother and
easier to roll out. Wrap the dough in clingfilm
and rest it for an hour.

White pasta dough

Pasta flakes

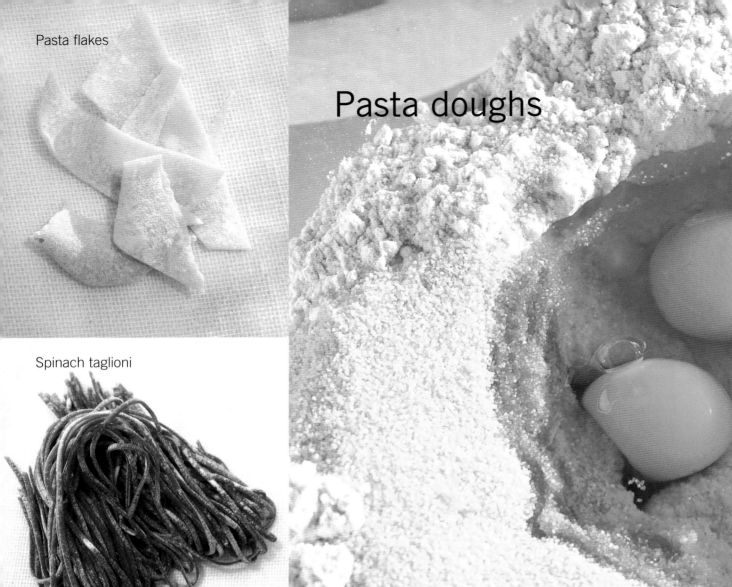

Pasta doughs

Spinach taglioni

Ravioli

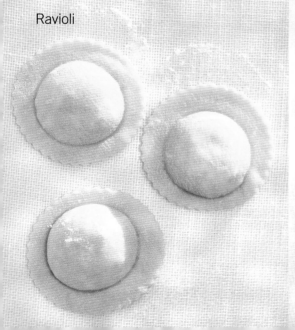

Tomato taglioni

Spinach pappardelle

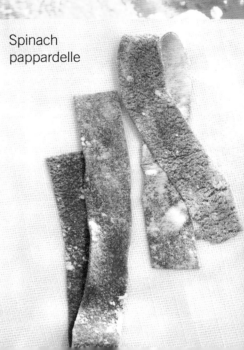

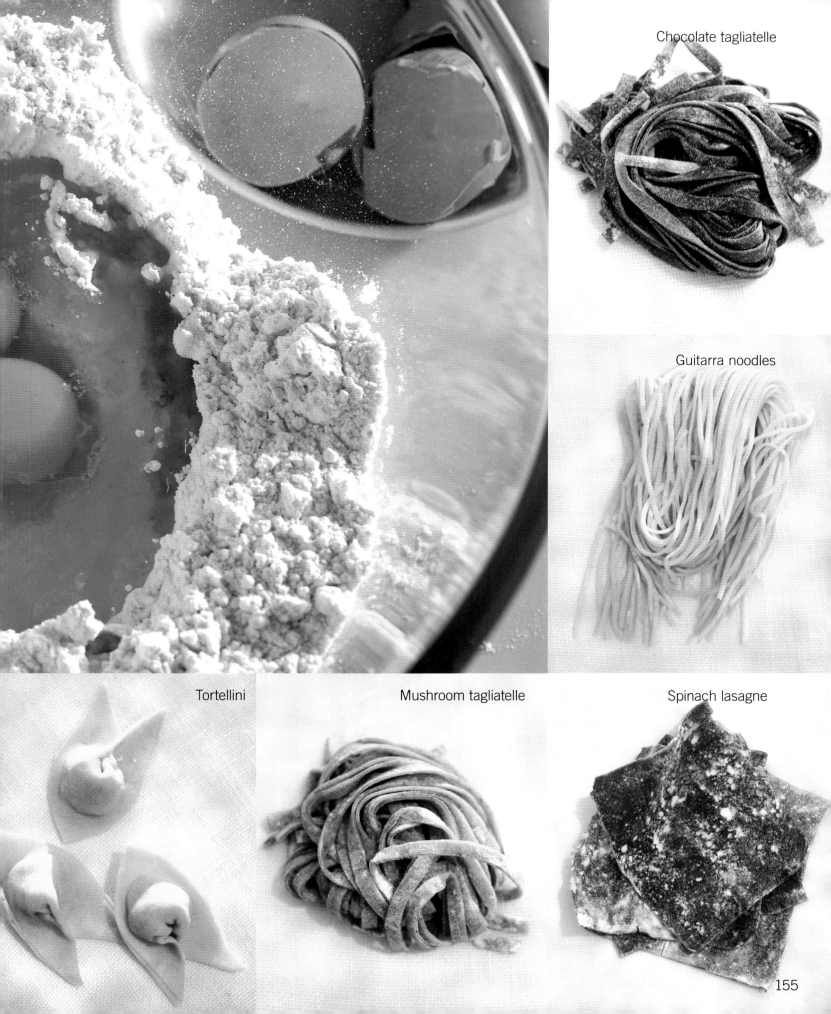

Chocolate tagliatelle

Guitarra noodles

Tortellini

Mushroom tagliatelle

Spinach lasagne

155

Pasta doughs

Spinach pasta dough

450 g / 16 oz spinach
6 egg yolks
450 g / 16 oz flour
200 g / 7 oz semolina
3 eggs
2 tbsp oil
A pinch of salt

Trim the spinach and wash thoroughly.
Cook in salted water for 5 to 8 minutes
until soft. Drain in a sieve, cool under
running cold water and squeeze to remove
all the water.
Purée the spinach in a blender (1). Add
the eggs, flour, semolina, oil and salt
and knead to a smooth dough (2+3).
Add more flour as required (4). Wrap the
spinach dough in clingfilm and rest it for
an hour.

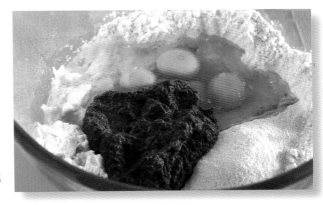

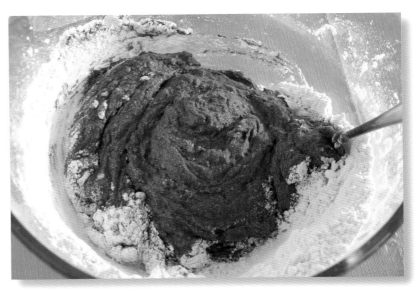

Pasta doughs

The preparation method for the different dough varieties is the same even though the ingredients are different.

Tomato pasta dough

440 g / 15 ½ oz flour
200 g / 7 oz semolina

3 eggs
6 egg yolks

2 tbsp tomato paste

2 tbsp oil

A pinch of salt

Tomato paste makes the dough bright red.

Place the flour and semolina in a bowl. Mix the eggs and egg whites with the tomato paste and add to the flour mixture. Add oil and salt and knead to a smooth dough. The oil makes the pasta dough smoother and easier to roll out. Wrap the dough in clingfilm and rest it for an hour.

Chocolate pasta dough

400 g / 14 oz flour
200 g / 7 oz semolina

80 g / 3 oz cocoa powder, unsweetened
30 g / 1 oz icing sugar

4 eggs
6 egg yolks

2 tbsp oil

1 pinch of salt

Knead the flour, semolina, cocoa and icing sugar with the remainder of the ingredients until smooth. Wrap the dough in clingfilm and rest it for an hour.
The dough does not acquire its chocolate aroma until it has been cooked in boiling water.

Mushroom pasta dough

400 g / 14 oz flour
200 g / 7 oz semolina

40 g / 1 ½ oz dry mushrooms (ceps, spring chanterelles or fairy ring mushrooms)

3 eggs
7 egg yolks

2 tbsp oil

A pinch of salt

Quick in the mixer: finely ground mushrooms.

Only use unsweetened cocoa powder for the chocolate dough.

Knead the flour, semolina and ground dried mushrooms together with the eggs, egg whites, oil and salt until smooth. Wrap the dough in clingfilm and rest it for an hour.
A very aromatic dough that is especially good in autumn, served with meat or poultry sauces.

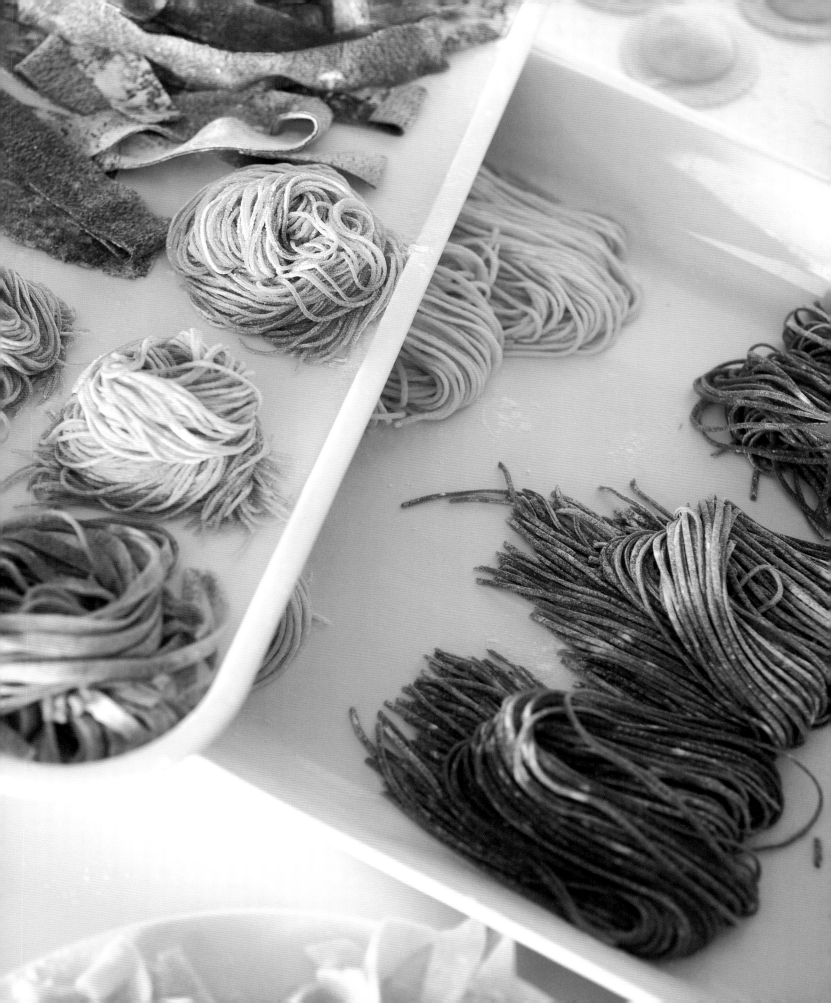

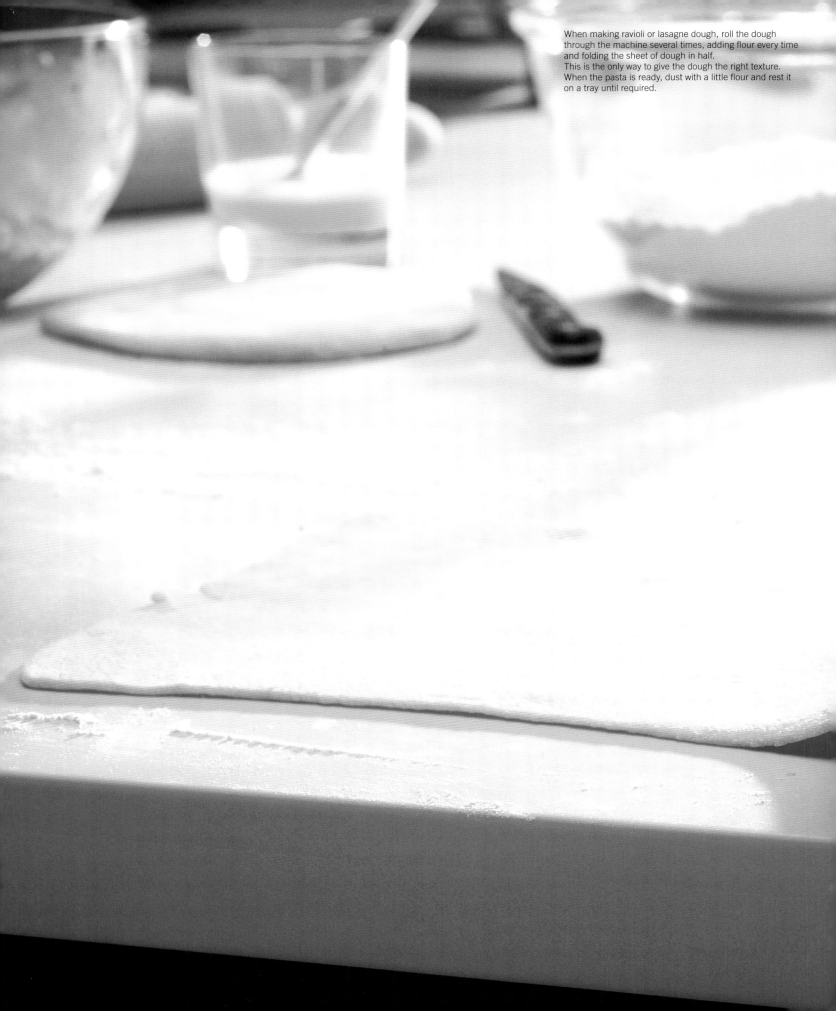

When making ravioli or lasagne dough, roll the dough through the machine several times, adding flour every time and folding the sheet of dough in half.
This is the only way to give the dough the right texture. When the pasta is ready, dust with a little flour and rest it on a tray until required.

Ravioli dough

500 g / 18 oz flour

3 eggs

2 tbsp olive oil

A pinch of salt

Knead the flour, eggs, salt, oil and 100 ml
(3 fl oz / cup) until smooth. Keep adding
a little water until the dough has the right
consistency. Wrap the dough in clingfilm
and rest it in the fridge for an hour. Then
roll it out in the pasta machine and use as
required.

Dust a worktop with flour and roll out the sheets,
then place small amounts of filling, making sure
the ravioli are not too close to each other (1).
Place the other sheet of dough on top and press
down lightly, taking care no air is trapped in
between (2).
Cut out the ravioli with a cutter and dispose of
any leftover dough (3).

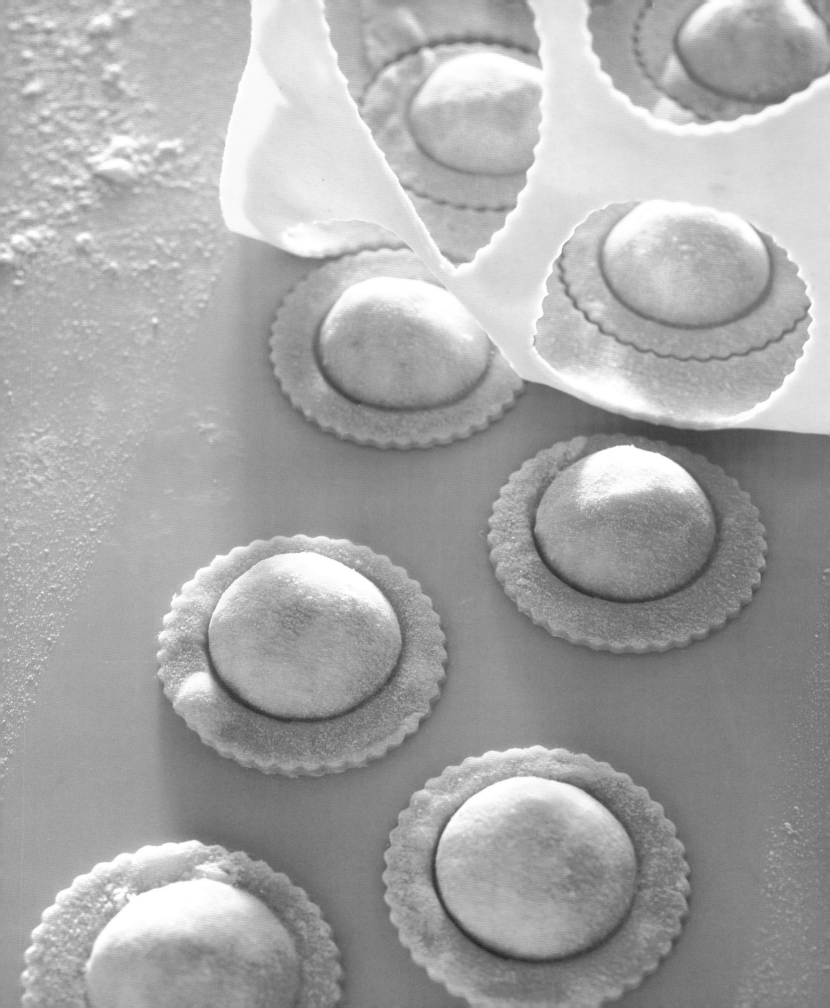

Ricotta ravioli with sage butter

Italy

Delicious filling for the ravioli. Mix well, then hide inside the pasta.

500 g / 18 oz ravioli dough (see recipe on page 162)

250 g / 9 oz fresh ricotta, grated

2 egg yolks

1 tbsp pesto (see recipe on page 92)

Salt
Freshly ground black pepper
Freshly grated nutmeg

1 egg for glaze

100 g / 3 ½ oz butter

Leaves from a bunch of sage

50 g / 1 ¾ oz Parmesan, finely grated

Prepare the ravioli dough and then roll out thinly on the pasta machine. It is important to roll the dough through the machine a few times. Dust each sheet with a little flour, then fold it in half and put it through the machine again. This gives the dough the right texture.
Mix the ricotta with the pesto and season.
Using a teaspoon, place small amounts of the ricotta filling on the dough sheets at a distance of 5 cm between each ravioli. Whisk the egg with a tablespoon of water. Brush the egg over the pasta thinly with a pastry brush. Top the filling with a second sheet, press the sides down firmly and seal with the back of a pastry cutter. Cut the ravioli out with a 6-cm diameter round pastry cutter and place on a floured tray until required. Use a pastry wheel or a knife to cut the ravioli out if you have not got a cutter. Boil the ravioli in salted water for 4 to 5 minutes, then remove carefully with a ladle.

Meanwhile, heat the butter in a pan until golden brown. Add the sage leaves, then remove the pan from the stove. The heat of the butter will be sufficient to crisp the sage leaves.
Lightly salt the butter. Arrange the ravioli on plates, top with the sage butter and garnish with Parmesan.

Tip
If you have too many fresh uncooked ravioli left over, place them on a tray and put them in the freezer. Once frozen, they are easier to handle and you can put them in a freezer container or plastic bag and keep them in the freezer for several weeks. Allow 1 to 2 extra minutes for cooking, depending on size.

✳✳✳ 60

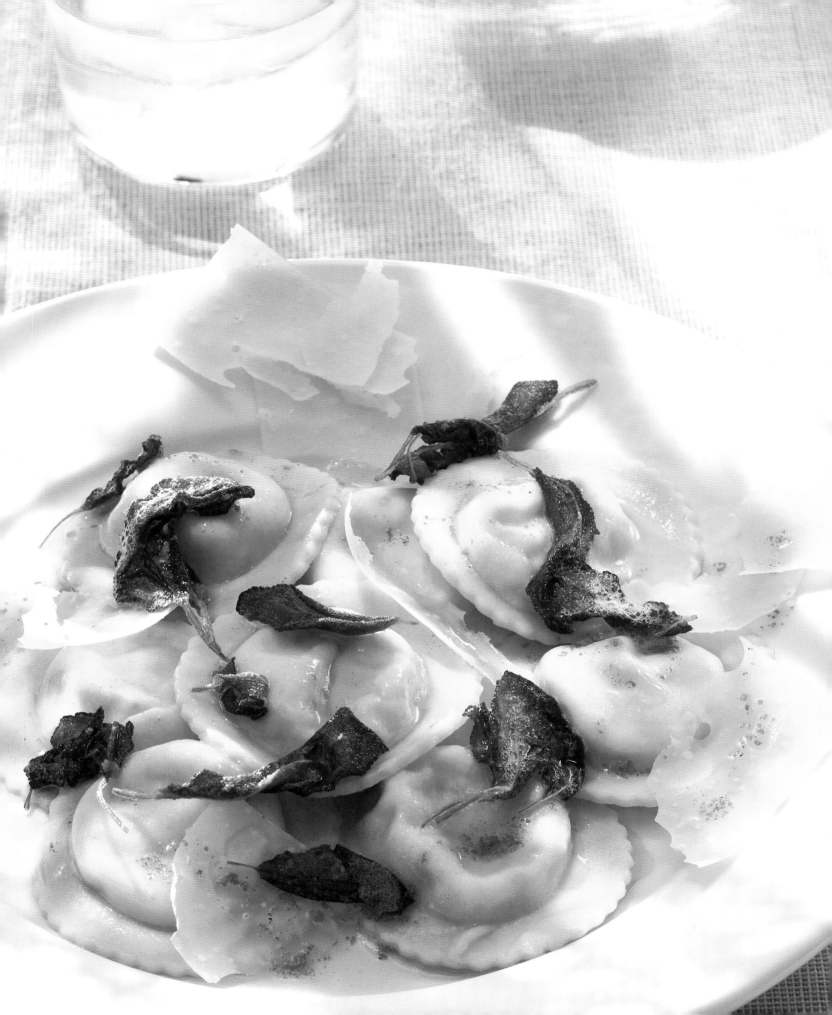

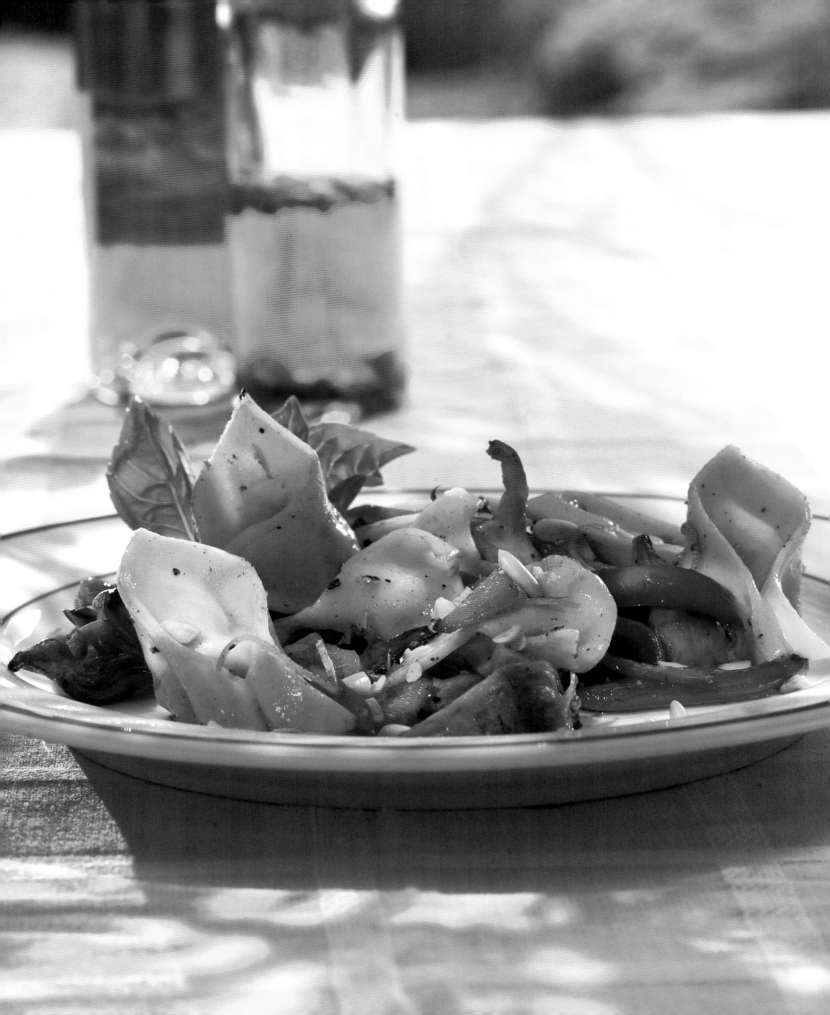

Artichoke tortelloni with peperonata and orange peel

Italy

½ garlic clove, finely chopped

1 shallot, finely chopped

60 ml / 2 fl oz / ¼ cups olive oil

4 trimmed artichoke bases, about 200 g (7 oz) each

80 ml / 2 ½ fl oz / ¼ cup white wine

150 g / 5 oz cooked starchy potatoes

½ teaspoon of thyme leaves
½ bunch of basil

1 tsp finely ground coriander seeds
Salt
Freshly ground black pepper

500 g / 18 oz white pasta dough (see recipe on page 153)

1 egg

8 artichokes

2 red peppers, halved, seeds removed

4 tbsp of extra virgin olive oil

Salt
Freshly ground black pepper

1 tsp orange peel, thinly sliced

To make the filling, fry the shallots and garlic in olive oil.
Add the chopped artichokes and season; pour over the white wine, then cover with a lid and simmer until the artichokes are soft. Mash the cooked potatoes in a bowl, add the drained artichokes, and season with thyme, finely chopped basil, coriander, salt and pepper. Leave the filling to cool down.
Roll the pasta dough out on the pasta machine and pass it through the machine several times.

Keep dusting the sheets with flour, then fold them and put them through the machine again. This ensures the dough has the right texture. Cut into squares to 10 to 12 cm and use a teaspoon to place small amounts of the filling on each square.
Whisk the egg with a tablespoon of water. Brush the egg over the pasta sides thinly with a pastry brush. Seal the ends diagonally and press firmly on the sides so that you have a triangle.
Place the triangle in front of you with the right angle pointing up. Use your index finger and

If you use a non-stick pan, you can fry the vegetables in very little fat.

thumb to press the two side ends together and shape the past into a bishop's mitre. Place on a floured tray and set aside until later.
Cut the top half off the artichokes, remove the outer green leaves and scrape the hairs off with a melon scoop.
Slice the artichokes into six and put in water to which you have added a little lemon juice to prevent them from turning brown. Cut the peppers into long, narrow strips and fry gently, with the artichokes, in olive oil for about 5 minutes. Season with salt and pepper. Add the orange peel to finish.
Cook the tortelloni in plenty of boiling salted water for about 3 minutes, then add to the pan. Combine well and arrange on plates.

Sauerkraut snails stewed in butter

Southern Germany

40 g / 1 ½ sugar

200 ml / 6 ½ / ¾ sparkling wine

60 g / 2 oz lard

150 g / 5 oz onions, sliced lengthways in strips

1 Cox's apple

500 g / 18 oz sauerkraut, ideally from a barrel

6 pasta sheets made from white pasta dough 10 x 20 cm (see recipe on page 153)

250 g / 9 oz melted butter

Salt
Freshly ground black pepper

150 g / 5 oz sour cream

1 tbsp parsley leaves, finely chopped

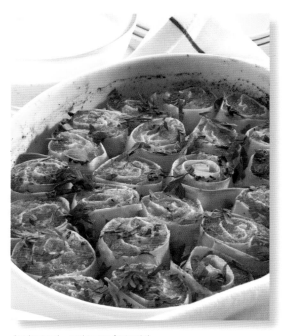

Looks good – and tastes fantastic!

Melt the sugar in a casserole with a small quantity of water and let it caramelize until golden yellow. Pour over the sparkling wine and leave to cool. Add the lard and onions and simmer for 10 minutes.
Peel the apple, remove the core and slice thinly.
Add the apple and sauerkraut to the onions and cook for 10 minutes.
Spread evenly on an oven sheet and leave to cool. The sauerkraut must be dry before you continue, otherwise the dough will turn soft when rolled out.
Place the sauerkraut on the pasta sheets and roll up lengthwise, then cut into three pieces.

Arrange close together in a buttered ovenproof dish and top with melted butter. Cook in a preheated oven at 180° C for 30 to 35 minutes.
Remove from the oven, gently arrange on plates, and garnish with sour cream, freshly ground pepper and parsley.

★★★45

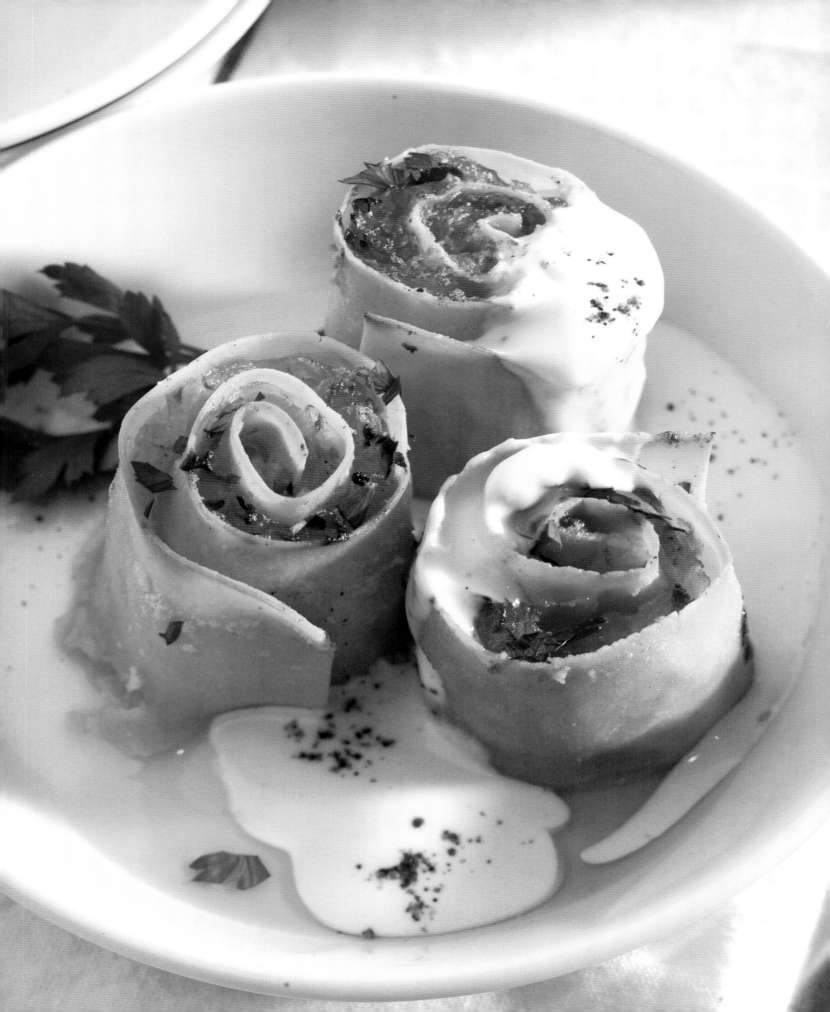

Golden sauerkraut spirals in butter

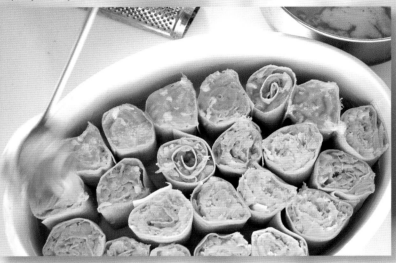

Shape the dough into slices of uniform size, put the filling on top and roll them up very carefully.

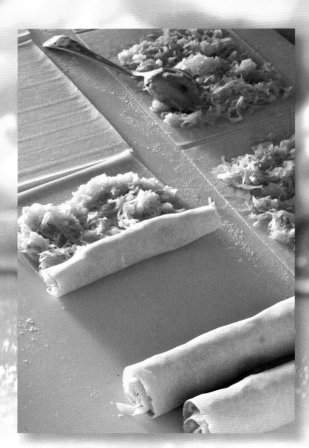

Cut the pasta rolls in pieces and place them next to each other in the soufflé baking tray. Using a large spoon, pour the butter over the top.

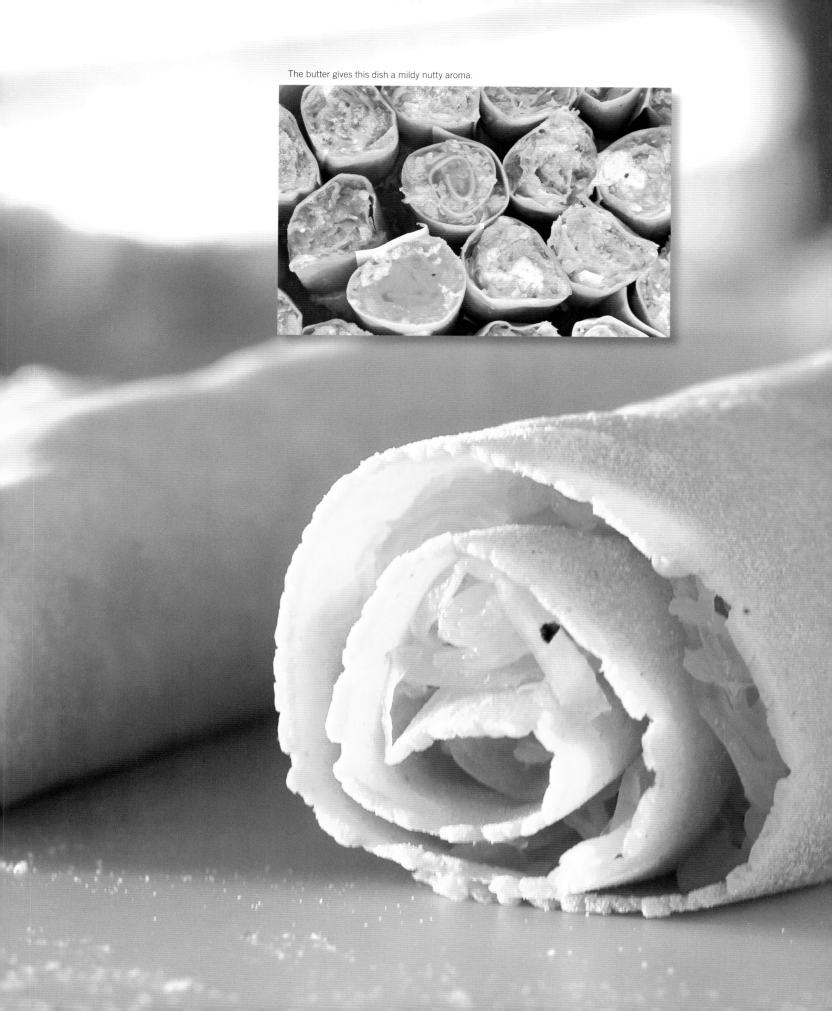

The butter gives this dish a mildy nutty aroma.

Borlotti bean ragout
Italy

280 g / 10 oz mixed red beans, soaked in cold water
for 2 hours

50 g / 1 ¾ oz carrots, finely chopped

50 g / 1 ¾ oz celery, finely chopped

50 g / 1 ¾ oz shallots, finely chopped

½ garlic clove, finely grated

30 g / 1 oz olive oil

20 g / ¾ oz butter

1 sprig of rosemary
1 bayleaf
2 large sage leaves for boiling

30 g / 1 oz tomato paste

1 l / 32 fl oz / 4 cups chicken stock

Salt
Freshly ground black pepper

8 pieces of raw cotechine (Italian sausage)

20 ml / ½ fl oz / 1/12 cups olive oil

Fry the chopped vegetable and garlic in a mixture of olive
oil and butter. Add the bayleaves, sage and rosemary
and red beans. Add the tomato paste, pour in the
chicken stock and let it simmer gently so that the beans
stay whole. Remove the rosemary, sage and bayleaf
and adjust the seasoning. Slice the cotechine into small
pieces and fry slowly in olive oil, then add to the bean
ragout. Season with freshly ground pepper.
Finish off with a few drops of quality olive oil if desired.

Fish dumplings coated in transparent noodles on a spicy cucumber salad
Thailand

1 cucumber, peeled

400 g / 14 oz pike fillet

80 g / 3 oz crab meat, separated

Juice of 1 lemon

Salt
Freshly ground white pepper

2 shallots, finely chopped

3 fresh farm eggs

2 tbsp Thai basil, cut thinly

50 g / 1 æ oz transparent noodles

1 garlic clove, finely chopped

2 tbsp rice vinegar

1 tbsp sunflower oil

1 tsp sambal oelek

Sugar

Oil for deep-frying

Slice the cucumber thinly, salt, and leave to absorb for
20 minutes. Cut the pike fillet and crab meat into small
pieces, or chop with a chopping machine. Season with
the lemon juice, salt and pepper. Add the shallots, 1 egg
and the Thai basil and mix well. Adjust the seasoning.
Break the noodles into small pieces or cut them up with
scissors. Drain the cucumber and season with garlic,
vinegar, 1 tbsp oil, sambal oelek, salt and sugar.
Use two teaspoons to form little dumplings out of the fish
paste. Dip in the remainder of the beaten egg, then toss
in the transparent noodles. Deep-fry in plenty of hot oil
until golden yellow, then place on kitchen paper. Put the
fish dumplings on top of the spicy cucumber salad and
serve.

Sweet horn-shaped pasta in hot milk
Germany

320 g / 11 oz horn-shaped pasta

500 ml / 16 fl oz / 2 cups fresh full-fat milk

30 g / 1 oz butter

80 g / 3 oz icing sugar

A pinch of salt

Cook the horn-shaped pasta in plenty of water with just a pinch of salt. Drain and cool under running cold water.
Bring the milk to the boil and reheat the pasta in it. Pour in soup bowls and top with butter flakes and icing sugar.

Tip
Children in particular love this highly nutritious dish.

Fried sweet pasta with glacé fruit

India

250 g / 9 oz Chinese egg noodles

80 g / 3 oz halved almonds

120 g / 4 oz mixed glacé fruit

50 g / 1 ¾ oz icing sugar

1 tsp ground cardamom

½ tsp turmeric

2 tbsp vegetable oil

Cook the egg noodles, then drain completely and mix with the icing sugar, glacé fruit and spices while still warm.
Heat the oil in a non-stick pan and place the noodle mixture in it. Fry gently until the noodles turn golden yellow. Turn over and fry the other side in the same way. Make sure the heat is not too high, as this will make the sugar bitter.
Drain the fried noodles on kitchen paper and arrange in a large dish.
Garnish with almonds or glacé fruit as preferred.

Cannelloni with walnut and chicken liver filling

Italy

120 g / 4 oz grated walnuts

350 g / 12 ½ oz chicken livers

2 egg yolks

300 g / ½ oz ricotta (Italian fresh cheese)

20 lasagne sheets or rolled out white pasta dough (see recipe on page 153)

120 g / 4 oz cream

4 cleaned artichoke bases

2 tbsp olive oil

3 tbsp butter

1 garlic clove, pressed in its skin

2 sprigs of thyme

Salt
Freshly ground black pepper
Freshly grated nutmeg

Fry the grated walnuts gently in a tablespoon of butter and cool. Cut the chicken livers into small pieces and fry gently in a tablespoon of butter, then season with salt and pepper. Mix the walnuts with the cooled livers, egg yolks and the ricotta. Season with salt, pepper and nutmeg.
Spread over the thinly rolled out sheets of dough and roll into finger-thick cannelloni. Butter an ovenproof dish and place the cannelloni inside. Pour over the cream and bake for 20 minutes at 180° C in a preheated oven.
Cut the artichokes into slices and fry in olive oil with the garlic and sprigs of thyme over a low heat, then season with salt and pepper.
Serve the cannelloni and fried artichokes on plates.

Tagliatelle alla carbonara
Italy

150 g / 5 oz piece of bacon

1 onion

2 tbsp of extra virgin olive oil

500 g / 18 oz tagliatelle

300 g / 10 ½ oz cream

6 egg yolks

50 g / 1 ¾ oz Parmesan, freshly grated

Salt
Freshly ground black pepper
Freshly grated nutmeg

Remove the rind and gristle from the bacon and cut into small pieces. Peel the onions and cut into small pieces. Fry the bacon and onion pieces in a large pan in olive oil over a low heat for 4 minutes until light brown.
Cook the tagliatelle in plenty of boiling salted water for 5 minutes until al dente. Drain in a sieve.
Mix the egg yolks with the Parmesan and season with salt, nutmeg and pepper.
Combine the warm pasta with the bacon and onions and pour over the cream sauce. Heat briefly, stirring constantly. Make sure that the sauce does not boil, or the egg yolks will set and lose their binding properties. If necessary, adjust the seasoning again, and serve immediately.

Chinese egg noodles with sole and fried vegetables
China

400 g / 14 oz Chinese egg noodles

600 g / 21 oz sole fillet

2 tbsp clear soy sauce

4 tbsp hoisin sauce

2 medium-sized carrots, peeled

1 leek, trimmed

150 g / 5 oz oyster mushrooms

120 g / 4 oz mangetout, cleaned

½ yellow pepper
½ red pepper

1 garlic clove, finely chopped

6 tbsp sunflower oil

200 g / 7 oz nameko mushrooms (tinned)

1 tsp sambal oelek

Cook the egg noodles according to the packet instructions. Drain in a sieve and cool under running cold water. Drain well. Cut the sole fillet into bite-sized pieces and marinate in a little soy sauce and a few shakes of hoisin sauce. Cut the carrots and leek into thin strips. Cut the oyster mushrooms into two or three pieces, depending on the size.
Halve the mangetout diagonally. Remove the seeds from the peppers, trim and cut into 1 cm sized rhombi. Heat 4 tablespoons of oil in a wok and stir-fry the vegetables one after the other. Start with the carrots, then continue with the mangetout, the peppers and the garlic. The vegetables should remain crisp.
Finally, add the marinated sole pieces and the drained nameko mushrooms and cook. Season with hoisin sauce and sambal oelek. Fry the noodles in batches in the rest of the hot oil and combine with the vegetables. Check the quantity of soy sauce once more.

German potato noodles with coffee sauce and cardamom

Turkey

450 g / 15 oz starchy boiled potatoes in their skins,
cooked the day before

150 g / 5 oz flour
50 g / 1 oz potato starch

2 egg yolks

Salt
60 g / 2 oz sugar
500 ml / 16 fl oz / 2 cups strong coffee

4 cl / 12 ¾ fl oz / 1 ½ cup whisky

8 white cardamom seeds

60 g / 2 oz cold unsalted butter, sliced
200 g / 7 oz crème fraîche

10 coffee beans, crushed

Peel and finely grate the potatoes. Work into a
homogenous dough with the flour, starch, egg yolks and
salt (1). Roll out into finger-thick strips, then cut into
1-cm-long pieces (2).
Dust your hands in flour and shape the pieces into 8 to
10 cm long noodles with pointed ends.
Place on a floured board (3).
Put in boiling salted water. As soon as the potato
noodles rise to the surface, remove them with a spoon
and plunge briefly into iced water to cool. Meanwhile,
caramelize the sugar in a large pan until light in colour.
Pour in the whisky, add the cardamom and then the
coffee. Reduce to about a third. Place the potato
noodles in the coffee sauce and gently stir in the cold
butter slices.
Arrange on plates and top each one with 2 tablespoons
of crème fraîche.
Finish by sprinkling over the crushed coffee beans.

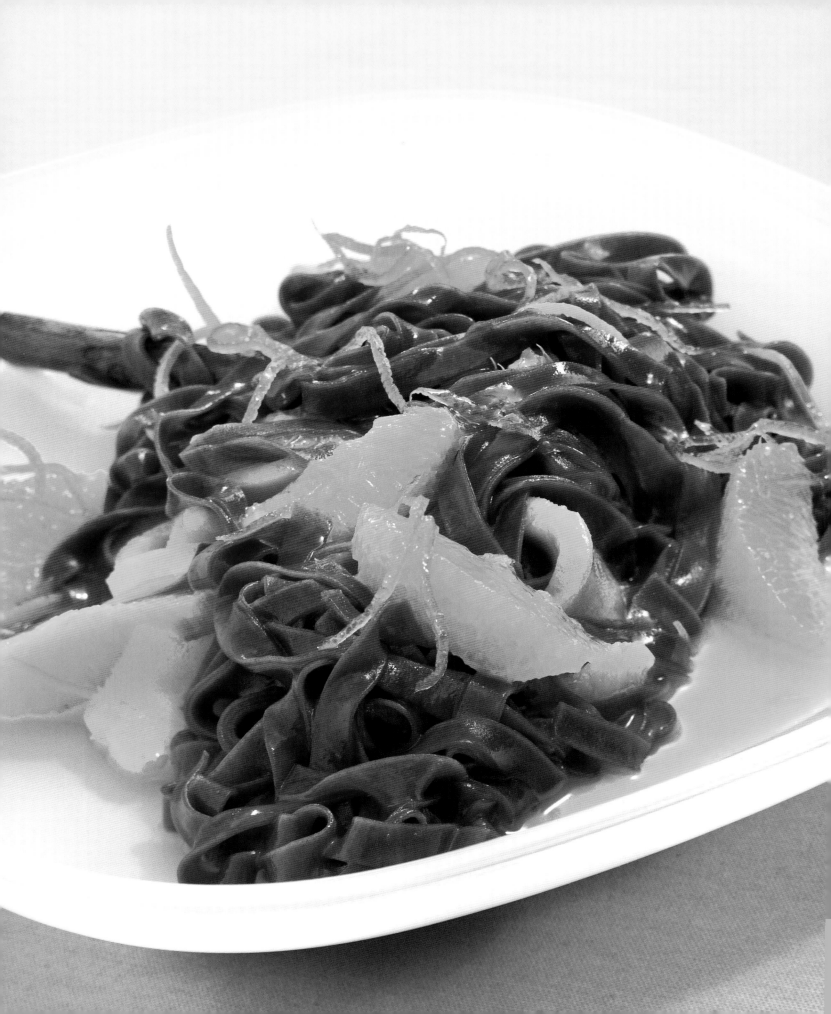

Chocolate noodles with orange and passion fruit sauce and mango strips

Florida

300 g / 10 ½ oz of chocolate dough (see recipe on page 158)

1 orange

100 g / 2 ½ oz refined sugar

1 cinnamon stick

250 ml / 8 fl oz / 1 cup orange juice
Flesh of two passion fruit
Fillets of 2 oranges.
1 mango, peeled

50 g / 1 ¾ oz cold butter

Chocolate noodles are not just for the sweet-toothed!

These yellow fruits with their sweet-tart aroma go particularly well with chocolate.

Roll out the chocolate dough thinly, pass through the tagliatelle roller and then place on plates in portion sizes to dry slightly until required.

To peel the orange zest, wash the orange in warm water and dry. Peel it thinly with parer, taking care not to remove any of the white pith. Cut in long strips and plunge in boiling water for just 5 seconds.

Cool under running cold water, then place in a small saucepan with 40 g (1 ½ oz) sugar and 100 ml (3 ¼ fl oz / ½ cup) water. Simmer gently until the liquid has boiled away and the orange strips have absorbed the sugar. Place in a glass and set aside.

To make the sauce, caramelise 60 g (2 oz) of sugar until golden yellow, then add the cinnamon stick and the orange juice.

Add the passion fruit and reduce to half the original quantity. Strain the sauce and add the orange and mango strips.

Meanwhile, cook the chocolate noodles in lightly salted water for 2 minutes, then drain and place in the sauce. Cook for a few more minutes in the sauce, then bind with cold butter.

Arrange on plates and top with orange zest before serving.

Let the machine do it: the strips are all the same size and shape.

Jumbo goat's cheese ravioli with tomato butter and pesto oil

Italy

400 g / 14 oz ravioli dough (see recipe on page 162)

1 middle sized goat's cheese roll

8 spinach leaves, washed

1 egg for glaze

1 shallot, finely chopped

½ garlic clove, finely chopped

4 tbsp of extra virgin olive oil

200 ml / 6 ½ fl oz / ¾ cup tomato juice

Salt

Freshly ground black pepper

1 pinch of sugar

40 g / 1 ½ oz cold butter

1 tbsp pesto (see recipe on page 92)

Roll the ravioli dough out thinly on the pasta machine. Cut the goat's cheese into 8 slices and place on a sheet of ravioli dough, leaving at least 8 cm between. Place a spinach leaf on each cheese slice and season with freshly ground black pepper. Paint the edges with whisked egg and top with another sheet of ravioli. Press down the sides and cut out the shapes using a 12-cm biscuit cutter.

Meanwhile, fry the shallots and garlic in 2 tbsp olive oil until transparent.

Season with salt, pepper and sugar and pour over the tomato juice. Simmer gently for 5 minutes and add the cold butter at the end. Cook until the butter has melted completely.

Place the ravioli in plenty of salted water and return to the boil. Remove from the stove and leave to stand for 1 minute.

Arrange the ravioli on warm plates and top with a little tomato butter and pesto mixed with the remaining oil.

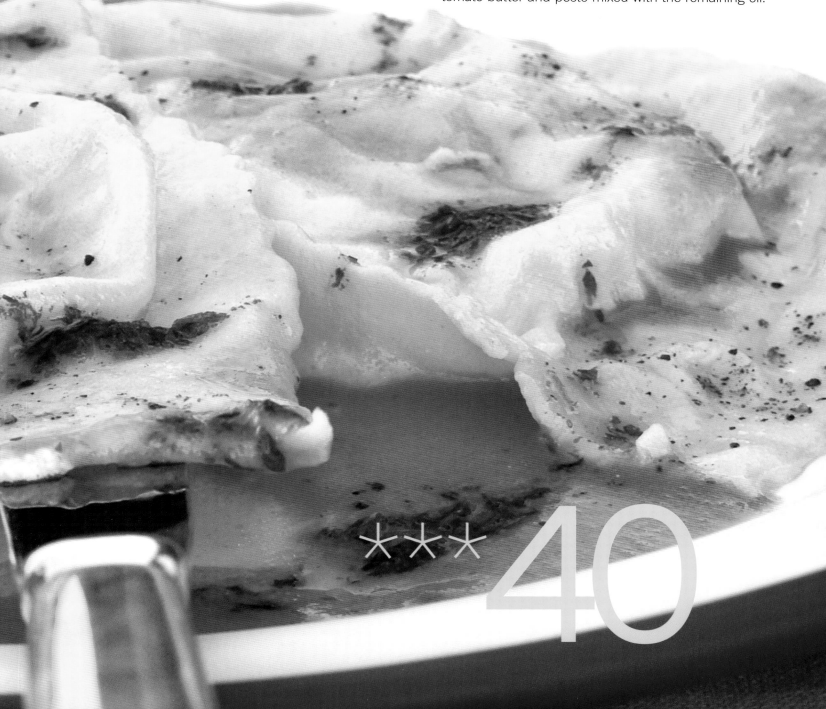

✴✴✴40

Beetroot ravioli with poppy seed butter
Italy

2 medium-sized beetroot

250 g / 9 oz cooked starchy potatoes

100 g / 3 ½ oz ricotta

2 egg yolks

Rock salt
Crystal sugar
Freshly ground white pepper
Freshly grated nutmeg

300 g / 10 ½ oz ravioli dough (see recipe on page 162)

1 egg for glazing

120 g / 4 oz butter

60 g / 2 oz ground poppy seeds

Please note: beetroot is strongly coloured and can stain. Wear rubber gloves and an apron when handling to prevent staining.

Put the beetroot in a pot of boiling water. Season the water with plenty of salt and sugar and cook for 15 minutes. Cool and peel by hand under running water. Grate finely, doing the same with the potatoes.
Mix with ricotta and the egg yolks, then season with salt, white pepper and nutmeg. Roll out the ravioli dough thinly, glaze with whisked egg and place teaspoon-sized amounts of the filling on the dough, leaving a space of 5 cm between each. Cover with another rolled-out sheet of ravioli and press down.

Be careful when you press the dough down over the filling not to trap any air in the ravioli, otherwise they will burst in the boiling water. Cut the ravioli out with a cutter of 5 to 6 cm diameter, and place in plenty of boiling water. Cook for just 1 to 2 minutes. Remove and place on warm plates.
Meanwhile, melt some butter in a pan and add the ground poppy seeds.
Salt the poppy seed butter lightly and pour over the ravioli immediately.

***70

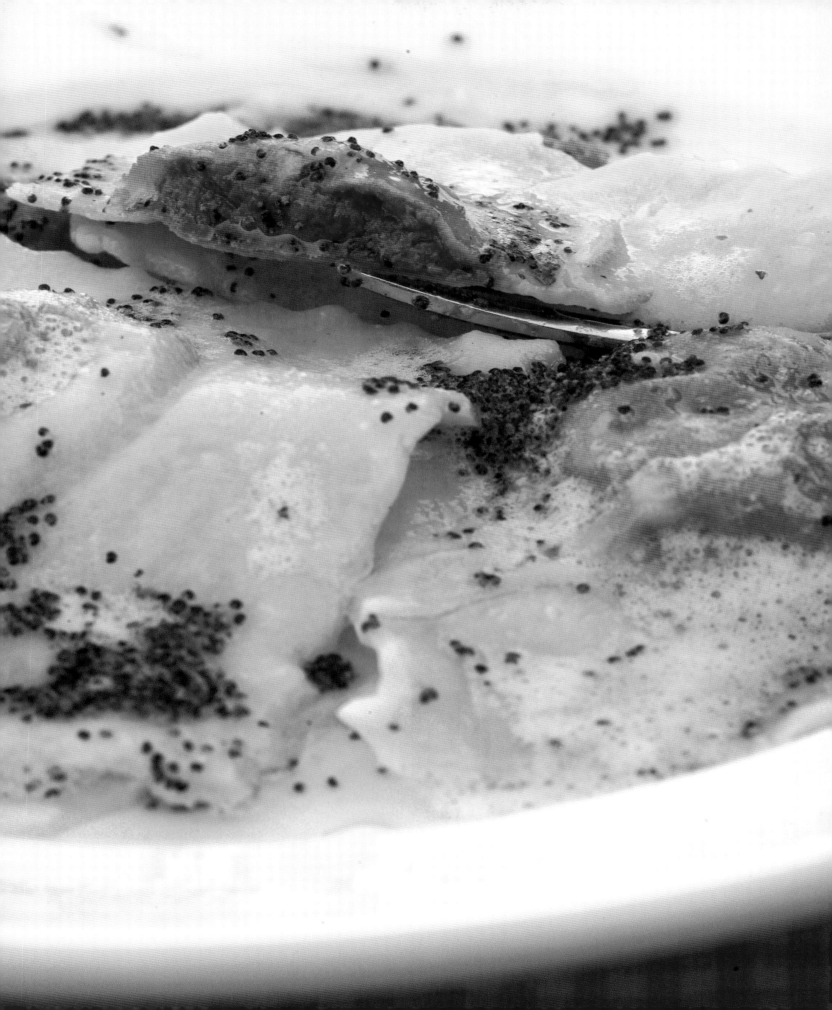

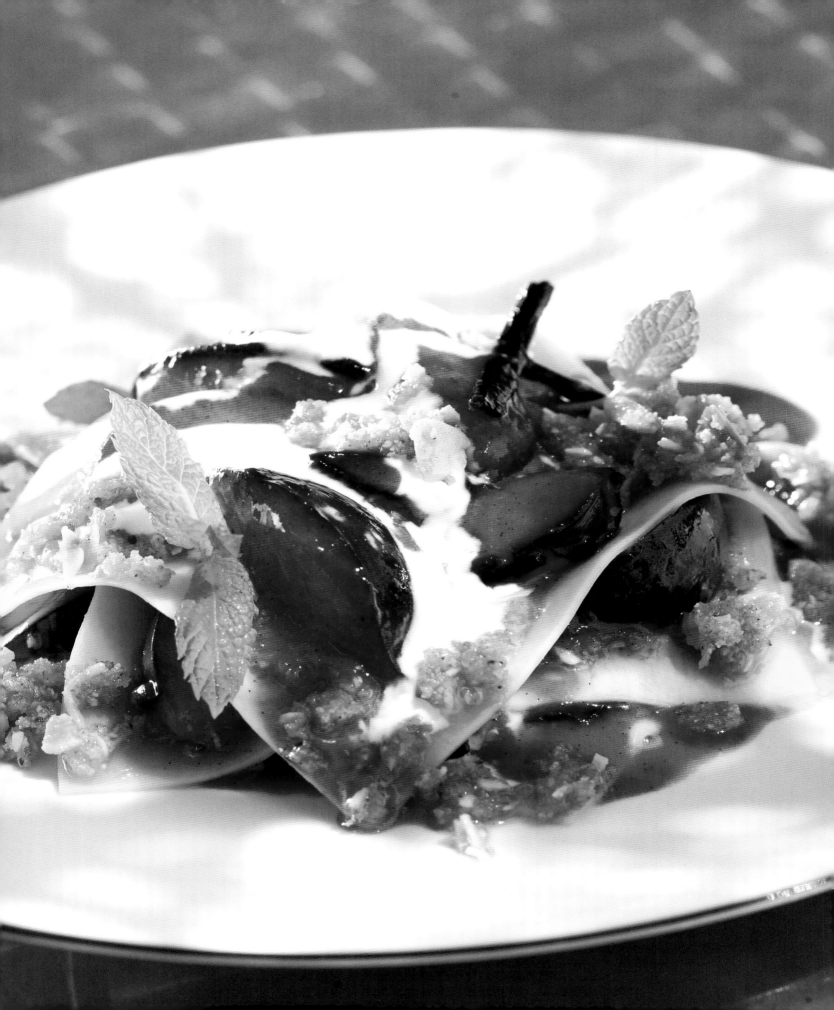

Plum lasagne with roast almonds

Austria

500 g / 18 oz ripe plums

170 g / 5 ¾ oz unsalted butter

110 g / 3 ¾ oz refined sugar

1 vanilla pod

100 g / 3 ½ oz white bread, crust removed

100 g / 3 ½ oz grated almonds

½ tsp ground cinnamon

8 white lasagne sheets

250 g / 9 oz sour cream

1 tsp icing sugar

A few mint leaves as garnish

There are many varieties of plum, but the best ones for this recipe are the dark blue ones with red flesh or damsons.

Remove the stones from the plums and cut into thin strips. Melt 40 g (1 ½ oz) butter in a pan with 50 g (1 ¾ oz) refined sugar. Cut the vanilla pod in half, scrape out the marrow, and cut the remainder into 4 cm long pieces. Place everything in the pan.

Add the plum strips and stir well. Don't let the plums become too soft, just allow them to melt. Melt the rest of the butter, make breadcrumbs from the bread and add to the butter with the almonds, remaining sugar and cinnamon and fry until golden.

Meanwhile, cut the sheets in half (use the edge of a table to break them) and cook in lightly salted water following the packet instructions. Add a little icing sugar to the sour cream and stir until smooth.

Arrange a little of the plum ragout on plates and cover with a sheet of lasagne. Top the lasagne with another layer of plum ragout and the roasted breadcrumbs with almonds, and a spoonful of sour cream.

Repeat this process until each portion consists of four sheets of lasagne.

Garnish with mint leaves and serve.

Time index

Country index

USA

Chinese shrimp noodles with grapefruit, green pepper and grilled chicken	73
Chocolate noodles with orange and passion fruit sauce and mango strips	179
Maccheroncini with cheddar cheese au gratin	41
Rotelle in pumpkin sauce baked in a pumpkin	137

Mexico

Maize rigatoni with chilli beans	97

China

Chinese egg noodles with sole and fried vegetables	175
Chinese egg noodles with beef strips and fried shitake mushrooms	117

Japan

Cold soba noodles with raw egg and spring onions	20
Udon noodles in chicken soup with vegetables and coriander	18

Thailand

Cold coconut soup with rice pasta and pineapple	74
Deep-fried transparent noodles in melon purée	52
Fish dumplings coated in transparent noodles on a spicy cucumber salad	172
Rice noodles with broccoli and curried scrambled eggs	121
Rice vermicelli salad with peppers and shrimp chilli flakes	100
Tofu curry with asparagus and cherry tomatoes	58
Transparent noodle salad with tomato chutney, peach and shrimps	111

India

Fried sweet pasta with glacé fruit	174

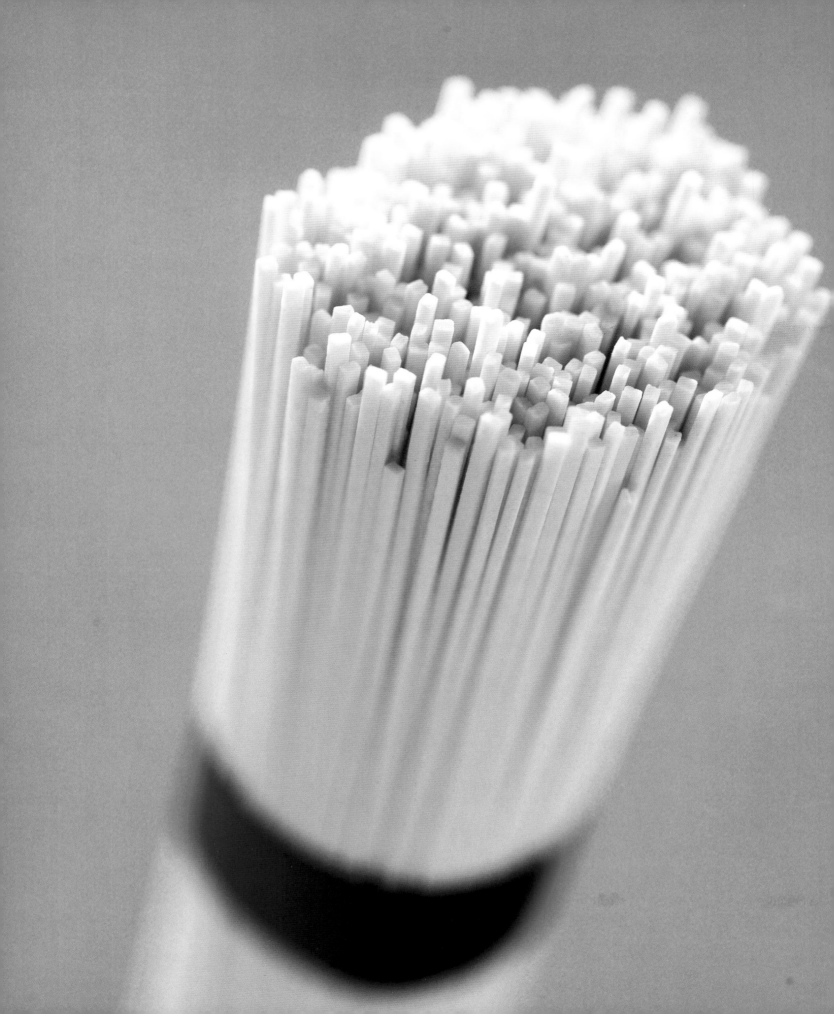